Ethics for a Digital Age
VOLUME II

Steve Jones
General Editor

Vol. 118

The Digital Formations series is part of the Peter Lang Media and Communication list.
Every volume is peer reviewed and meets
the highest quality standards for content and production.

PETER LANG
New York • Bern • Berlin
Brussels • Vienna • Oxford • Warsaw

Ethics for a Digital Age

VOLUME II

Bastiaan Vanacker *and* Don Heider,
Editors

PETER LANG
New York • Bern • Berlin
Brussels • Vienna • Oxford • Warsaw

The Library of Congress has catalogued the first volume as follows:

Names: Vanacker, Bastiaan, editor. | Heider, Don, editor.
Title: Ethics for a digital age / edited by Bastiaan Vanacker and Don Heider.
Description: New York: Peter Lang, 2016.
Series: Digital formations, vol. 104 | ISSN 1526-3169
Includes bibliographical references and index.
Identifiers: LCCN 2015025403
ISBN 978-1-4331-2959-9 (vol. 1, hardcover: alk. paper)
ISBN 978-1-4331-2958-2 (vol. 1, paperback: alk. paper)
ISBN 978-1-4539-1687-2 (vol. 1, ebook pdf)
ISBN 978-1-4541-9123-0 (vol. 1, epub) | ISBN 978-1-4541-9122-3 (vol. 1, mobi)
ISBN 978-1-4331-5180-4 (vol. 2, hardcover: alk. paper)
ISBN 978-1-4331-5179-8 (vol. 2, paperback: alk. paper)
ISBN 978-1-4331-5181-1 (vol. 2, ebook pdf)
ISBN 978-1-4331-5182-8 (vol. 2, epub) | ISBN 978-1-4331-5183-5 (vol. 2, mobi)
Subjects: LCSH: Internet—Moral and ethical aspects.
Computer networks—Moral and ethical aspects. | Online etiquette.
Classification: LCC TK5105.878.E79 2016 | DDC 175—dc23
LC record available at https://lccn.loc.gov/2015025403
DOI 10.3726/978-1-4539-1687-2 (vol. 1)
DOI 10.3726/b14177 (vol. 2)

Bibliographic information published by **Die Deutsche Nationalbibliothek.**
Die Deutsche Nationalbibliothek lists this publication in the "Deutsche
Nationalbibliografie"; detailed bibliographic data are available
on the Internet at http://dnb.d-nb.de/.

The paper in this book meets the guidelines for permanence and durability
of the Committee on Production Guidelines for Book Longevity
of the Council of Library Resources.

Table of Contents

Part III: Ethics and Ontology

Foreword

DON HEIDER

Increasingly technology surrounds us, no longer as a tool or an aid, but as a way of life. As Luciano Floridi argues, we are experiencing a fourth revolution in human development, as we are becoming informational organisms living in a cocoon of technology (Floridi, 2014).

All this is happening without a full understanding or discussion of the ethical implications of this revolution. Evidence of this can be found now almost weekly, if not daily. People livestream murders and other unspeakable acts on Facebook and other platforms as the technology providers deny their role as media companies. Instead, the companies race to get a handle on how to control unruly and objectionable posts and ask for crowdsourcing help to police their sites. YouTube ads appear on anything from cute cat videos to clips of terrorists beheading hostages. Apparently the company never considered the implications of letting computers place ads.

When we founded the Center for Digital and Ethics & Policy in 2008, the idea was to help foster discussions and research about ethics involving new technology. We have found a community of scholars and professionals who are deeply concerned about issues such as privacy, access, piracy, behavior online, and more. Though scholars from many different disciplines have been engaging in research in this area, we have a void when it comes to the tech companies themselves. Not that these companies are filled with people with no moral grounding. But there is a deafening silence from the leaders of these organizations when it comes to ethics.

Some have described a bubble of arrogance surrounding Silicon Valley, where CEOs often equate financial success to moral superiority (Edwards, 2013). Add that to a lack, thus far, of serious regulation and you begin to see the scope of the problem. We have now begun calling on tech companies to consider hiring trained ethicists; people who, if given the chance, might

help leaders make better decisions about the technology they unleash upon us on a regular basis (Heider, 2017). In the meantime, we will continue to gather excellent research and hold yearly symposia in an effort to spur on rich discussions of the issues at hand.

In this volume we offer 10 chapters, all with important research regarding digital ethics. Susan Currie Sivek discusses emotion analytics tools, used increasingly to not only record what we are thinking about but also to sense, record, and respond to emotional information. This is especially important information to advertisers, who have known for years that appealing to our emotions is often more effective than appealing to our intellect. The data that now can be collected includes not only our facial expressions, but also things like blood pressure, voice stress, perspiration rate, and body temperature. This raises new and important questions about privacy and who controls our data.

Joseph Jerome and Bénédicte Dambrine discuss our new sharing economy, which is also by the way, data driven. Who controls that data, and with whom it is shared is an important question. Most of us might not expect that our ride-sharing history might end up in the hands of the F.B.I. or some other state security agency. Jerome and Dambrine endorse more transparency, so we know when our information is being recorded, stored, and transmitted and why. How companies respond when an employee has a social media mistake is the subject for study by Heidi McKee and James Porter. The two scholars use rhetorical analysis and a network perspective to shed light on the subject. When using social media, when is a person speaking as a representative of the company whom they work for and when are they speaking for themselves as individuals? What policies do companies have in regard to employees' use of social media? Does the culture of a company influence employee behavior? These are all questions companies need to think through, as well as what an appropriate response is when there is a misstep.

Digital technology has raised an interesting new set of questions for journalists, as Kathleen Bartzen Culver found out, including some ideas about when, where, and how drones should be used. Drones in the United States do fall under regulations set by the Federal Aviation Administration, but beyond laws, Culver explores the ethical concerns, not just from journalists but also by citizens for whom journalists are producing their work.

Chad Painter and Patrick Ferrucci wondered how digital journalists who do not work for legacy media organizations conceive of themselves as journalists, and how that might be different from traditional practitioners. Meanwhile, Stephen Ward believes the digital shift calls for a form of radical journalism ethics. He calls for a new global journalism ethics which is "discursive in method,

imperfectionist and non-dualistic in epistemology, integrationist in structure, and globally open in criticism."

As digital technology has developed, there are some new behaviors that have emerged or behaviors that have morphed in some way due to the technology. One of these is the idea of public shaming, also sometimes labeled cybervigilantism. Mathias Klang and Nora Madison compare acts of cybervigilantism to the concept of vigilantism to see how accurate this label may be. It's an interesting discussion, especially given that this behavior continues to be prevalent in the online community.

Philosopher David Gunkel contributes an outstanding and thought-provoking piece on whether machines, in this case robots, can and should have rights. It's a much thornier issue than it may seem at first blush. In a chapter that has some interesting common ground with Gunkel, Timothy Engström looks at our physical bodies and how the digital devices often used in diagnostics and treatment raise a myriad of questions about consent.

We wrap up the volume with a look at space, as David Allen discusses the importance of public space in the vitality of a democracy, and questions whether digital media can provide a meaningful public space for citizens.

As we approach having four billion people on the Internet, with Americans spending an average of ten hours a day engaged in Internet media, the ubiquitous nature of digital technology in addition to the reluctance of CEOs of silicon valley firms (and others) to take real responsibility in even discussing ethical concerns demonstrate the need for the research found here, and much more research to come. We offer this volume as a small effort to get the world to engage seriously in some very important questions about privacy, access, behavior, and more that are not going away, but in fact, will increase with time.

References

Edwards, J. (2013). Silicon Valley is living inside a bubble of tone-deaf arrogance. *Business Insider*. Retrieved from http://www.businessinsider.com/silicon-valley-arrogance-bubble-2013-12

Floridi, L. (2014). *The 4th revolution; How the Infosphere is reshaping human reality*. Oxford: Oxford University Press.

Heider, D. (2017). Why Facebook should hire a chief ethicist. *USA Today*. Retrieved from https://www.usatoday.com/story/opinion/2017/01/08/facebook-ethics-fake-news-social-media-column/96212172/

Part I: Trust, Privacy, and Corporate Responsibility

Introduction to Part I

DAVID KAMERER

Perhaps the most visible digital ethics issues are connected to business. Technological innovations allow businesses to know their audiences better, interact with them through social media, and facilitate transactions. However, these opportunities also carry substantial risks if executed without ethical forethought.

A student once bragged that he had figured out how to get rid of the ads on Google's Gmail service. "Just send a fake note to someone, and in it, express grief over a suicide. The ads will just stop—for a while, anyway."

If this scenario is true, it's an example of the emerging technology of emotion analytics. You might think emotion analytics are only found in a research lab, but no. They're here today. Susan Currie Sivek presents a series of applications and companies working in this area and asks some important questions about the technology.

What kind of data lies at the core of emotion analytics? Think of the Microsoft Kinect camera, perhaps the most common facial recognition tool. When you use a Kinect, you know you're being tracked. It's just for fun. But some retail stores use a similar technology to watch customers. This presents very different ethical issues. While no "killer app" has yet emerged, and while people will likely push back once they're made aware of it, it's not hard to imagine ethical issues arising by the broad diffusion of facial recognition software.

And faces are just the beginning of emotion analytics. Think of what your phone knows about you: your location, how much exercise you're getting, and social artifacts such as self-reported moods on a social network. Throw in some external sensors (Fitbit, anyone?), and you can measure physiological responses. So many possibilities.

But Sivek is no technological determinist. Holding emotion analytics back are two major issues: privacy and informed consent. People have differing levels of acceptance of surveillance and will reject anything that crosses an invisible line. What is acceptable to one person may be creepy to another. And companies will have to clearly demonstrate the benefits of emotion analytics in order to gain the assent of their audience. As these technologies become pervasive, the devil will be in the details.

Still, as a cautionary tale, consider the case of tracking cookies on the advertiser-supported web. In the United States at least, no one asks if you object to being served advertising tracking, and as a result data about us flies across the Internet at lightning speed. Is this the path we want with emotion analytics?

The other two chapters in this grouping of applied research place social media in their sights. Joseph W. Jerome and Bénédicte Dambrine consider the intersection of trust and privacy in the sharing economy, that world in which we Uber to our AirBNB.

Trust is the lubricant that makes this economy work. And trust often must be mutual. In a ride share, the passenger expects a safe vehicle and a competent driver, but the driver must also trust the passenger to show up on time and to pay for the ride. Mutual trust is also necessary in vacation rentals; the renter has to trust the listing details, and the owner must be comfortable having a stranger in their home.

In the sharing economy there are two primary ways to establish trust. One relies on a direct intervention by the platform, such as when a ride share company requires criminal background checks for its drivers. The other approach is through a reputation system, whether by feedback, social connections, or a public profile.

But what if you don't have or want to have a public profile? Despite the ubiquity of Facebook and other networks, there are many good reasons to not participate. Yet services such as Uber and AirBNB are exerting real changes in our infrastructure. In the near future, we may depend on these services just as we used to depend on taxis and hotels. The authors are wary of this approach, noting that, unlike credit scores, there is no regulatory protection for social data. Privacy can quickly become roadkill in an environment that relies so heavily on social data. The authors look to the US Federal Trade Commission's FIPPs (Fair Information Practice Principles) as one framework that can help protect both sides' data. And they fairly ask: must your social graph become your universal ID?

Heidi A. McKee and James E. Porter go back to the roots of classical rhetorical theory to examine the ethics of dealing with employees' missteps on

social media. How should a company handle negative or off-brand posts by employees? They discuss one well-known case—when Justine Sacco, a public relations professional working for Internet company IAC sent a racist tweet before flying to South Africa—and one case that flew under the viral radar, of a disgruntled employee writing negative comments about his or her employer on an anonymous blog.

The authors develop a model that includes consideration of the agent and the event, but also considers cultural and historical context, response, and the unique qualities of information and communication technology. In Sacco's case, they note that her role as a professional communicator made her a more likely target for scorn than, say, an accountant or janitor. IAC instantly fired her, and, though she had less than 200 followers on Twitter, she became "Internet-famous" so quickly that the hashtag #hasjustinelandedyet trended globally on Twitter, and someone actually went to the airport to take a picture of her deplaning.

The case of the slanderous blogger was handled completely differently. Here, the CEO (and victim of the slander) circled the wagons and engaged his employees, employing phronesis, or practical wisdom. Eventually the employee took down the offending post, ostensibly having been led to a consideration of the greater good.

If Quintilian were working today, he might define rhetoric as "a good person, tweeting well." McKee and Porter build a meaningful bridge between that ancient body of knowledge and the thrum of digital media today.

1. Media That Know How You Feel: The Ethics of Emotion Analytics in Consumer Media

Susan Currie Sivek

It's a moment that can strain even the best relationship. A couple sits on the couch after a long day, ready for an escape into the multitude of worlds offered by Netflix. They click restlessly from title to title, evaluating plot summaries and star ratings, searching for the perfect movie that will satisfy their emotional needs. The inefficiency and conflict of the search wear on them. Eventually, they give up and just go to bed.

For better or worse, new technologies may soon prevent this fruitless search scenario. Instead of requiring users to evaluate media options on their own, media recommendation and targeting engines will use emotion analytics to assess users' emotional states and match them to suitable media and advertising. Emotion analytics draws upon omnipresent mobile devices, increasingly low-cost and powerful cloud computing, biometric sensors embedded in multiple consumer products, and social media input provided by consumers themselves to determine how audiences feel at any given moment. Users of digital media providers—like the couple above, stumped by Netflix's huge range of choices—will likely receive suggestions or feeds of media that have been shaped by emotion analytics, thereby more easily finding options that suit their current emotional status and needs.

Avoiding the Netflix crisis described above sounds desirable, to be sure. Yet the growth of emotion analytics and the integration of this technology into consumer media experiences and devices also bring significant ethical challenges. Users' emotional data are among the most private types of information that they might share with their devices. However, they might not understand how those data are gathered or even be aware that they are

collected. The media and advertising they consume may also have been modified based on emotion data. As a whole, the ethics of designing and delivering marketing and media messages based on emotion analytics should be examined closely.

Defining Emotion for Computers

Emotion analytics tools have emerged from the field of affective computing, which combines computer science with psychology and cognitive science to integrate emotional savvy into technology. Affective computing researchers develop tools that "recognize, express, model, communicate, and respond to emotional information" (Picard, 2003, p. 55). Ideally, these tools help computers smoothly interact with humans by integrating emotional awareness into their communication. The computer can recognize how a human user is feeling, offer an appropriate response that demonstrates empathy, and perhaps also express (what may be perceived by the user to be) actual emotion. Some of the current methods for detecting users' emotions include facial expression and gesture recognition via cameras; voice analysis; physiological data, such as pulse and respiration rates; and analysis of spoken or written comments (Tao & Tan, 2005).

Helping computers recognize and simulate emotion is technically challenging. Human emotion would appear to be too complex and idiosyncratic for even the most powerful computers to comprehend. And yet, researchers have developed ways to define and operationalize emotion in such a way that computers can identify and classify its expressions. It is important to note that *emotions* are key in these emerging technologies, as opposed to *moods* or *feelings*, which appear to be synonymous terms. Affective computing has a particular interest in the short-term reactions—emotions—expressed by humans during their interactions with technology. If devices are intended to respond appropriately and immediately to human expressions of frustration or happiness, they must be able to quickly recognize emotions. The term *emotion* is generally used to describe this short-term reaction to an event, either internal or external to the individual, which can include expressions, physiological "symptoms," and a "subjective experience" of a *feeling* in response to the reaction (Scherer, 2005, pp. 697–698). *Moods* are regarded as distinct from emotions. Moods are "diffuse" states of longer duration in which particular *feelings* dominate; they may or may not be linked to specific events (Scherer, 2005, p. 705).

Categorizing and Detecting Emotion

To simplify computers' recognition of emotions, many affective computing researchers have adopted typologies of emotion developed by psychologists and then taught devices how to categorize emotion data. Among these typologies, Paul Ekman's research has become central. Ekman has sought to demonstrate not only the universality of certain "basic emotions" across human cultures, but also the uniformity of certain aspects of facial expressions and physiological activity related to those emotions. In his initial research, Ekman established six basic emotions: anger, fear, happiness, sadness, surprise, and disgust (Ekman & Friesen, 1976). Later studies led Ekman (1999) to add amusement, pride in achievement, satisfaction, relief, and contentment to the typology.

Based on this research, Ekman developed the influential Facial Action Coding System (FACS), a system of highly detailed guidelines used for "comprehensively describing all observable facial movement" (Ekman & Friesen, 1976; Paul Ekman Group, 2016). Using this detailed description, Ekman's system enables the classification of human facial expressions into his typology of basic emotions. The FACS has been refined and tested in multiple contexts over the years since Ekman first introduced it. People in varied occupations, such as law enforcement and sales, seek FACS certification to better understand "microexpressions" and their interlocutors' emotions.

Researchers have now enabled computers to apply the FACS guidelines for the purpose of recognizing emotions in human facial expressions (e.g., Hamm, Kohler, Gur, & Verma, 2011). A full history of the development of computers' "machine vision" and face recognition algorithms is beyond the scope of this chapter, but Pentland and Choudhury (2000) provide an excellent overview. Notably, 16 years ago, these authors stated:

> ...facial expression research has so far been limited to recognition of a few discrete expressions rather than addressing the entire spectrum of expression along with its subtle variations. Before one can achieve a really useful expression analysis capability one must be able to first recognize the person, and tune the parameters of the system to that specific person. (2000, p. 7)

Today, computers' recognition of facial expressions has become much more detailed. Computers now can access facial expressions through increasingly common, high-resolution cameras, such as webcams in laptops, front-facing cameras in smartphones and tablets, and cameras attached to home entertainment devices (e.g., the Microsoft Kinect camera for the Xbox gaming system). Devices with cameras also are tied to specific users' personal data.

All of these devices are constantly collecting additional forms of data that can be combined with camera inputs to aid in the recognition of users' emotions. These devices may be wearable, such as a heart rate monitor built into a fitness device or smart watch; they may be integrated into devices, such as smartphones that analyze user's app usage patterns or intensity of touch; they may collect data within an environment, such as sensors within a home or business that detect movement patterns and factor restless or sedentary states into the analysis of emotion. In addition, social media platforms collect emotion data when users share text, emojis, likes, or other "reactions" (as on Facebook). If coordinated, these tools can compile a holistic assessment of an individual's (or group's) emotions from moment to moment, and enable computers and their users to respond accordingly.

Emotion analytics is a relatively new term that parallels the application of "analytics" in a variety of industries. Companies in this field are using insights and tools developed in academic research, such as the work of Ekman and of researchers at the MIT Media Lab, and integrating them in many different contexts, including homes, businesses, and educational institutions. Emotion is now yet another factor that can be incorporated into "big data," the array of personal data gathered on individuals from other digital sources, and now can be used to shape products and services. So far, emotion analytics companies primarily appear to be marketing their emotion analytics tools for the testing and enhancement of advertising messages, media content, and product design, with additional wearable devices and ambient emotion detection systems (for use in homes and retail stores, among other settings) in their preliminary stages of release.

Emotion Analytics and Ethics in Media Applications

Emotion analytics techniques are already used today in the development and delivery of consumer media experiences, including advertising and entertainment. For decades, marketers and media companies have tested their work on focus groups and individuals to try to maximize messages' appeal to target markets. However, these tests rely primarily on human audiences' ability and willingness to express their honest responses to what they are shown, which may not always reliably measure the messages' effectiveness. As a result, media researchers have turned to technologically intensive methods, such as eyetracking, EEGs, and functional MRI scanning (as detailed in Bridger, 2015). Emotion analytics can now be added to that list.

As emotion analytics continues to gain momentum and investors' attention, it will be more widely integrated into consumers' media experiences.

Messages' content can be shaped with insights from emotion analytics, and these tools will be used to improve the delivery and recommendations of music, movies, or other products in customized flows of media (i.e., in systems resembling Netflix, Pandora, etc., which actively suggest specific media for their users). This integration into media raises difficult ethical questions. The remainder of this chapter will address the specific ways emotion analytics are being used in consumer media as of this writing, as well as ways they will likely be extended in the near future. A review of the websites of 10 companies involved in emotion analytics and media—as well as news coverage of their work and their patent applications—reveals the many ways these technologies are currently being used. This review also suggests that the numerous ethical concerns they present have been little discussed in public discourse.

Current Uses of Emotion Analytics in Media

Advertising Content and Delivery

Emotion analytics companies offer services for advertisers and agencies. They provide testing of advertisements that is meant to reveal precisely how consumers feel upon viewing an ad. These companies assert that ads that cause emotions are more effective: "Emotional campaigns are likely to generate larger profit gains than rational ones. It's a fact: establishing an emotional connection with the audience creates a more effective tie," says Eyeris. Similarly, Realeyes' website states, "Emotional content multiplies effectiveness. The more people feel, the more they spend. Research has firmly established that emotional content is the key to successful media and business results. Intangible 'emotions' translate into concrete social activity, brand awareness, and profit." These companies uniformly argue that their advertising analysis methods lead to deeper understanding of emotions caused by these messages, and that the more sophisticated evocation of emotion will lead to greater profit.

In addition to shaping consumers' emotions through skillfully crafted ad content, emotion analytics can help deliver targeted advertising precisely when it might best strike an emotional chord. Emotion analytics built into media devices could identify a consumer's emotional state and send a specific advertisement meant to capitalize upon that state. According to an Apple patent, existing audience targeting systems rely on an overly broad understanding of the user's "interest in targeted content." Weak targeting "can lead to periods of time where the targeted content delivery is misaligned, thereby resulting in decreased satisfaction for both the content provider and the content receiver"

(Greenzeiger, Phulari, & Sanghavi, 2015). Apple's solution for more effective alignment and increased satisfaction is to synthesize a huge array of data on the consumer. As listed in a recent patent, these data could include:

> heart rate; blood pressure; adrenaline level; perspiration rate; body temperature; vocal expression, e.g. voice level, voice pattern, voice stress, etc.; movement characteristics; facial expression...sequence of content consumed, e.g. sequence of applications launched, rate at which the user changed applications, etc.; social networking activities, e.g. likes and/or comments on social media; user interface (UI) actions, e. g. rate of clicking, pressure applied to a touch screen, etc.; and/or emotional response to previously served targeted content...location, date, day, time, and/or day part....music genre, application category, ESRB and/or MPAA rating, consumption time of day, consumption location, subject matter of the content, etc. (Greenzeiger et al., 2015)

(Followers of Apple technology will likely recognize features of the Apple Watch, the Apple Health app, and the Force Touch pressure detection sensors now embedded in various Apple mobile devices and accessories.) The patent also mentions the need for compliance with "well-established privacy policies" and for "informed consent" by the user, who may opt out of this data collection.

Khatchadourian (2015) reports on a console developed by Verizon for home use that will select ads based on a similarly long list of data points, including home occupants' body temperature, voices, demographics and physical characteristics, facial features, language, activities, digital activities on other devices, and—naturally—emotions. The console would display ads on the available media devices that were judged appropriate by the analytics: "A marital fight might prompt an ad for a counsellor. Signs of stress might prompt ads for aromatherapy candles. Upbeat humming might prompt ads 'configured to target happy people'" (Khatchadourian, 2015).

Affectiva claims on its website that these methods of targeting are supported by research: "Evidence has shown that targeting of advertisements can be beneficial to consumers and raise the profits for all involved." The "benefit" to consumers appears to be that they are shown ads that are more relevant to them at a given emotional moment, which presumably makes advertising more informative and tolerable.

Media Messages' Content and Delivery

The media content surrounding these advertisements is also likely to be subjected to emotion analytics, given that it will contribute to an audience's emotions when exposed to an advertising message. For example, Affectiva

describes television network CBS' use of its Affdex facial recognition emotional analytics software to "analyze the interplay of promos, ads and prime-time show content in order to better understand audience emotional engagement." With the aid of emotion analytics, CBS was able to "identify impactful scenes and uncover optimal arrangements of TV promos and ads. Affdex also assessed the audience's strong emotional connection to a new character with engagement peaks, and gathered new normative measures for emotional engagement in a drama series."

Similarly, Emotient also markets a system that uses emotion analytics for "Shifting Media Tests from Art to Science":

> Will consumers enjoy and recommend this movie? Is this program actually funny or engaging, and to whom? Will this news program segment create viewer loyalty? Programming for digital, cinematic, broadcast or other media is renowned for being a mix of art and science, marked by the occasional hit making up for numerous flops. What if you could move the needle farther in the direction of science, reduce your risk, and increase your hit rate? That is the promise of measuring the direct emotional response of your video programming before you spend millions on launch and risk underperforming with advertisers. Emotient Analytics lets you directly measure if customers are paying attention, at which points they are engaged with your programming, and what emotions it elicits.

Emotient says that the goal of refining the emotional appeal of media is financial: reducing risk, increasing profit, and satisfying advertisers. Improving the quality of the media content itself does seem relevant, in terms of enjoyment, engagement, and loyalty, but the primary stated purpose is to achieve greater revenue. As a testimonial on the Realeyes website puts it, "Realeyes helps us deliver the highest possible ROI back to clients instantly."

Media content can be tested at various points in its development using emotion analytics. As Affectiva's website states, "...our emotion layer can enrich any aspect of your work, guiding your creative process and measuring the effectiveness of content." Realeyes also offers analytics at "the stage of storyboards," before any further production continues, offering data on potential audience members' emotional responses to plot and characters at a preliminary preproduction stage. Dynamically shaping media content during its consumption will probably become more frequent, as well. A TV show is currently in development that will use Affectiva tools to respond to the individual viewer's emotions and adjust what's shown on screen accordingly. The plot doesn't change, according to an interview with one of its creators, but the presentation of events may: "Should your mouth turn down a second too

long or your eyes squeeze shut in fright, the plot will speed along. But if they grow large and hold your interest, the program will draw out the suspense" (Hempel, 2015).

Media Message Recommendation Systems

In addition to refining the content of media messages, new technologies are also using emotion data to determine which media to suggest for consumption at any given moment. EmoSPARK makes a small cube-shaped device for the home, "dedicated to your happiness," that specifically recommends media to improve its user's mood:

> EmoSPARK initially tries to recommend particular pieces of content—be it a song or a YouTube video—that might help to improve the user's mood....If you start to laugh, it will show you similar content....We all want to be happy and experience pleasure. We all want to avoid pain.

The EmoSPARK not only analyzes the user's feelings to recommend what it deduces is happiness-causing content, but also calls upon aggregated emotional ratings in the cloud to make recommendations: "Each Cube will discover what media (with similar emotion tags) other Cubes have registered. This will further enable your Cube to recommend and play suitable media to you according to your mood."

Affectiva also recently patented a video recommendation system, though the patent also covers emotion-informed recommendations in movies, games, educational media, and other media messages (el Kaliouby, Sadowsky, Picard, Wilder-Smith, & Bahgat, 2015). In a press release, the company writes that the technology will capture the viewer's "true, moment-by-moment reaction," which then elicits further content recommendations. The release quotes the company's cofounder, Rana el Kaliouby: "Our emotions are great drivers of interest, and now with Affectiva's technology, we can get recommendations based on our emotional engagement, truly personalizing our digital experiences."

Ethical Challenges in Emotion Analytics and Media

The above sections detail some of the current applications for emotion analytics in the realm of consumer media experiences. However, each of these uses raises questions regarding the ethical gathering, analysis, and usage of emotion data.

Privacy and Consent

An obvious ethical concern regarding all uses of emotion analytics is the collection and storage of emotion data from consumers who may not be aware of or consent to the use of these data. While some emotion analytics applications are obvious to the consumer, more subtle efforts to gather emotion data—as in Apple's apparent effort to synthesize a variety of phone and watch data—are likely unknown to most users who haven't read Apple's patents in detail. The emotion analytics companies mention privacy and consent concerns occasionally on their websites, but only briefly. Moreover, privacy matters sometimes are juxtaposed with statements about the effectiveness of emotion analytics software in gathering information on consumers "in the wild" or "in low light." Presumably, some marketers and other potential customers would want to use emotion analytics tools in places with less-than-ideal conditions for cameras to capture detailed facial recognition data.

For example, Emotient's website says its tools "can detect sentiment in natural contexts, and aggregate over many people in an anonymous way," and describes a study of Super Bowl ads conducted in a bar. The website does not explain the means of storing and anonymizing the data, nor is there any mention of informing consumers that emotion data may be gathered, even though the data are apparently anonymous and aggregated. Emotient's website also suggests that emotion analytics could be used "in cluttered sensory environments such as out of home (OOH) venues," presumably to evaluate the results of ads in public places, where data gathering may not be known to passersby. The inclusion of these "strengths" of the software suggests that not every consumer would be positioned for, or even aware of, cameras' detection, analysis, and storage of their emotion data.

Today, consumers are protected only by the ethical integrity of emotion analytics companies. Affectiva states on its "values" webpage that the company takes seriously its responsibility of protecting data: "*Honor.* As caretakers of the world's emotional data, we take on this responsibility with the utmost respect and humility....We treat everyone with respect and care, making sure that they are protected." This statement would include, one hopes, obtaining consent for participation in emotion analytics. However, these companies are not always the only users for their own tools. For example, Affectiva licenses its software to other developers for integration into other products. Emotient likewise "allows customers and 3rd-party developers to programmatically connect their systems or applications with the Emotient Analytics cloud service." Eyeris provides similar offerings: "We strive everyday to accommodate a wide range of applications while maintaining our software's speed, accuracy

and customization. We have a solution for every use case and work with a wide range of sensor and electronic manufacturers."

The potential for integration of these companies' emotion analytics into a wide variety of devices and contexts suggests that many other developers will be involved in the collection of emotion data. It will be difficult for emotion analytics companies to require or enforce privacy or consent requirements among these third-party developers, even if they themselves would abide by ethical principles in this regard. Affectiva does require user consent in its developer license agreement: "Licensee will ensure that each user of a Licensee Product is notified of and consents to the use of images or video of such user prior to using any features or functions of the Licensee Product enabled by the Affdex Code" (Affectiva, 2016). Not all emotion analytics companies may be so prescriptive, however. Furthermore, regardless of what their agreements state, it could be challenging to track and enforce the integrity of user consent among all licensees.

Moreover, there are not yet laws in place to protect consumers from being subjects of emotional analytics tracking without their knowledge and consent. Khatchadourian (2015) reports on an effort in the U.S. House to draft legislation that would require companies to inform users that a technology intends to sense their emotions and to give them a chance to disable it. This legislation met resistance from Verizon and Samsung lobbyists and never made it to a hearing. In short, consumers are for now only protected by emotion analytics companies' good will and ethical standards, and the willingness of their licensees to abide by those same standards.

Advertising

Additional ethical questions arise in the application of emotion analytics to the creation and delivery of advertising. Traditional advertising research methods, such as focus groups and experiments, have long been used to design and test the emotional states provoked by advertising messages. However, emotion analytics can precisely refine the emotional impact of advertising content and then deliver that content to consumers at a specific moment of likely receptivity. These new capabilities could extend marketing research beyond the bounds of ethical practice.

Marketing researchers have long known that different emotional appeals can alter consumers' decision-making processes to favor marketers. For example, critical thinking can be diminished when consumers are made to feel happy, perhaps because the positive emotion is inappropriately factored as "information" into the decision-making process (Schwarz & Clore, 2003).

Even fear appeals can function to bolster "interpersonal" relationships with brands when consumers feel alienated or lonely (Dunn & Hoegg, 2014, p. 164). Similarly, Kemp, Bui, and Chapa (2012) demonstrate how negative emotions evoked by advertising can boost the sale of "hedonic" items to soothe consumers' anxieties. However, consumers may not be aware of the sources of their emotions, and as such, cannot consciously remove their emotions from their evaluation of a marketing message. Therefore, the evocation of emotion by marketing messages reduces consumers' autonomy and agency in decision-making (Fulmer & Barry, 2009). The application of emotion analytics to provoke and play upon consumers' emotional states—perhaps without their knowledge and without their ability to consciously respond— is a further reduction of their agency as rational decision-makers.

The recent development of "neuromarketing" techniques has presented a parallel ethical dilemma. The interpretation of physiological responses, such as brain scans, to shape consumer reactions to stimuli is ethically problematic when the results are used to craft marketing messages. As Wilson, Gaines, and Hill (2008) write, "…the underlying intent is to trigger emotions that encourage purchase rather than to provide consumers with accurate information on which to make beneficial decisions" (p. 402). These authors argue that traditional advertising methods use persuasion strategies that are well known and recognizable to consumers, but the application of neuromarketing techniques is not transparently evident and can circumvent engagement with the persuasive content. Without thorough consumer education and consent to such practices, the authors conclude that neuromarketing "limits consumer free will…a rational person would never select to be so manipulated" (p. 403).

This assessment is also true of advertising messages designed and delivered with the insights gained via emotion analytics. Emotion analytics' goal within marketing is to unite emotion data with other sources of personal data to refine and individualize marketers' emotional appeals. The goal is not to provide information or enhance decision-making, but rather simply to provoke and play upon emotion. Understanding consumers' preexisting emotional states through emotion analytics, and then aligning that state with customized marketing content, could not only significantly enhance marketers' profit but also compromise their ethics.

Media Messages

While the use of emotion analytics in the creation of media content could possibly improve its quality, emotion analytics companies' websites and other corporate materials do not emphasize quality; rather, they focus on media

companies' goal of increasing profit. To be sure, media companies would want a return on their investment in an emotion analytics service, and would want to know how their bottom line would benefit from its implementation. However, the main priority is not necessarily improving audiences' media experiences, but rather creating a more favorable emotional environment for advertisers. It is impossible to know the influence that emotion analytics might have on media content itself, and how the emotional aspects of that content might have been tweaked to achieve a desired effect.

Integrating emotion data into the creative process also raises questions about the ethics of creative production. Those involved in production may find their creative process suborned to the findings of emotion analytics, especially if characters, plots, and other key components of their work are altered to better evoke particular emotions. Furthermore, media companies will probably prioritize emotion analytics data over creative authenticity as they seek to perfect emotional contexts for their advertisers' messages. An advertiser may want to place a message within media content known to cause a happy or sad mood among consumers; that desired emotional context is likely to drive storytelling changes that do not suit creators' original vision.

A similar issue is the use of product placement in media content, whose ethical ramifications are explored by Wenner (2004). Media creators may be required by marketing deals to feature specific products visibly in their work, and though they might not like this practice, they feel they have to accept product placement in their work in order to stay employed. Wenner argues that product placement requires artists to think of their work primarily as a vehicle for marketing: "the viability of mass art becomes judged based on its abilities to serve as a Trojan horse for products, product tie-ins, and as an uncontested site for the logic of commodity culture" (2004, p. 123). In addition to product placement, media creators will be now asked to shape their work even more profoundly to suit commercial goals by provoking specific emotions that they did not perhaps initially intend.

Furthermore, the ways that media content is delivered to audiences will be shaped by emotion analytics. The role of consumers' own emotions in changing the media recommended and delivered to them will probably not be transparent—an ethical problem in itself. Emotion analytics usage also causes an ethical problem when consumers' own emotions are factored into their media experiences. Consumers themselves may be affected in lasting ways when external forces manage their emotions in our increasingly media-saturated world.

Many emotion analytics technologies are designed to analyze expressions of emotion over time and compare emotions expressed at a given moment to a baseline profile for a user. They do in this way attempt to detect and

alter mood by recommending certain media, such as dynamic music or a mellow movie, or just delivering it. This relationship between emotion and media experiences has been the topic of significant media research, though not always from the standpoint of ethics. Media effects researchers have long studied audiences' efforts to change or reinforce their own moods—those long-term, diffuse states of feeling—using media content. In particular, mood management theory argues that individuals develop "selective exposure patterns" to media that shape their emotions in particular ways (Knobloch-Westerwick, 2006, p. 241).

Even though consumers are often unaware of their own mood management strategies involving media, they possess agency and self-efficacy in the media selection process. They are certainly aware of their choices of energetic music for a workout or of a horror movie for an escapist thrill. Mood management theory is predicated on the agency of individuals, who, as active media users, can select the media message best suited to their emotional state and their desire to alter or reinforce that existing state. This awareness would be decreased in a media world managed by emotion analytics, undermining the personal agency inherent to the individual's mood management using media. Consumers may not be shown or otherwise made conscious of how analytics tools have assessed their emotions and selected media for them.

Would this diminished awareness and agency matter, however, if emotion analytics were only ever used to generate happiness among media audiences? Could increasing happiness be a bad thing, even if increasing profit might be a convenient side effect? Isn't greater happiness inherently a good goal? As the EmoSPARK description quoted earlier says, "We all want to be happy and experience pleasure," after all.

A possible response to this perspective emerges from the literature on the ethics of pharmacological mood enhancement (e.g., with antidepressants). Schermer (2015) writes that research shows people want:

> *reasons* to be happy and not just *causes* of happiness. We want our happiness to relate to things that actually happened, things we actually have done, or that are out there in the world and not just be caused by some pill or some machine…a happy mood is not enough for, or identical to, overall well-being, to having a good life, or to human flourishing. (p. 1183; emphasis in original)

For many people, sadness, alienation, and discontent produce individual development, Schermer writes. Therefore, even the use of emotion analytics to generate happy states among (otherwise clinically healthy) media audiences is questionable on ethical grounds in that doing so removes their opportunity for personal growth through the experience of negative emotions.

Potential Large-Scale Uses

If implemented within media experiences on a wide-ranging basis, emotion analytics could be used to assess and attempt to alter the emotional state of a population, for better or worse. Given the ubiquity of media devices—from smartphones to laptops to televisions to video game systems—embedding the ability to detect emotion in each would lend their manufacturers immense power to monitor, capture, and react to wide-ranging trends in public sentiment. Moreover, by creating media recommendation systems that knowledgeably proffer audiences media content designed to provoke emotions in specific ways, these devices have the potential to carry messages that could manipulate mass audiences toward particular emotional states. While the development of these technologies is still in preliminary stages, affective computing pioneer Picard and coauthor Klein (2002) imagine a possible dark future, involving:

> the potential misuse and/or abuse of [affective computing tools], including the use of these devices to help maintain disciplined citizens and consumers. At the level of culture, might the advent of such devices be used to foster positive change on a society-wide basis, or might they be used as another means for manipulation and control, fostering the dismantling of a society that once held dear values of individuality, autonomy, and authenticity? (p. 20)

Picard and Klein envision a situation in which those in power have seized upon the potential of affective computing devices to recognize and manage emotions among the public on a large scale. While emotion analytics are today focused on honing advertising and product design, a skeptic can easily imagine darker applications for these tools.

As of yet, Khatchadourian (2015) reports that, among the emotion analytics companies, at least Affectiva has turned away government agencies' interest in their products. But according to Thomas (2015), Affectiva and Emotient have also both tested their software in political contexts. They have both measured voters' emotional responses to presidential debates and thereby attempted to predict their voting preferences. Affectiva did so with an accuracy rate of 73%. As Thomas (2015) notes,

> On one hand, it could be argued that enabling political leaders to be better attuned to the emotional state and preferences of their constituents will lead to better, more democratic policy making. On the other, it could also contribute to an increase in short-term policy making in order to win votes, placing the focus on snappy one-liners which draw a smile rather than sound long-term policy.

Thomas (2015) also describes the potential for the abuse of emotion analytics by leaders of a "less democratic stripe," who could use the software to identify dissenters among citizens watching a propaganda film. Using emotion analytics to refine, enable targeted delivery of, or assess reactions to political media content presents serious questions about effects on democracy.

Conclusion

As a whole, the integration of emotion analytics into consumer media experiences carries the risk of diminishing consumers' privacy, subjecting them to emotional manipulation for the purpose of increasing marketers' profit, and removing the agency and personal growth found in managing their own emotional states using media. Emotion analytics may also lessen the authenticity of creative media work in order to provoke emotion among audiences and guide them toward increased consumption. Potential large-scale uses for political intent present challenges to democratic citizenship.

This analysis has demonstrated the significance, both theoretical and practical, of these ethical considerations and the need to maintain a critical awareness of these tools' uses in the future. While emotion analytics is today a technology largely unknown to the public, greater attention should be paid to its development in order to alleviate these potential ethical issues and protect media consumers' free will to the greatest degree possible.

Corporate Websites Reviewed

http://www.affectiva.com/
http://www.alchemyapi.com/
http://www.beyondverbal.com/
http://www.emotient.com/
http://www.emospark.com/

http://www.emovu.com/
http://www.hitachi.com/
http://www.nviso.ch/
http://www.oovoo.com/
http://www.realeyesit.com/

References

Affectiva. (2016). *Affectiva SDK Trial License Agreement*. Retrieved August 16, 2016 from http://www.affectiva.com/sdk-trial-license-agreement/

Bridger, D. (2015). *Decoding the irrational consumer: How to commission, run and generate insights from neuromarketing research*. London: Kogan Page.

Dunn, L., & Hoegg, J. (2014). The impact of fear on emotional brand attachment. *Journal of Consumer Research, 41*(1), 152–168. doi:10.1086/675377

Ekman, P. (1999). Basic emotions. In T. Dalgleish & M. Power (Eds.), *Handbook of cognition and emotion* (pp. 45–60). New York, NY: Wiley.

Ekman, P., & Friesen, W. V. (1976). Measuring facial movement. *Environmental Psychology and Nonverbal Behavior, 1*(1), 56–75. doi:10.1007/BF01115465

el Kaliouby, R., Sadowsky, R. S., Picard, R., Wilder-Smith, O. O., & Bahgat, M. (2015). *U.S. Patent No. 9,106,958.* Washington, DC: U.S. Patent and Trademark Office.

Fulmer, I. S., Barry, B. (2009). Managed hearts and wallets: Ethical issues in emotional influence by and within organizations. *Business Ethics Quarterly, 19*(2), 155–191. doi:10.5840/beq200919210

Greenzeiger, M. F., Phulari, R., & Sanghavi, M. K. (2015). *U.S. Patent No. 8,965,828.* Washington, DC: U.S. Patent and Trademark Office.

Hamm, J., Kohler, C. G., Gur, R. C., & Verma, R. (2011). Automated Facial Action Coding System for dynamic analysis of facial expressions in neuropsychiatric disorders. *Journal of Neuroscience Methods, 200*(2), 237–256. doi:10.1016/j.jneumeth.2011.06.023

Hempel, J. (2015, April 22). Computers that know how you feel will soon be everywhere. *Wired.* Retrieved from http://www.wired.com/2015/04/computers-can-now-tell-feel-face/

Kemp, E., Bui, M., & Chapa, S. (2012). The role of advertising in consumer emotion management. *International Journal of Advertising, 31*(2), 339–353. doi:10.2501/IJA-31-2-339-353

Khatchadourian, R. (2015, January 19). We know how you feel. *The New Yorker.* Retrieved from http://www.newyorker.com/magazine/2015/01/19/know-feel

Knobloch-Westerwick, S. (2006). Mood management: Theory, evidence, and advancements. In J. Bryant & P. Vorderer (Eds.), *Psychology of entertainment* (pp. 239–254). Mahwah, NJ: Erlbaum.

Paul Ekman Group. (2016). *Facial Action Coding System.* Retrieved from http://www.paulekman.com/product-category/facs/

Pentland, A., & Choudhury, T. (2000). Face recognition for smart environments. *Computer, 33*(2), 50–55. doi:10.1109/2.820039

Picard, R. (2003). Affective computing: Challenges. *International Journal of Human-Computer Studies, 59*, 55–64. doi:10.1016/S1071-5819(03)00052-1

Picard, R., & Klein, J. (2002). Computers that recognise and respond to user emotion: Theoretical and practical implications. *Interacting with Computers, 14*(2), 141–169. doi:10.1016/S0953-5438(01)00055-8

Scherer, K. R. (2005). What are emotions? And how can they be measured? *Social Science Information, 44*(4), 695–729. doi:10.1177/0539018405058216

Schermer, M. (2015). Ethics of pharmacological mood enhancement. In J. Clausen & N. Levy (Eds.), *Handbook of neuroethics* (pp. 1177–1190). Berlin: Springer. doi:10.1007/978-94-007-4707-4_90

Schwarz, N., & Clore, G. L. (2003). Mood as information: 20 years later. *Psychological Inquiry, 14*(3&4), 296–303.

Tao, J., & Tan, T. (2005). Affective computing: A review. In J. Tao, T. Tan, & R. W. Picard (Eds.), *Affective computing and intelligent interaction* (pp. 981–995). Berlin: Springer. doi:10.1007/11573548_125

Thomas, E. (2015). Are you happy now? The uncertain future of emotion analytics. *Hopes & Fears*. Retrieved from http://www.hopesandfears.com/hopes/now/inter net/216523-the-uncertain-future-of-emotion-analytics

Wenner, L. A. (2004). On the ethics of product placement in media entertainment. In M. Galician (Ed.), *Handbook of product placement in the mass media: New strategies in marketing theory, practice, trends, and ethics* (pp. 101–132). Binghamton, NY: Haworth.

Wilson, R. M., Gaines, J., & Hill, R. P. (2008). Neuromarketing and consumer free will. *Journal of Consumer Affairs, 42*(3), 389–410. doi:10.1111/j.1745-6606.2008.00114.x

2. The Intersection of Trust and Privacy in the Sharing Economy

Joseph W. Jerome and Bénédicte Dambrine

Introduction

Peer-to-peer exchanges are not new, nor is the so-called sharing economy a new concept, even as its precise definition is open to debate. At its most basic, a sharing economy is an economic model based upon the exchange of human or physical resources between two individuals, where one person who needs a good or service can borrow, rent, or even buy it from another who has it (Botsman, 2013). This model lies at the heart of many long existing neighborhood co-op arrangements and community exchanges, but today's sharing economy is increasingly fueled by online and mobile platforms. The use of technological intermediaries to facilitate peer-to-peer exchanges has allowed the sharing economy to grow to a size and scale otherwise unimaginable (Newcomer, "Uber Traveling...," 2015).

The economic value of transactions within the global sharing economy surpassed $26 billion in 2013 and could generate as much as $110 billion annually in the near future (Cannon & Summers, 2014). Today's sharing economy is the realization of earlier efforts to harness technology and online connectivity to alter and improve commercial interactions. Early "sharing" services like eBay and Craigslist emerged as an outlet for users to trade or discard their many unwanted items, using technology to help reduce transaction costs. At eBay, for example, crowdsourcing reputational information reduced the risks of transacting with strangers and increasing trust in the platform itself (P2P Foundation, 2015). Building on these early models, mobile platforms have further encouraged the development of new peer-to-peer exchanges and hundreds of different sharing economy start-ups have emerged in recent years. While ride-share and room-share platforms have been the most visible

sharing economy efforts, consumers can now use online platforms to find everything from custom-made goods to designer clothes to tool and equipment rental (Federal Trade Commission, 2015).

As customers gain the capacity to directly transact with each other, existing institutions and industries are being disrupted and disintermediated (Owyang, 2013, p. 7). As has occurred across the digital space, the sharing economy may harken an economic order organized around "access to assets" rather than one organized around ownership (Gansky, 2011). The U.S. Federal Trade Commission (or the FTC), the chief federal consumer protection authority, has posited that the sharing economy opens new, previously unavailable opportunities for profitable trade, facilitating better use of underutilized resources such as spare rooms or apartments, idle automobiles, or the labor of underemployed individuals. This model may offer individual consumers an array of benefits. Surveys suggest that there is widespread belief that sharing economy services can make life more affordable, convenient, and efficient (PWC, 2015). It also is part of a collection of trends that are disrupting our notions of employment, and depending upon what supports are provided, the sharing economy may effectively democratize employment opportunities for certain categories of workers, or at least facilitate new forms of employment entrepreneurship (Singer, 2014).

Yet the benefits of the sharing economy come with attendant risks. Government players and incumbent industries eye the new sharing services with skepticism as they challenge existing labor laws (Fitzsimons, 2015; Kennedy, 2015), tax rules (New York State Attorney General, 2014), and health and safety regulations (Roberts, 2014). Regulatory issues are rising to the forefront, and the FTC has already begun to consider the extent to which existing regulatory frameworks can promote sharing economy business models while appropriately protecting consumers (Federal Trade Commission, 2015).

Into this maelstrom of legal and regulatory questions, confronting privacy and data management issues will be important to ensure trust in the sharing economy. These platforms and services are increasingly data-driven, and much of this information is necessarily personally identifiable information. Data collection can present a privacy risk, particularly when this information must be used to authenticate and verify users and when it is shared with third parties and government agencies. Protecting privacy can also conflict with efforts to promote trust among users, and efforts by sharing service platforms to engender trust with their users can also be impacted by privacy practices. This chapter explores this challenging privacy dynamic by looking at how two major platforms, Airbnb and Uber, have dealt with reputation management and the handling of user data.

In the sharing economy, privacy controls can abut effective reputation management and online identity, placing them into potential conflict. This is problematic because reputation and identity are essential mechanisms to establish trust between consumers and to participate effectively in a peer-to-peer exchange. This is not only true between users—sharing platforms must also establish positive relationships to facilitate trust with their users and engender confidence in their services. Yet trust deficits are pervasive online and can quickly overwhelm a sharing platform. Why would one feel comfortable staying in a stranger's house overnight? Or trust a platform to facilitate a safe and secure exchange? Established companies can trade on their brands, but the complex interplay among new platforms, aggressive business models, and individuals offering their goods and services can make sustaining trust in the sharing economy a challenge in the long term. Successful sharing economy participants will need to understand the relationship among identity, anonymity, and obscurity, and what information is necessary (or not) to facilitate trust within the entire ecosystem.

This overarching challenge is compounded by a wide variety of different reputation systems and data standards being implemented across the sharing economy (Owyang, 2013, p. 9), as well as aggressive plans by platforms to use and share information. Section I of this chapter looks first at some of the chief privacy issues that have emerged in the sharing economy with an emphasis on major incidents at Airbnb and Uber. As the two giants of the sharing economy, their experiences demonstrate how greater transparency and offering users meaningful access and control over their information can empower users and result in greater trust. Section II explores these and other Fair Information Practice Principles (FIPPs) and how they can be implemented by platforms to build trust. While greater transparency and user control over information may empower users, platforms will also need to think carefully about how they collect, use, and share sensitive and nonsensitive information from users. Section III discusses how the sharing economy must embrace formal data stewardship in order to reach its full potential.

I. Privacy Issues in the Sharing Economy

Participating in the sharing economy requires at the minimum an exchange of information among users and platforms, and at maximum, establishing some degree of trust among users. Data exchanges and establishing trust are questions of data management. Data management issues generally go hand-in-hand with traditional privacy concerns, but the role of reputation in the sharing economy may also impact personal autonomy or the individual's

ability to participate in a given exchange. Concerns about personal privacy and reputation may come into conflict in the sharing economy.

Reputation systems help to aggregate and disseminate information about past performance among consumers. They can be unmediated, based on word of mouth, or mediated, where platforms and third parties can gather and organize information into scores, ratings, reviews, or reports (Goldman, 2010). As these systems increase in influence offline and in our day-to-day interactions, user trust will be essential. Moreover, though a measure of trust underlies every economic exchange, trust management is especially important to the healthy functioning of the online sharing economy. Many of the tools and mechanisms needed for users to participate in the sharing economy—both to take advantage of these services and to maintain a presence on these platforms—are premised on the sharing of personal information and present privacy challenges. Users will need to trust that individual platforms and the greater sharing economy are using their personal information to benefit rather than harm them (Hirsch, 2016; Richards & Hartzog, 2016). Reputation systems must be not only effective, but to promote trust, it will be essential to understand who keeps, calculates, and displays our scores on platforms (Farmer, 2012) and who may get access to them.

In this section, we look at existing privacy principles, their relationship to reputation management, and where platforms like Airbnb and Uber have made missteps in their efforts to engender trust.

A. Reputation: Privacy vs. Trust

A positive reputation is an important component to ensure a positive outcome or experience in a peer-to-peer exchange. At a basic level, buyers and sellers have to be able to trust in the benefit of an exchange, and increasingly, technological intermediaries play a role both in facilitating trust among users and in providing a trustworthy service. Reputation management for peers and platforms is essential to the growth of the sharing economy: 69% of U.S. adults are hesitant to engage in the sharing economy until they receive a positive recommendation or other reassuring feedback (PWC, 2015, p. 4).

However, trust and reputation online often come at the expense of information privacy and personal anonymity. To be trusted, individuals must, to some extent, be exposed (Whitfield, 2012). As a result, privacy often conflicts with trust. In the sharing economy, information management in both the form of review systems and identity verification is essential to building and maintaining one's online reputation and establishing trust, but the need to share information within the sharing economy strains individual's' capacity

to keep close control over their information. This reliance on reputation may not only diminish user privacy, but it also can marginalize newer users or late-movers that lack either the ability to build a positive reputation or traditional trust markers that could help them otherwise qualify to participate in the sharing economy (Bracy, 2015).

Platforms attempt to use some variety of persistent online profile as a mechanism for establishing online identity, and such a profile may also serve as the very foundation of a platform's reputation system (Groupe Chronos & BlaBlaCar, 2012). Persistent profiles encourage and promote trust through a variety of different factors such as photos, verified contact details, and positive ratings from the community (Clippinger, 2012). Not all review- and ratings-based profiles generate and represent user reputation in the same way: ratings can be displayed more or less prominently, and platforms can take different approaches to monitoring and policing profile information. As a result, platforms can develop systems that use more or less personal information and offer individuals more or less control (Dambrine, Jerome, & Ambrose, 2015).

In addition to rating and review systems, many platforms may generate reputation using both real-world and online identity. For example, online social networks can be used as a proxy for trustworthiness by measuring the number of social connections, frequency with which an individual interacts with others, time during which an individual has been active online, and the general richness of an individual's social networking activity (Zeltser, 2015). In other contexts, we have seen online dating apps leverage "mutual friends" to promote trust as well as novel efforts to evaluate whether participation on social media can be used as a potential indicator of an individual's creditworthiness. The more activities that can be observed and the more meaningful those activities are, the more trustworthy a person's online social identity can be presumed to be. Consider, for example, the value of a more detailed LinkedIn profile or presence of a photograph when evaluating a prospective employee or connection. As a result, sharing economy platforms have gone so far as to offer easy integration with more popular social-networks: services like Airbnb, RelayRides, and Lyft all easily integrate with Facebook to let users see whether they have friends (or friends of friends) in common. This sort of integration can help to make users "generally more comfortable meeting new people using technology" ("All Eyes on the Sharing Economy," 2013).

Yet while online identity can improve trust and efficiency in peer-to-peer exchanges, it also presents a clear privacy trade-off. A key challenge facing the sharing economy as it develops will be how best to combine online identity and reputation management with tools to protect individual privacy (Clippinger,

2012). At a basic level, each user in a peer-to-peer exchange wants to know as much information as possible about the other to trust in a positive outcome, yet both users also have an interest in disclosing as little information about themselves as they can and to remain anonymous to the extent feasible. Frequently, platforms attempt to address this dynamic by offering some degree of anonymity or obscurity, though this presents challenges for building and developing reputation.[1] Striking the proper balance is not easy.

B. Airbnb: Verified ID—A Shortcut to Trust

Bringing existing sources of online and offline information to a new platform can be an easy way for a new user to demonstrate that user's already-existing reliability and good reputation. Coming into a service with a clean slate, new users have no reputation to put forward; outside information can provide a reputational shortcut of sorts and eliminate barriers to entry by new users who wish to participate in peer-to-peer exchanges.

This takes its strongest form when outside information is used for explicit identity verification. Identity verification is frequently cited as necessary "to build trust in the community" (Airbnb, 2015), but it can also require users to provide an array of sensitive information to platforms and potentially have their social networking information used against them. For example, in April 2013, Airbnb began a new implementation of "Verified Identification" in an effort to build trust and provide users with more information about whom they stayed with or hosted. The process required users to demonstrate both that they were a real online person through participation on LinkedIn or Facebook *and* a real offline person by scanning a government-issued photo ID or providing other personal details (Gannes, 2013). According to Airbnb executives, bridging their users' offline and online identities was a necessity to promote trust where "people are sleeping in other people's homes and other people's beds." For its portion of the sharing economy, Airbnb declared users had "no reason to have an anonymous experience" (Geron, 2013b).

Yet the implementation of Verified Identification raised concerns about the detail of the information being required and for the premium the system placed on having a social media presence. Critics were concerned not only about the security implications of sending Airbnb copies of government-issued IDs (Constable, 2014), but some users were placed into a Kafka-esque situation from which there was no return. "Have you ever been told you don't have enough friends—and are a Luddite to boot? It's crushing," wrote one middle-aged woman who lacked a certain number of Facebook friends for verification purposes (and was unable to rely on Google or LinkedIn as

alternatives) ("I Didn't Have Enough Facebook Friends...," 2014). Airbnb proposed the woman upload a video of herself, yet she also lacked the technology to do that effectively.

Rather than increase trust in Airbnb, the service had, in the words of Doc Searls, burned bridges. Searls, a technology writer, explained that Verified ID failed "because it alienates both the supply and the demand sides of the marketplace. It turns away good, loyal, paying customers, and denies hosts those customers' bookings. Worse, it filters through only those customers who are comfortable exposing themselves through social media and in video performances" (Searls, 2013). He argued Airbnb's implementation of Verified ID seemed to be conflating the service's valuable consumer-oriented business model with aspirations to be a "social" community.

Airbnb quickly apologized, admitting there were "corner cases" that did not fit into its verification framework (Hakim, 2013). The company committed to developing alternative solutions and implement new ways to very exceptional cases when necessary. It has subsequently directed users having difficulties with Verified ID to contact customer support.

User experiences with Verified ID show both the benefits and drawback of leveraging offline and other online information to generate reputation within the sharing economy. In this instance, while Airbnb has a reasonable argument that identity verification may be necessary to trust the sharing economy, they failed to communicate the *why* and more important, the *how* of their system. Verification was initially rolled out to only 25% of Airbnb users, and users frequently found themselves needing to generate and share information only at the end of the platform's reservation process. This inconvenience was compounded by a lack of a clear explanation as to how the system's "scoring system" worked to evaluate the legitimacy of a user's social network.

C. Uber: Rider Ratings—The Opaque Side of Reputation

Opacity of scoring systems has become a recurring problem for sharing economy platforms. The amount of insight and transparency into a user's reputation can vary widely across companies and among different sectors of the sharing economy (Dambrine et al., 2015). An informal survey of leading platforms' policies suggest that platforms focused on the transportation and services sector frequently restrict access or bifurcate what information is available to different parties in the peer-to-peer transaction (pp. 10–12).

Driving services such as Uber and its competitors were criticized for their early reluctance to provide passengers with any insight, let alone access, into how they were being rated by drivers (Kerr, 2014). Lack of transparency

can easily and inadvertently lead to users being barred from participating in the market ecosystem when negative reviews or ratings pile up without clear notice or ability to respond. The importance of reputation management can be lost on users who do not understand how the platform's reputation system works—or that it can be a two-way exchange. In May 2015, *New York Times* columnist Maureen Dowd was "shocked" to learn that Uber drivers were ignoring her because she was frequently a tardy passenger (Dowd, 2015). This is hardly an isolated incident: with regards to Uber, many users have been surprised to find out that rating systems go both ways.

More complicated, scoring systems can create unwritten rules of the road. Lyft, for example, offers a five-star rating scale, but this scale offers little room for nuance. Honest evaluations may be difficult to obtain either because users are afraid of repercussions or because they have ulterior motives (Slee, 2013). Critics argue ratings are fundamentally "insincere" because "[t]he majority of customers give 5 stars across the board, reserving one-star scores for only the most egregious experiences. There's hardly any middle ground" (Kane, 2015). Lyft explicitly tells users that reviews of "anything lower than 5 indicates that you were somehow unhappy with the ride" (Lyft Support Center, 2015). Drivers can be dropped from their services when they fall below 4.5, but it is unclear what it takes to get banned as a passenger (Streitfeld, 2015). The result is that the platforms prepare formal tips for their drivers to maintain five-star rating (Cook, 2015), while intrepid journalists independently poll drivers to see what behaviors are deserving of a bad review (Price, 2015). Some of this guidance, such as forcing drivers to wait, echo lessons that could be learned from Maureen Dowd, and ultimately distill down into a formulation of the golden rule. Nevertheless, other guidance reveals some of the arbitrariness of the system. According to one driver, passing gas automatically warrants two stars "unless it's me then I usually blame you for it anyway" (Price, 2015).

It may be easy to discount one bad rating, but determining the threshold where users' reputation is sufficiently tarnished that they are effectively excluded from the platform is not clear. Online reputation can move from being opaque to a potential black box. The CEO of Uber admitted to suffering a string of middling ratings and did not know why, suggesting he might not have been as courteous as necessary (Streitfeld, 2015). Secret blacklists have always existed, but the emergence of online reputation to mediate real-world transactions highlights the need for consumer education about the importance of reputation and the tools available to control and monitor it (Fertik, 2015, pp. 145–146). Moreover, as reputation scores are either shared or merged across platforms, additional ethical issues will emerge. There have

already been proposals to create a "FICO score for the sharing economy," and Rachel Botsman, a thought-leader on "collaborative consumption," describes her vision as follows:

> A realtime stream of who has trusted you, when, where and why, your reliability on TaskRabbit, your cleanliness as a guest on Airbnb, the knowledge that you display on Quora. They'll all live together in one place, and this will live in some kind of reputation dashboard that will paint a picture of your reputation capital. (Tanz, 2014)

The implications of such a system are enormous and will require considering whether a regulatory response is appropriate. We have already determined that important eligibility determinations such as credit evaluations require consumer protections. FICO scores, for example, are determined by credit reports that are governed by the Fair Credit Reporting Act, which provides individuals with access and correction rights and governs how a given organizations may use a credit score. No such formal mechanism exists in many platforms across the sharing economy. In the case of Uber, the company shut down technical workarounds that allowed users to determine their ratings (M. Smith, 2014), and it was only after the company experienced a string of privacy crises that they implemented a method for users to formally request how they had been scored.

D. Uber: God Mode—Building Trust with Platforms

At the same time that sharing economy platforms are driving developments in digital reputation, the platforms themselves also need to assure that users trust them as intermediaries. As platform sizes keep growing, the need to establish trust may shift from among peers to between users and the platform itself. As discussed earlier, some Uber users were surprised to get poor ratings from their driver for being "tardy." In a pure traditional peer-to-peer model, peers are on the same level. However, this example suggests that users increasingly tend to see the platform as a service provider rather than an intermediary that merely connects them with another peer. As a result, platforms will be strongly incentivized to build on their own reputation and goodwill, elevating privacy issues to a crucial point. Indeed, nowadays, users are more and more sensitive to privacy violations and missteps done by companies, and a recent U.S. government study suggested forty-five percent of online households avoid online activities due to concerns about data privacy and security (Goldberg, 2016). However, the prevailing strategy by some of the major platforms to "ask for forgiveness, not permission" may be less acceptable to consumers in the future—or regulators (Pasquale & Vaidhyanathan, 2015;

Streitfeld, 2014). Privacy violations may reduce trust over time, potentially leading users to abandon a given platform or stunting the greater sharing economy.

Start-up culture can present challenges here. Because so much of the modern sharing economy is driven by a diverse array of Silicon Valley start-ups ("A Brief Guide...," 2015), the ethos behind many sharing economy platforms echoes the aggressive use of consumer data that is being seen across the tech industry landscape. This mindset prioritizes an emphasize on data collection and use to fuel revenue generation and get products up to scale, and as a result, start-up culture is frequently in conflict with privacy prioritization (Pfeifle, 2015). Hiring privacy officers—or lawyers capable of establishing dedicated privacy programs—is frequently low priority for new companies, which many members of the sharing economy currently are. New companies frequently lack adequate public privacy notices, let alone a sophisticated internal policy, and reasonable security measures are far from ubiquitous.

Establishing a "privacy culture" is essential for any company that uses or traffics in personal information (Bustin, 2010). This can entail a company-wide understanding of basic privacy principles and their value to individuals, appreciation of the need for privacy commitments, and training employees that are empowered and able to consider privacy interests as organizations make decisions about the use of personal information (Bolinger, 2015). At a minimum, a privacy culture requires organizations to have established privacy policies, data breach response protocols, and some modicum of training. Professor Daniel Solove has suggested that data protection can largely be distilled into a simple rhyme: "The C-Suite must care; the workforce must be aware" (Solove, 2014). However, absent a dedicated privacy program, new entrants into the sharing economy can have difficulty establishing any sort of culture around privacy.

This type of neglect can eventually result in high financial and reputational costs to sharing economy platforms. Uber provides a strong example of what can happen when sharing economy participants have a cavalier attitude about user privacy. In November 2014, Uber suffered a series of public relations crises that centered on the company's privacy practices. This began when a company executive discussed an effort to hire opposition researchers to look into the personal lives of journalists who had been critical of the company's business practices (B. Smith, 2014). This was followed by press reports that company employees were mishandling trip data about individual users and actively tracking the physical locations of individual users (Bhuiyan, "God View," 2014). An internal tool known as "God View" documented users' trips in real time, and Uber was accused of not only granting employees

widespread access to this tool but also using it as something of a party trick to track guests who were late to a company party (Biddle, 2014; Hill, 2014).

Widespread public condemnation soon followed. On social media, campaigns to boycott Uber appeared under the hashtag *#deleteuber* (Di Caro, 2014), and critics claimed the company needed to take steps to increase its accountability to consumers (Pease, 2014). For the first time, Uber revealed a public-facing privacy policy, which explained that the company had a "strict policy prohibiting all employees at every level from accessing a rider or driver's data" with exceptions for "a limited set of legitimate business purposes" (Bhuiyan, "Amid User Concerns," 2014). In a letter to Uber, Senator Al Franken (2014) suggested that the public privacy policy did "not in any clear way match or support what your company has stated [raising] serious concerns for me about the scope, transparency, and enforceability of Uber's policies." The Senator's letter also questioned how Uber was communicating its policies to employees and contractors alike and what steps were being taken to ensure its policies were being actively enforced.

In response, Uber chose to engage in an external review of its practices. The company brought on Hogan Lovells (2015), a law firm with one of the nation's leading privacy and data management practices, and had Harriet Pearson, former Chief Privacy Officer at IBM, conduct an assessment of Uber's existing privacy practices (Uber Newsroom, 2014). In January 2015, the firm released a report detailing its audit of Uber. The report was largely laudatory, though the firm did propose a number of steps Uber could take to improve the transparency of its practices and controls it offers users. The report recommended:

- Streamlining and enhancing both the content and availability of the company's existing privacy disclosures to help consumers understand Uber's data practices, including making the policy more accessible online and in-app and specifically discussing the company's practices around consumer geolocation information.
- Improving Uber's consumer access, inquiry, and complaint practices by (1) offering consumers easier access their rider ratings and (2) creating an automated process for account deletion.
- Implementing additional procedures to review inactive or closed accounts that have been retained to determine whether or not a valid reason for retaining this information still exists.
- Updating Uber's written privacy policies to document any unwritten policies surrounding customer data.

- Formalizing Uber's training and awareness program to provide tailored trainings about company privacy practices based on job responsibilities and to require regular refresher trainings. (pp. 35–39)

Critics contend that the audit failed to address how Uber was actually treating consumer data (Frizell, 2015), though Pearson concluded that internal treatment of rider information had already been addressed within Uber prior to the audit (Newcomer, "Uber broadens…," 2015). Uber hired its first privacy counsel in August 2014 to little fanfare, but has subsequently highlighted new additions to the company's privacy team (DeAmicis, 2015). The company has made an effort to clarify its privacy practices and, as discussed earlier, to offer riders access to their ratings.

In May 2015, Uber significantly rewrote and streamlined its public privacy policy "in the interest of transparency" and offered users additional control mechanisms (Uber Newsroom, "An update on…," 2015). The new policy demonstrated a clear effort by Uber to better communicate with users, but privacy advocates cautioned that the revision actually expanded the amount of data being sought by Uber (Electronic Privacy Information Center [EPIC], 2015). Potentially more problematic, the company continues to collect and retain indefinitely sensitive location information about users. While collecting location data as part of a transportation service is logical, both the lack of a clear retention period and the lack of any explanation for such omission is curious. Uber explains only that storing trip history presents "a benefit to riders," but as critics contend, if maintaining trip histories is a benefit to users, they ought to have the ability to delete this information (Roberts, 2015).

II. Building Trust and Improving Privacy

Across the sharing economy, platforms frequently leave individuals without any clear understanding of how to address perceived reputational slights or why platforms need certain categories of information. When it comes to reputation management, some platforms provide limited guidance as well as spotty customer support. For example, Handy, which provides house work and home cleaning services, offers a help center that provides little information about how reputation and trust are maintained on their platform.[2]

Many of these issues appear to be the result of not adequately considering potential privacy concerns and might be addressable through a thoughtful application of the FIPPs. Similar to how technological changes are motivating today's concerns about privacy, the FIPPs emerged in the early 1970s against a backdrop of worries about new ways to monitor individuals and the "black

boxes" of early automated data systems (Gellman, 2012). These practices established a framework for both the public and private sectors to implement procedures governing the collection, use, and disclosure of personal information (Gellman, 2012), and they have become the bedrock of modern privacy law, both in the United States and across the globe (Gellman, 2012; Teufel, 2008).

There are many different iterations of the FIPPs and as a set of principles, a degree of flexibility has been built into their precise application. At different times and in different circumstances, different principles have been prioritized—sometimes emphasizing the rights of individuals to the obligations of data collectors. As discussed earlier, some of the reputation management and trust mechanisms adopted throughout the sharing economy can strain these principles. Sharing economy platforms would be wise to consider the full range of FIPPs, and as the Uber audit suggests, data governance and accountability mechanisms are essential for any company that handles large amounts of sensitive customer information. That stated, the biggest privacy issues in the sharing economy are arguably the result of a failure to empower individual users to control their experience in the sharing economy.

From their earliest formulation, the FIPPs stressed the ability for individuals (1) to find out what information exists about them in records and how that information is used, (2) to prevent information obtained for one purpose to be used or made available for other purposes without consent, and (3) to be allowed to correct or amend identifiable records (Dep't of Health, Education, and Welfare, 1973). The principles were enshrined as legal obligations in the European Union's Data Protection Directive and emphasized once more in the White House's 2012 Consumer Privacy Bill of Rights (The White House, 2012), and yet sharing economy platforms can do much more to offer meaningful notice, access, and control to their users.

A. Transparency as "the Best of Disinfectants"

As a practical matter, many of these issues could be addressed through more effective communication with users. Transparency, after all, reflects Louis Brandeis' frequently cited principle that sunlight is "the best of disinfectants" (Brandeis, 1913). Often, trust correlates with transparency, and consumer trust benefits where companies are "open, simple, and clear" in their communications with consumers (Federal Trade Commission, 2012). Lack of transparency not only produces a trust deficit, but it can also lead to consumer confusion, impairing the ability of users to protect their privacy and raising regulators' ire.

This last point is essential: notice has been deemed the most "fundamental" principle of privacy protection by U.S. regulators (Federal Trade Commission, 1998). In theory, notice informs the individual of the consequences of sharing her information, giving the individual a free choice as to whether to decide to share her information or otherwise use a service. While a "notice-and-choice" regime has been heavily criticized, it stresses the importance of transparency (Cate, 2010), and it has been strongly embraced by the FTC, the chief consumer privacy regulator in the United States.

This embrace may be partially due to limits on the Commission's authority under the FTC Act—it can only enforce affirmative privacy promises and not generally require an organization to make any public pledges about its collection and use of personal data. In other words, the Commission's privacy enforcement with respect to consumer data is often controlled by the contents of a company's privacy policy. Still, the patchwork of state and federal laws and self-regulatory codes of conduct has made public privacy policies more than mere best practice. Publishing a privacy policy is ostensibly designed both to encourage companies to consider their privacy practices and to inform users, but long-standing criticism of privacy policies by scholars and privacy advocates (Bruening & Culnan, 2016; Turow, Hoofnagle, Mulligan, Good, & Grossklags, 2007) suggests that meaningful notice should extend beyond the four corners of a privacy policy.

Effective notices should be clear and specific. Companies and application developers are regularly accused of using ambiguous language to reserve more rights to data than is immediately apparent, and policies that obfuscate data practices may not be considered meaningful disclosures (Future of Privacy Forum & Center for Democracy & Technology, 2012, pp. 3–5; Reidenberg, Bhatia, Breaux, & Norton, 2016). Users in the sharing economy maintain privacy interests in both personally identifiable information and any anonymous or deidentified data that could be linked back to an individual or used to alter a user's experience (Future of Privacy Forum & Center for Democracy & Technology, 2012, p. 4). Sharing economy platforms should be encouraged to experiment with new mechanisms for communicating their data practices with users. For example, in the context of mobile applications, the Commission has promoted clear and understandable "just-in-time" disclosures at the point of information collection, privacy "dashboards" and functionality, and better user interfaces and iconography (Federal Trade Commission, 2013, pp. 14–17). Similar functionality can be offered by platforms and should extend to providing users with access to and control over their information, as well.

B. *Offer Access and Control*

Clear privacy policies and terms of service are a starting point. More transparency can mitigate some of the privacy issues raised earlier, but disclosures alone do not necessarily provide users with control of either their information or their experience within the sharing economy. Whatever transparency's place in the pantheon of FIPPs, individual control may be equally important. Alan Westin famously defined privacy as "the claim of individuals, groups, or institutions to determine for themselves when, how, and to what extent information about them is communicated to others" (Westin, 1968). The depth and variety of access controls available to users and deployed by platforms vary widely across the sharing economy. Existing trust deficits and issues with respect to transparency and effective consumer communication suggest that implementing meaningful access and control may present a significant challenge.

Individual control is essential to protect privacy in circumstances where users lack legitimate or realistic alternatives to a given platform or where users' participation within a given sector of the sharing economy becomes required or a day-to-day necessity. At present, peer-to-peer startups have proliferated across a variety of different categories, from transportation, lodging, and goods. However, it is conceivable that as the sharing economy matures that platforms will consolidate or consumers will feel compelled to participate. In either situation, transparency has limited value as a privacy-protecting measure. Providing users with additional access to data and control over that information is one way to compensate and is traditionally favored by law.

Where notice-and-choice completely break down, regulations generally emerge to mandate specific requirements around access and control over information.[3] For example, access to credit and healthcare have become societal necessities, and as a result, credit reporting and health insurance have become effectively compulsory for the average consumer. Mere notice and disclosure of this does little to give consumers any control over this situation, and federal laws that govern privacy in healthcare and credit reporting reflect this reality. While notice requirements are important elements in the Fair Credit Reporting Act and the Health Insurance Portability and Accountability Act, the resulting legal frameworks also give consumers specific rights with respect to how they can access data held about them and correct any misinformation. Regulations also impose timelines for responding to access requests and dictate rules on fees and formats for providing information.

While it is possible to overstate the importance of access and control mechanisms, platforms would be wise to devote more attention to them

now lest market forces or regulation requires them. Arguably, as individuals become more familiar with the how and why of data collection within the sharing economy, the more individuals will trust these platforms whatever mechanisms they offer. Yet, tools and procedures to facilitate access and control over information can be critical drivers for establishing trust and support for these services. The 2012 White House Consumer Privacy Bill of Rights calls for giving users a right to access and correct personal information, particularly when information is sensitive or consumers face a risk of adverse consequences if information is inaccurate (White House, 2012, p. 19). Useful access to personal data, as well as any reputational information, empowers users as well as invites scrutiny of organizations' information privacy and could expose potential data misuse. It may also help ground policy debates in fact-based scenarios, rather than speculations about possible worst cases that predominate today (Finch & Tene, 2015, p. 1608).

But just like disclosures, access and control alone are not a panacea. Individuals will spend neither the time nor the effort to care for transparency and access for their own sake without any tangible benefit (Tene & Polonetsky, 2013). Privacy experts Omer Tene and Jules Polonetsky explain:

> The enabler of transparency and access is the ability to use the information and benefit from it in a tangible way. Such use and benefit may be achieved through "featurization" or "appification" of privacy. Useful access to PII will engage individuals, invite scrutiny of organizations' information practices, and thus expose potential misuses of data. It would be value-minimizing to leave this opportunity untapped. Organizations should build as many dials and levers as needed for individuals to engage with their data. (p. 268)

For the sharing economy to reach its full potential, it will not be enough to offer individuals only basic access to their data. Meaningful access will allow individuals to declare their own policies and preferences and do it across the entire sharing economy, ensuring that the "consumer is God" (Searls, 2012).

III. Share the Benefits, Avoid the Risks

While the sharing economy would benefit from offering more transparency about its privacy practices and granting users more access to and control over their information, another potential way to improve public perceptions is to ensure the wide distribution of benefits from data collected in the sharing economy. Sharing and cross-pollinating data across the sharing economy in both the public and private sector could produce any number of society-wide benefits, but platforms will need to create strong internal mechanisms to ensure this is done responsibly. Whenever information is being used and

shared in novel ways, companies will need to assess, prioritize, and—to the extent possible—ensure that potential benefits outweigh the range of privacy, reputational, and financial risks that could affect individual users.

Sharing economy platforms may be in a unique position to engage in what is called data philanthropy (Stempeck, 2014). All of the information being generated by the sharing economy platforms is valuable to not only economic participants in the sharing economy but also to researchers, reporters, and public officials. According to the former Chief Technology Officer of Washington, D.C., for example, the sharing economy could fundamentally reshape how governments provide services:

> Imagine Uber or similar rider services sharing anonymized data with their local governments to uncover new transportation corridors for buses and trains. Or overlaying that data on top of public safety information to reduce traffic accidents. Imagine Airbnb sharing anonymized renter data to enable cities to communicate to small businesses about optimum business hours, such as days when its vacancy rates are low—a proxy for when an area has high occupancy and thus high economic activity. (Kundra, 2015)

Forward-thinking officials envision a world where public and private data can help governments understand how cities "live, breathe, and move" and can offer citizens increased transparency (Kundra, 2015).

The challenge is that platforms within the sharing economy play an essential gatekeeper function with respect to maximizing these benefits while keeping users in the loop. At present, releasing vast swaths of data for purposes of data philanthropy may only increase privacy risks, particularly where users have both limited control over their information to begin with and little understanding of where their data is going. Frequently, requests by government agencies and law enforcement for information about ride-sharing and room-sharing have been criticized by both industry and privacy advocates as privacy invasive (Constitution Project et al., 2014; Jerome, 2013). At the same time, platforms have also sought to leverage their data repositories both to appeal to government interests and rebut criticism. Data-sharing initiatives demand that platforms, including small- and medium-sized enterprises, develop formalized review processes such as privacy impact assessments and a methodology for assessing exactly how proposed data uses can benefit users, organizations, or the community at large.

Responsible data management involves both technical controls and procedural considerations. For example, Uber has begun to release information to municipalities with the hope that public officials can utilize the platform's data to achieve transportation and infrastructure planning goals (Badger, 2015). Immediately, this effort raised questions about how to release sensitive

information in a privacy-protective manner, and Uber committed to providing only information that was sufficiently aggregated and deidentified (Uber Newsroom, "Driving solutions to...," 2015). While Uber should be applauded for its careful consideration in this instance, effective deidentification—particularly for public datasets—is not a simple exercise. Prior releases of "anonymized" taxi records by the New York City Taxi & Limousine Commission have already been used to reidentify passengers, and well-meaning organizations and start-ups frequently take a cavalier attitude toward what constitutes deidentified information (Goodin, 2014; Singer, 2015). Merely removing obviously personal information such as names does not effectively deidentify data, and platforms would be wise to both carefully scrub data of any directly-identifying information and otherwise obscure indirect identifiers (National Institute of Standards and Technology [NIST], 2010).

While using and sharing deidentified data may resolve many traditional data privacy concerns, use of information generated by the sharing economy can also raise larger ethical issues about whether users and platforms are engaging in fair and equitable practices. Uber, for example, has learned that users are more or less likely to agree to pay higher "surge" prices based on their phones' battery life (NPR, 2016), and other platforms have begun to have to confront systemic racial disparities among their users (Edelman, Luca, & Svirsky, 2016). Resolving these sorts of questions goes beyond legal compliance with a patchwork of applicable rules and regulations, and requires a commitment to data stewardship that moves away from a world where companies are largely forced to rely on the instincts of marketers, the C-Suite, and Silicon Valley entrepreneurs. There are neither easy answers nor "correct" answers to these issues, but sharing economy platforms should heed the lessons learned by both highly regulated industries and social networks to develop structures that promote a fair relationship among users and platforms (Etlinger & Groopman, 2015, p. 11). In practical terms, this means that sharing economy platforms should move early to establish both practices and procedures to promote data stewardship. This could involve formalized roles, empowered advisory boards, and continuous and proactive engagement with regulators, researchers, and civil society.

Embracing transparency efforts and access controls can go hand-in-hand with promoting a positive ethic around data use, and all three may be essential to ensuring that the sharing economy can both promote trust and protect privacy. Platforms will need to think carefully about how to best achieve both—achieving the full potential of the sharing economy may require finding the intersection between trust and privacy.

Notes

1. Uber, for example, implements phone number masking, while TaskRabbit's platform ensures that all communication between clients and Taskers is done entirely through the TaskRabbit platform. TaskRabbit absolves the need for either party to exchange contact information: Taskers can chat with clients using in-app chat messaging and in-app call functions. A client's phone number is never displayed, and the client's actual location—or the location of the task—only becomes available after an assignment. Until that time, Taskers only see a generalized location.
2. Handy also did not respond to e-mail requests for further information. Handy. Help Center. Retrieved from https://www.handy.com/help (last visited 2015, October 15).
3. One argument increasingly advanced by privacy advocates and regulators during debates around broadband privacy rules proposed by the Federal Communications Commission is that strong rules are appropriate because consumers lack choices of high-speed internet providers.

References

A brief guide to America's sharing economy. (2015, August 30). *The Week*. Retrieved from http://theweek.com/articles/573929/brief-guide-americas-sharing-economy

Airbnb. What is Verified ID? Retrieved May 15, 2015 from https://www.airbnb.com/support/article/450

All eyes on the sharing economy. (2013, March 9). *The Economist*. Retrieved from http://www.economist.com/news/technology-quarterly/21572914-collaborative-consumption-technology-makes-it-easier-people-rent-items

Badger, E. (2015, January 13). Uber offers cities an olive branch: Your valuable trip data. *Washington Post*. Retrieved from http://www.washingtonpost.com/news/wonkblog/wp/2015/01/13/uber-offers-cities-an-olive-branch-its-valuable-trip-data/

Bhuiyan, J. (2014, November 18). "God View": Uber investigates its top New York executives for privacy violations. *Buzzfeed*. Retrieved from http://www.buzzfeed.com/johanabhuiyan/uber-is-investigating-its-top-new-york-executive-for-privacy

Bhuiyan, J. (2014, November 18). Amid users concerns, Uber rolls out its privacy policy. *Buzzfeed*. Retrieved from http://www.buzzfeed.com/johanabhuiyan/amid-user-concerns-uber-rolls-out-its-privacy-policy

Bhuiyan, J. (2015, October 4). Here's how Uber beat the Las Vegas taxi industry. *Buzzfeed*. Retrieved from http://www.buzzfeed.com/johanabhuiyan/sex-drugs-and-transportation#.irZeR5yjM

Biddle, S. (2014, September 30). Uber used private location data for party amusement. *Gawker*. Retrieved from http://valleywag.gawker.com/uber-used-private-location-data-for-party-amusement-1640820384

Bolinger, S. (2015, April 28). His task? Start up a privacy program at a start-up. *IAPP Privacy Advisor*. Retrieved from https://iapp.org/news/a/his-task-start-up-a-privacy-program-at-a-start-up-3/

Botsman, R. (2013, November 22). *The sharing economy lacks a shared definition*. Retrieved from http://www.collaborativeconsumption.com/2013/11/22/the-sharing-economy-lacks-a-shared-definition/

Bracy, J. (2015, June 10). In the sharing economy, could reputation replace regulation? *IAPP Privacy Advisor*. Retrieved from https://iapp.org/news/a/in-the-sharing-economy-could-reputation-replace-regulation/

Brandeis, L. (1913, December 20). What publicity can do? *Harper's Weekly*, 10–13. Available at http://3197d6d14b5f19f2f440-5e13d29c4c016cf96cbbfd197c579b45.r81.cf1.rackcdn.com/collection/papers/1910/1913_12_20_What_Publicity_Ca.pdf

Bruening, P. & Culnan, M. (2016). Through a glass darkly: From privacy notices to effective transparency. *North Carolina Journal of Law & Technology, 17*(4), 515–580.

Bustin, K. (2010, September 1). Practical strategies for creating privacy culture in your organization. *IAPP Privacy Advisor*. Retrieved from https://iapp.org/news/a/2010-08-24-strategies-for-creating-a-privacy-culture-in-your-organization/

Cannon, S., & Summers, L. (2014, October 13). How Uber and the sharing economy can win over regulators. *Harvard Business Review*. Retrieved from https://hbr.org/2014/10/how-uber-and-the-sharing-economy-can-win-over-regulators/

Cate, F. (2010, March 29). Looking beyond notice and choice. Bureau of National Affairs, Privacy & Security Law Report.

Clippinger, J. (2012). The biology of reputation. In H. Masum & M. Tovey (Eds.), *The reputation society: How online opinions are reshaping the offline world* (pp. 25–36), The MIT Press.

Constable, K. (2014, March 3). Think twice before giving Airbnb your ID. *The Huffington Post*. Retrieved from http://www.huffingtonpost.ca/kris-constable/airbnb-privacy-security-id-jumio_b_4887509.html

Constitution Project et al. (2014, November 19). *Letter addressed to the Taxi and Limousine Commission*. Retrieved from http://www.constitutionproject.org/wp-content/uploads/2014/11/Taxi-and-Limousine-Commission-Letter-re-Proposed-Rule-Change-November-19-2014.pdf

Cook, J. (2015, February 11). Uber's internal charts show how its driver-rating system actually works. *Business Insider*. Retrieved from http://www.businessinsider.com/leaked-charts-show-how-ubers-driver-rating-system-works-2015-2?r=UK&IR=T

Dambrine, B., Jerome, J., & Ambrose, B. (2015, June). User reputation: Building trust and addressing privacy issues in the sharing economy. Retrieved from https://fpf.org/wp-content/uploads/FPF_SharingEconomySurvey_06_08_15.pdf

DeAmicis, C. (2015, May 20). Uber hires new legal counsel from Apple to help with its privacy issues. *Re/Code*. Retrieved from http://recode.net/2015/05/20/uber-hires-new-legal-counsel-from-apple-to-help-with-its-privacy-issues/

Department of Health, Education, and Welfare. (1973). *Report of the secretary's advisory committee on automated personal data systems.*

Di Caro, M. (2014, November 25). Will you delete Uber app following controversial comments from exec? *WAMU.* Retrieved from http://wamu.org/news/14/11/25/will_you_delete_uber_following_controversial_comments_from_ceo

Dowd, M. (2015, May 23). Driving Uber mad. *The New York Times.* Retrieved from http://mobile.nytimes.com/2015/05/24/opinion/sunday/maureen-dowd-driving-uber-mad.html

Edelman, B., Luca, M., & Svirsky, D. (2016, January 6). *Racial discrimination in the sharing economy: Evidence from a field experiment.* Retrieved from http://www.benedelman.org/publications/airbnb-guest-discrimination-2016-01-06.pdf

Electronic Privacy Information Center. (2015, June 22). *Complaint to the Federal Trade Commission.* Retrieved from https://epic.org/privacy/internet/ftc/uber/Complaint.pdf

Etlinger, S. & Groopman, J. (2015, June 25). The trust imperative: A framework for ethical data use. *Altimeter Group.*

Farmer, R. (2012). Web reputation systems and the real world. In H. Masum & M. Tovey (Eds.), *The reputation society: how online opinions are reshaping the offline world* (pp. 13–24), The MIT Press.

Federal Trade Commission. (1998). *Privacy online: A report to Congress.*

Federal Trade Commission. (2012, March). *Protecting consumer privacy in an era of rapid change.*

Federal Trade Commission. (2013, February). *Mobile privacy disclosures: Building trust through transparency.*

Federal Trade Commission. (2015, June 9). *The "sharing" economy: Issues facing platforms, participants, and regulators.* Retrieved from https://www.ftc.gov/system/files/documents/public_events/636241/sharing_economy_workshop_announcement.pdf

Fertik, M. (2015). The Reputation Economy: How to Optimize Your Digital Footprint in a World Where Your Reputation Is Your Most Valuable Asset. *Crown Business*, pp. 145–146.

Finch, K., & Tene, O. (2015). Welcome to the metropticon: Protecting privacy in a hyperconnected town. *Fordman Urban Law Journal, 41*(5), 1581–1615.

Fitzsimons, T. (2015, April 23). In a sharing economy, labor laws fall short. *Marketplace.* Retrieved from http://www.marketplace.org/topics/tech/sharing-economy-labor-laws-fall-short

Franken, A. (2014, November 19). *Letter addressed to Mr. Travis Kalanick.* Retrieved from http://www.franken.senate.gov/files/letter/141119UberLetter.pdf

Frizell, S. (2015, January 30). What Uber still won't say about your data. *Time.* Retrieved from http://time.com/3690325/uber-privacy-audit/

Future of Privacy Forum & Center for Democracy & Technology. (2012). *Best practices for mobile application developers.* Retrieved from https://www.cdt.org/files/pdfs/Best-Practices-Mobile-App-Developers.pdf

Gannes, L. (2013, April 30). Airbnb now wants to check your government ID. *AllThingsD*. Retrieved from http://allthingsd.com/20130430/airbnb-now-wants-to-check-your-government-id/

Gansky, L. (2011, January). *The future of business is the "mesh"* [video file]. Retrieved from https://www.ted.com/talks/lisa_gansky_the_future_of_business_is_the_mesh?language=en

Gellman, R. (2012, August 3). *Fair information practices: A basic history*. Retrieved from http://bobgellman.com/rg-docs/rg-FIPShistory.pdf

Geron, T. (2013b, April 30). Airbnb adds identity verification to end anonymity in sharing economy. *Forbes*. Retrieved from http://www.forbes.com/sites/tomiogeron/2013/04/30/airbnb-adds-identity-verification-in-big-step-for-sharing-economy/

Goldberg, R. (2016, May 13). National Telecommunications & Information Administration. *Lack of trust in internet privacy and security may deter economic and other online activities*. Retrieved from https://www.ntia.doc.gov/blog/2016/lack-trust-internet-privacy-and-security-may-deter-economic-and-other-online-activities

Goldman, E. (2010). The regulation of reputational information. In B. Szoka & A. Marcus (Eds.), *The next digital decade: Essays on the future of the internet* (pp. 293–204), TechFreedom.org. Retrieved from https://www.nyu.edu/projects/nissenbaum/papers/The-Next-Digital-Decade-Essays-on-the-Future-of-the-Internet.pdf

Goodin, D. (2014, June 23). Poorly anonymized logs reveal NYC cab drivers' detailed whereabouts. *Ars Technica*. Retrieved from http://arstechnica.com/tech-policy/2014/06/poorly-anonymized-logs-reveal-nyc-cab-drivers-detailed-whereabouts/

Groupe Chronos & BlaBlaCar. (2012). *Trusted online communities: Signs of a better future*. Retrieved June 1, 2015 from http://www.betrustman.com/

Hakim, N. (2013, May 30). *Airbnb, verified ID*. Retrieved from http://nerds.airbnb.com/verified-id/.

Hill, K. (2014, October 3). "God view": Uber allegedly stalked users for party-goers' viewing pleasure. *Forbes*. Retrieved from http://www.forbes.com/sites/kashmirhill/2014/10/03/god-view-uber-allegedly-stalked-users-for-party-goers-viewing-pleasure/

Hirsch, D. (2016, February). Privacy, public good, and the tragedy of the trust commons. *Duke Law Journal Online, 65*, 67–93.

Hogan Lovells. (2015, January). *Review and assessment of Uber's privacy program*. Retrieved from https://newsroom.uber.com/wp-content/uploads/2015/01/Full-Report-Review-and-Assessment-of-Ubers-Privacy-Program-01.30.15.pdf

Jerome, J. (2013, November 15). *Protecting privacy and people using Airbnb to go on vacation*. Retrieved from http://www.futureofprivacy.org/2013/11/15/protecting-privacy-and-people-using-airbnb-to-go-on-vacation/

Kane, K. (2015, March 19). The big hidden problem with Uber? Insincere 5-Star ratings. *Wired*. Retrieved from http://www.wired.com/2015/03/bogus-uber-reviews/

Kennedy, J. (2015, July 9). Labor laws are a mismatch with the sharing economy. *ComputerWorld*. Retrieved from http://www.computerworld.com/article/2946098/retail-it/labor-laws-are-a-mismatch-with-the-sharing-economy.html

Kerr, D. (2014, September 25). Should Uber and Lyft keep passenger ratings secret? *CNET*. Retrieved from http://www.cnet.com/news/should-uberand-lyft-keep-passenger-ratings-secret/

Kundra, V. (2015, August 5). Government data and the Uber question. *TechCrunch*. Retrieved from http://techcrunch.com/2015/08/05/government-data-and-the-uber-question/

Lyft Support Center. *The Star rating system*. Retrieved October 10, 2015 from https://lyft.desk.com/customer/portal/articles/1453135-the-star-rating-system?b_id=3240

National Institute of Standards and Technology (NIST). (2010, April). *Guide to protecting the confidentiality of personally identifiable information (PII)*. Retrieved from http://csrc.nist.gov/publications/nistpubs/800-122/sp800-122.pdf

New York State Attorney General. (2014, October). *Airbnb in the city*. Retrieved from http://www.ag.ny.gov/pdfs/Airbnb%20report.pdf

Newcomer, E. (2015, May 28). Uber broadens rider privacy policy, asks for new permissions. *Bloomberg*. Retrieved from http://www.bloomberg.com/news/articles/2015-05-28/uber-broadens-rider-privacy-policy-asks-for-new-permissions

Newcomer, E. (2015, July 1). Uber traveling down same road as Amazon as growth trumps profit. *Seattle Times*. Retrieved from http://www.seattletimes.com/business/uber-traveling-down-same-road-as-amazon-as-growth-trumps-profit/

NPR. (2016, May 17). This is your brain on Uber. *NPR*. Retrieved from http://www.npr.org/2016/05/17/478266839/this-is-your-brain-on-uber

Owyang, J. (2013, June 4). The collaborative economy. *Altimeter Group*.

P2P Foundation. *Sharing economy*. Retrieved from http://p2pfoundation.net/Sharing_Economy

Pasquale, F., & Vaidhyanathan, S. (2015, July 28). Uber and the lawlessness of "sharing economy" corporates. *The Guardian*. Retrieved from https://www.theguardian.com/technology/2015/jul/28/uber-lawlessness-sharing-economy-corporates-airbnb-google

Pease, M. (2014, December 3). Will Uber try to end its narcissism? *CNN*. Retrieved from http://www.cnn.com/2014/12/01/opinion/pease-uber-corporate-narcissism/

Pfeifle, S. (2015, October 2). Privacy start-ups, privacy at start-ups. *IAPP Privacy Advisor*. Retrieved from https://iapp.org/news/a/privacy-start-ups-privacy-at-start-ups/

Price, R. (2015, February 23). Uber drivers tell us how to get a 5-star passenger rating. *Business Insider*. Retrieved from http://www.businessinsider.com/how-to-get-a-5-star-uber-customer-rating-2015-2

PWC. (2015, April). *Consumer intelligence series: The sharing economy*. Retrieved from http://www.pwc.com/CISsharing

Reidenberg, J., Bhatia, J., Breaux, T., & Norton, T. (2016). Ambiguity in privacy policies and the impact of regulation. *Journal of Legal Studies*, Forthcoming; Fordham Law Legal Studies Research Paper No. 2715164.

Richards, N., & Hartzog, W. (2016). Taking trust seriously in privacy law. *Stanford Technology Law Review, 19*(Spring), 431–472.

Roberts, C. (2014, August 14). *Report: Airbnb legalization has safety implications.* Retrieved from http://www.nbcbayarea.com/news/local/Report-Airbnb-Legaliza tion-Has-Safety-Concerns-271309941.html

Roberts, J. (2015, June 23). Uber privacy charges are overblown—Except for one thing. *Fortune.* Retrieved from http://fortune.com/2015/06/23/uber-privacy-epic-ftc/

Searls, D. (2012, July 20). The customers as a god. *Wall Street Journal.* Retrieved from http://www.wsj.com/articles/SB10000872396390444873204577535352521092 154

Searls, D. (2013, May 28). *Let's help Airbnb rebuild the bridge it just burned.* Retrieved from http://blogs.law.harvard.edu/doc/2013/05/28/lets-help-airbnb-rebuild-the-bridge-it-just-burned/

Singer, N. (2014, August 17). In the sharing economy, workers find both freedom and uncertainty. *The New York Times*, p. BU1.

Singer, N. (2015, January 29). With a few bits of data, researchers identify 'anonymous' people. *The New York Times.* Retrieved from http://bits.blogs.nytimes.com/2015/01/29/with-a-few-bits-of-data-researchers-identify-anonymous-people/

Slee, T. (2013, September 29). *Some obvious things about internet reputation systems.* Retrieved from http://tomslee.net/2013/09/some-obvious-things-about-internet-reputation-systems.html

Smith, B. (2014, November 17). Uber executives suggests digging up dirt on journalists. *Buzzfeed.* Retrieved from http://www.buzzfeed.com/bensmith/uber-executive-suggests-digging-up-dirt-on-journalists

Smith, M. (2014, July 28). How well do Uber drivers rate you? *Engadget.* Retrieved from http://www.engadget.com/2014/07/28/how-well-do-uber-drivers-rate-you/

Solove, D. (2014, August 25). *The 2 essential ways to prevent data breaches.* Retrieved from https://www.linkedin.com/pulse/20140825052614-2259773-the-two-most-essential-ways-to-prevent-data-breaches

Stempeck, M. (2014, July 24). Sharing data is a form of corporate philanthropy. *Harvard Business Review.* Retrieved from https://hbr.org/2014/07/sharing-data-is-a-form-of-corporate-philanthropy/

Streitfeld, D. (2014, April 21). Companies built on sharing balk when it comes to regulators. *The New York Times.* Retrieved from http://www.nytimes.com/2014/04/22/business/companies-built-on-sharing-balk-when-it-comes-to-regulators.html

Streitfeld, D. (2015, January 30). Ratings now cut both ways, so don't sass your Uber driver. *The New York Times.* Retrieved from http://www.nytimes.com/2015/01/31/tech nology/companies-are-rating-customers.html

Tanz, J. (2014, May 5). The sharing economy needs to start sharing its data. *Wired.* Retrieved from http://www.wired.com/2014/05/sharing-economy-fico/

Tene, O., & Polonetsky, J. (2013). Big data for all: Privacy and user control in the age of analytics. *Northwestern Journal of Technology and Intellectual Property, 11*(5), 239–273.

Teufel, H. (2008, December 29). Department of Homeland Security. *Privacy Policy Guidance Memorandum.* Retrieved from http://www.dhs.gov/xlibrary/assets/privacy/privacy_policyguide_2008-01.pdf

The Guardian. (2014, November 14). *I didn't have enough Facebook friends to prove Airbnb I was real.* Retrieved from http://www.theguardian.com/money/blog/2014/nov/14/airbnb-wont-let-book-room-facebook-friends

The White House. (2012, February). Consumer data privacy in a networked world: A framework for protecting privacy and promoting innovation in the global digital economy.

Turow, J., Hoofnagle, C., Mulligan, D. K., Good, N., & Grossklags, J. (2007). The Federal Trade Commission and consumer privacy in the coming decade. *I/S: A Journal of Law and Policy for the Information Society, 3*(3), 723–749.

Uber Newsroom. (2014, November 20). *Strengthening our privacy practices.* Retrieved from http://newsroom.uber.com/2014/11/strengthening-our-privacy-practices/

Uber Newsroom. (2015, January 13). *Driving solutions to build smarter cities.* Retrieved from https://newsroom.uber.com/us-massachusetts/driving-solutions-to-build-smarter-cities/

Uber Newsroom. (2015, May 28). *An update on privacy at Uber.* Retrieved from http://newsroom.uber.com/2015/05/an-update-on-privacy-at-uber/

Westin, A. (1968). *Privacy and freedom.* New York, NY: Atheneum Press.

Whitfield, J. (2012). The biology of reputation. In H. Masum & M. Tovey (Eds.), *The reputation society: How online opinions are reshaping the offline world* (pp. 39–50), The MIT Press.

Zeltser, L. (2015, February 14). *Why on-line social identity and reputation is a big deal.* Retrieved from https://zeltser.com/social-identity-reputation

3. Corporate Response to Employee Social Media Missteps: A Rhetorical and Ethical Lens*

HEIDI A. MCKEE AND JAMES E. PORTER

> Social media will continue to challenge and change laws, regulations, business practices, and the nature of the employee/employer relationship. Until the dust settles—and that will not be for many years—employers and employees alike are better off proceeding with caution. There are many landmines waiting for companies and workers in our new and evolving social era.
> —Augie Ray (2012), Director of Social Media at Prudential Financial

The intense use of social media by companies and employees raises complex ethical issues. In this chapter we focus on one particular ethical issue involving corporate social media: social media missteps by employees and how corporations respond to those missteps.

Media headlines, U.S. National Labor Relation Board rulings, and innumerable legal cases today are replete with examples of employees getting themselves and/or their employers into legal, ethical, and reputational controversies because of social media missteps: tweets meant as jokes that fall terribly flat (Justine Sacco being one example, as we will discuss); the right photo used at the wrong time (Ford's advertising vehicles alongside their Boston Marathon bombing tweet); McDonald's ill-conceived use of a hashtag (#McDStories) that the public co-opted to criticize the fast food chain; and employee postings used to air personal grievances to wide public forums, the examples go on and on.

Of course long before the advent of Twitter, Facebook, and Instagram, employees could harm company reputation and embarrass companies with missteps. But in the age of social media, the extent and velocity of embarrassment are significantly more dramatic: The twitterstorm happens immediately, offensive events go viral within hours (companies certainly don't want the embarrassing point to be "trending"), and aired dirty laundry stretches across the entire globe. In addition, the public can more readily and instantly mock, remix, refute, and parody the corporate response—and then that becomes a new problem.

Often the immediate corporate response to an employee social media misstep (made as an individual or on behalf of the company) is to fire the employee(s) responsible. And sometimes such an action is justified. But is it always? Should an employee be fired over one offensive tweet even if that tweet is made on a personal account and not on company time? Do employees have the right to express their own opinions (and make their own mistakes) on social media without fear of retribution from employers? When and where are people *employees* and when are they *citizens* who have rights of privacy and expression beyond their work lives? What analytical lenses might we as business professionals, as the general public, as academic researchers apply to understand social media missteps and the corporate reaction and response that follow?

In this chapter we analyze two cases involving employee missteps on social media and the corporate responses to those missteps.[1] First we lay out the rhetorical and ethical framework we use in our analysis: a critical lens that merges rhetorical analysis and ethical reasoning and that examines events as cases unfolding forward and backward in time (rather than as isolated moments). We advocate for a networked, rhetorical analysis of professional communications that certainly includes the problematic event itself (the social media misstep) but that also examines the entire context for the social media event, particularly the corporate response. Our visual frame for analyzing social media communication (represented in Figure 3) includes the problematic event or misstep, the immediate context, the historical–cultural context, the information communication technologies involved, and the near-time and far-time reactions. The ethical issues surrounding the response to a social media misstep are fascinating sites of interaction, revealing important considerations for understanding digital media ethics in a circulatory, networked culture.

In the second part of the chapter we discuss two cases: (1) the well-publicized case of Justine Sacco, her ill-conceived tweet, her firing for that tweet, and how the company interpreted her role as a communicator, and (2) a case drawn from our interview with the president and CEO of a small U.S. manufacturing company, who found himself faced with an employee

blogging derogatory statements about company management in a public blog. Our analysis includes insights shared with us by the Director of Ethics for a U.S. subsidiary of a multinational manufacturing company.

We conclude the chapter by reflecting on the ethics of corporate response to employee social media missteps. We offer some recommendations for how corporations might avoid social media missteps in the first place, for how to respond to them when they do happen, and for how to use social media strategically as a way to build a positive corporate *ethos* and to promote positive relations with clients, customers, and the public at large.

Framing Rhetoric and Ethics

A number of works within rhetoric and communication studies have argued that ethics has changed and will continue to change in the era of digital technology—and that there is a distinct "digital media ethics." These works include, most notably, Charles Ess's *Digital Media Ethics* (2nd ed., 2014) and Bastiaan Vanacker and Don Heider's coedited collection *Ethics for a Digital Age* (2016), as well as many other works (e.g., Crushel & German, 2011; McKee & Porter, 2009; Porter, 1998; Pruchnic, 2014). As Vanacker and Heider (2016) put it, "The development of information and communication technologies (ICTs) does indeed necessitate a revision of our ethics in order to deal with the challenges of this new world" (p. viii).

The overall argument of this scholarship is that the dynamic of internetworked communications, when combined with their prevalence and ubiquity and with the velocity of distribution and circulation, creates new kinds of interactions, which, over time, results in emerging new standards and norms. Social media communications have their own distinctive qualities and thus their own issues, problems, cases, and situations that are distinct from print and broadcast communications—and businesses and business communicators need to attend to these differences. Digital culture is developing its own set of norms and standards regarding what is acceptable, right, and just, which diverges from previous non-digital norms. Rather than regretting or opposing this change, the emerging field of digital media ethics (of which our work is a part) strives first to understand the changing scene, and then to propose new standards and best practices that take into account the distinct cultural dynamics of social media and its distinct ethical dilemmas.

A second important point, though, is one not always explicitly articulated outside the realm of rhetoric and communication scholarship: what happens on social media is fundamentally communication interaction, and so the ethics involved very much concerns communication ethics. How we interact

with and engage one another through words, sounds, images—*texts*, broadly understood—has ethical implications, a point we elaborate below.

Our approach to thinking about social media missteps and corporate response is very much informed by rhetoric theory—but it is a particular kind of rhetoric theory based mainly on (1) a view of rhetoric and ethics as integrated concerns (rather than as isolated or separate), and (2) a network approach to interpreting rhetorical events (versus a discourse- or context-centered approach).

Rhetoric and Ethics as Integrated

When the popular media talk about the ethics of social media usage as it pertains to business, they often subsume ethics within legal or criminal lenses, as major violations of law, policy, or regulation: for example, security lapses or "breach of confidentiality, conflicts of interest, [and] misuse of company resources" (Lunday, 2010). The term *ethics* is not typically used to refer to everyday interactions or behaviors.

We see ethics as every day, because we see ethics as fundamental to all human communication and thus to all human interaction. Ethics pertains to character and credibility and to issues of trust, responsibility, honesty, and integrity—what in rhetoric is termed *ethos*. *Ethos* applies to everyday, even mundane human interactions as well as to large-scale policy matters. In taking this perspective on rhetoric and ethics, we are calling upon a rhetoric tradition that views the two arts—rhetoric and ethics—not as separate arts in separate spheres but rather as an inextricably intertwined set of concerns that are also fundamental to communication interaction (Johnstone, 1980; McKee & Porter, 2009, 2015, 2017; Porter, 1998).

The crux of our position can be summed up in Quintilian's definition of rhetoric as "A good man [or woman, we would add] speaking well [or writing, we would add]" (*Institutio* 12.1.1). In that definition we find Quintilian's insistence that in order to achieve effective rhetoric, the rhetor must, first, be a virtuous person—a *vir bonum*, or good person—or else they will not have the rhetorical credibility (*ethos*) to compel an audience. This same principle applies to the collective or corporation: To be effective, a corporation must also "speak well."

"Speaking well" carries a double meaning of course. First it means speaking/writing effectively in the stylistic and aesthetic senses: the rhetor crafts her language carefully, fluently, concisely, correctly using precisely the right words to convey the message and to instruct and compel the audience, and with a flair and nuance that also makes the message aesthetically pleasing. Many view rhetoric as concerned *only* with this—that is, only the art of packaging,

only concerned with style, arrangement, and delivery, "speaking well" only in the stylistic, aesthetic, and presentational senses. Hence the derogatory and popular notion of rhetoric as being "mere rhetoric": hollow and false, manipulative and misleading, lacking substance or truth.

But "speaking well" has a second important meaning, a meaning that has not always been viewed as the purview of rhetoric but that is considered by Quintilian at some length (e.g., *Institutio* 11.1.8–10). The good speaker speaks with knowledge and expertise, and that expertise is very much guided by her public position, her duties and obligation to the *polis*. The rhetor is speaking in favor of *the good*, of some good for the audience; the aim of the rhetorical act is, ultimately, the good of the audience, the good of state, the good of the *polis*, some mutual good that is at the core of the speech. The motivating force behind symbolic action is, or should be, a common good, and so when a speaker/writer takes up the question of purpose—Why am I speaking or writing?—it is interlaced with considerations of ethics. *Cui bono?*: For whose benefit am I speaking or writing?

As we will discuss in the cases below, company executives, spokespeople, the very company itself are impacted—long-term and short-term, directly and indirectly—by whether they "speak well" in the Quintilian sense of considering one's ethical obligations to a greater community. The question of "Why am I communicating, for what purpose, and for whose good?" brings considerations of ethics to the fore. Within this view rhetoric and ethics are necessarily interrelated, overlapping arts; one can't work without the other.

Ethos

Central to this integrated view of rhetoric and ethics is the rhetorical appeal of *ethos*. *Ethos*—one of the three persuasive appeals discussed by Aristotle in *Rhetoric*, along with *logos* (the appeal to reason) and *pathos* (the appeal to emotions)—was the appeal related to the credibility of the speaker: that is, to "the speaker's securing the trust and respect of an audience by representing him- or herself in the speech as knowledgeable, intelligent, competent, and concerned for the welfare of the audience" (Cherry, 1988, p. 256).

Aristotle identifies three particular qualities that comprise an effective ethos: "For the orator to produce conviction three qualities are necessary: good sense [*phronesis*, or practical wisdom], virtue [*arête*], goodwill [*eunoia*]" (*Rhetoric* 2.1.5). For communicators to be effective, they must be viewed as credible, honest, just, wise, virtuous, and concerned with the goodwill of the audience. In other words, ethos is one key rhetorical principle, though not the only one, where the concerns of rhetoric and ethics very much overlap and intertwine (McKee & Porter, 2017; Porter, 2017).

Two other aspects of ethos are particularly important for our analysis: ethos as collective, and ethos as complex and variable. First, the collective: Ethos can refer to corporate image or identity as well as to individual identity. Every company has an ethos, too: that is, an image or identity that it projects to the public and becomes the face of the company. Volkswagen, Uber, Google, Exxon—these companies all have corporate identities and reputations, whether good or bad, or both, with different audiences, established over time. When an employee's actions hurt the company image, or when the company engages in behaviors that violate the social trust or that come across as hypocritical, that ethos is harmed—and the company must take steps to repair both its ethos and its relationship with the public.[2]

Ethos also refers to identity or role as established through communication interactions, and this identity or role can change over time and in different rhetorical circumstances: in short, it is complex and variable. The ethos you have in one situation, for one kind of audience might be different from the one you have for another situation and audience. Your ethos as a private citizen, as a friend or family member, might be very different from your ethos as an employee of a company. Who you are as a private citizen is different from who you are as a spokesperson for your company, and yet the difference between these roles can become blurred, even indistinguishable, especially with social media usage, as we discuss in the Justine Sacco case.

A Network Approach to Rhetoric and Ethics

As we mentioned, discussions of ethical lapses in business, particularly in popular media, often focus on the ethics *event*—that is, a problematic moment when somebody did something wrong, with a focus on the wrongful act (e.g., Justine Sacco's fateful tweet; Ford Motor Company's insensitive tweet)—or on the agent of the event, the person or corporation who erred (Sacco, Ford): Was Sacco's tweet a joke or not? Was Ford's apology for its lapse adequate or not? In other words, the focus tends to fall first and foremost on the event, on the offending text, or on the person or corporation who does something wrong (see Figure 1).

Figure 1. Agent/event as primary focus of ethical analysis

For rhetorical analysis this focus on the agent/event is just the starting point. What is also needed is a broader perspective that includes *context*. That is, it is not enough to focus merely on the isolated rhetor (writer or speaker) or on the isolated text (the speech or piece of writing)—or, in the case of ethics, on the isolated wrongdoer or ethical lapse. Rather, to understand the effectiveness or ineffectiveness of that discourse or event, you have to understand how it operates within its immediate rhetorical context or rhetorical situation: that is, for example, the cultural moment, audience, exigence, purpose, constraints, etc., for a particular discursive event (Bitzer, 1968). In Figure 2 we have added context to our map.

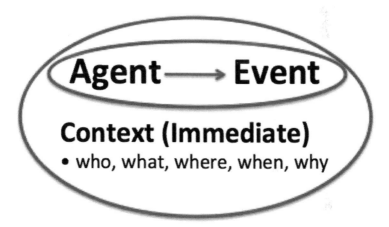

Figure 2. Agent/event in its immediate rhetorical context

But the immediate context is not enough either. All communications occur within broader (and multiple) historical and cultural contexts that also must be considered. Borrowing from the insights of Actor-Network Theory, or ANT (Latour, 1996, 2005; Law, 2000), we think it is important to examine the rhetorical event in a broader "array of relations [...] *as a network*" (Law, 2000; emphasis added). We need to view discursive events, such as problematic ethical events or moments, as part of a larger network or system in which these events occur. There is not just the isolated event, the agent, and the immediate context, but, as shown in Figure 3, a much broader network involving context-in-a-broader-sense (historical and cultural background); near-time and far-time responses to the event; and multiple agents who contribute to the event, shaping past, present, and future understandings, interpretations, and actions.

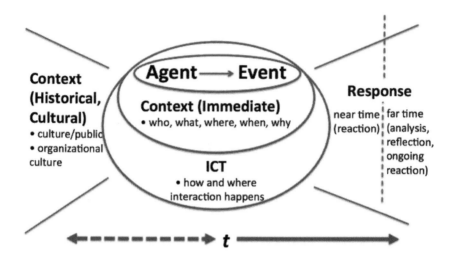

Figure 3. Agent/event in a network and as a system unfolding over time (t)

Figure 3 represents a network perspective on rhetorical activity, a perspective insisting that for us to understand a rhetorical or ethical event or moment, we must first start by not viewing it as isolated. That event exists in an immediate rhetorical context, but it also happens within a network and within a system unfolding over, across, and within time. And this network is ever-shifting and changing: the view of the event itself or the agent herself can change. Communication events exist in fluid models of circulation, what some call *ecologies* (Chaput, 2010; Edbauer Rice, 2005), *assemblages* (Bennett, 2010), or *systems* (Jung, 2014).

In taking a network perspective, we are not excusing the actions and responsibilities of individuals or of corporations within the network. Not at all. What we are saying, though, is that the network does exert an influence on human action—and that individual and corporate collective rhetorical/ethical actions need to be understood and evaluated within that network, that "array of relations," an array that involves both human and nonhuman agents.

Information and Communication Technologies

Notice that technology is very much a part of this array of relations. A key point of ANT —particularly as articulated by Bruno Latour in *Aramis* (1996) and by Jane Bennett in *Vibrant Matter* (2010)—is the importance of viewing objects, including technologies, as active agents, or actants, within the

network. Technology exerts its own power and influence, often apart from or even contrary to the wishes and intentions of the technology creators and designers (a point we can also take from Mary Shelley's *Frankenstein*). ANT looks at communication events and communicators within an entire system of relations including human and nonhuman actants—and that is what Figure 3 attempts to represent.

Technology is not simply a neutral tool or instrumental factor; nor is it, on the other hand, an all-shaping substantive power. Rather it is, as Andrew Feenberg (1991) notes, a critical factor (see also Porter, 2004). Humans are both shaping and shaped by the communication technologies they use, and particularly so by ICTs. These communication networks or assemblages are not simply human communities but also include objects and things working as actants—a point particularly important for understanding digital media ethics where often the ICT exerts an effect perhaps beyond what any individual human agent in the assemblage intends or anticipates. For example, twitterstorms occur not just because of the humans who tweet and retweet but also because of the connectivity across digital devices that has created the conditions for such a viral network to occur.

For our analysis we are looking at ICTs in the form of social media applications—and the system of relations they create, foster, and develop—which shape the dynamic interplay of interactions and attitudes and, eventually, change ethical standards and practices. We have to take this into account in our rhetorical-ethical analysis of social media missteps by employees and the corporate reaction to those missteps.

Kairos

Time, as represented by the bottom t-line in Figure 3, is an important aspect of our analytic frame, in two different senses. First, there is time in the traditional *chronos* sense—when events happened and how they unfold from past, to present, to future. But also important is time/timing in the rhetorical sense, or what is known as *kairos*.

In rhetoric, *kairos* is typically defined as "the right time" but a better definition might be "opportune moment" (Poulakos, 1983): that is, the best time to speak or to write, or the opportune time to persuade an audience, or knowing what to say and how to say given the rhetorical situation (Kinneavy, 1986). Thomas Rickert (2013) describes *kairos* as "a matter of making appropriate or fitting use of the opportunities that arise, whether they stem from the temporality of the situation or the governing properties of the culture in which the situation emerges" (p. 80). *Kairos* in the rhetorical sense includes

considerations of chronological time—as in social media studies that advise us about the best time of day or the best day of the week to post on Facebook or Twitter (Gardner, 2013). But *kairos* also refers to "a qualitative character of time" (Smith, 2002, p. 47) that pertains more to knowledge about cultural and historical moments that are imbued with audience attitudes, feelings, and emotions and that are very often tied to places and locations and to cultural memories, stories, and events.

What we see on social media, again and again, are missteps in the form of companies failing to acknowledge *kairos* as an important form of communication knowledge related to timing, appropriateness, audience, location, and culture.[3] The speed at which events and reactions to events happen online means that cultural attitudes, values, and emotions can shift, move, and morph rapidly. The crowd can assemble (or disperse) quickly, become emotionally charged, shift allegiances, change attitudes, become hostile or friendly, an ally or enemy, all in the course of a few hours. What is deemed appropriate or harmless at one moment can become offensive, racist, or unjust in the next. Companies that maintain a strong social media presence have come to recognize the importance of virtual vigilance and attentiveness to these moments, and quick response to and intervention in crisis situations (e.g., negative messages going viral, trending).

Most importantly for our purposes, *kairos* needs to be understood as a *form of knowledge* shaping how one views, understands, and experiences events. Sensitivity to *kairos* is key to a rhetorical understanding of communicative events, especially ethically problematic social media events, as shown in our discussion of two cases.

Case Analysis

Case 1: Justine Sacco and IAC

The Event
Figuring out the "who" and the "where" of a communication context is harder than it looks, as illustrated by the case of Justine Sacco. Sacco was the senior director of corporate communications for IAC, a media and internet company that in 2013 managed more than 150 brands and corporations. On December 20, 2013, on her way to South Africa to visit family, she sent the following tweet from her personal Twitter account: "Going to Africa. Hope I don't get AIDS. Just kidding. I'm white!" She then turned off her phone and was in the air for ten hours.

Unbeknownst to her, while she was flying, a twitterstorm erupted. Sam Biddle, an editor at the time for Gawker Media's *Valleywag*, was the first to retweet Sacco's tweet to his 15,000 followers and to post it on his *Valleywag* blog. As he explained a year after the event, "As soon as I saw the tweet, I posted it. I barely needed to write anything to go with it: This woman's job was carefully managing the words of a large tech-media conglomerate, and she'd worded something terribly" (Biddle, 2014, n.p.). Sacco's post was retweeted extensively, trended highest worldwide, and a new hashtag developed, #HasJustineLandedYet. Many people found themselves glued to Twitter waiting to find out what would happen when Sacco landed.

But even before Sacco landed, her company, IAC, sent the following statement to Biddle and *Valleywag*: "This [tweet] is an outrageous, offensive comment that does not reflect the views and values of IAC. Unfortunately, the employee in question is unreachable on an international flight, but this is a very serious matter and we are taking appropriate action" (qtd. in Biddle, 2013, n.p.). When Sacco landed, she learned she was in deep trouble at work, was the subject of CNN news stories (Stelter, 2013), and had her Twitter feed, which had only about 150 followers, read through by thousands (many who pointed out other potentially inappropriate tweets made months and years earlier). Not surprisingly, Sacco deleted her Twitter account.

The next day, Sacco released a public apology in a South African newspaper, "Words cannot express how sorry I am, and how necessary it is for me to apologize to the people of South Africa, who I have offended due to a needless and careless tweet" (qtd. in Dimitrova, Rahmanzadeh, & Lipman, 2013). Her employer, IAC, also released a statement:

> The offensive comment does not reflect the views and values of IAC. We take this issue very seriously, and we have parted ways with the employee in question. There is no excuse for the hateful statements that have been made and we condemn them unequivocally. We hope, however, that time and action, and the forgiving human spirit, will not result in the wholesale condemnation of an individual who we have otherwise known to be a decent person at core. (qtd. in Biddle, 2013, n.p.)

Tellingly, in this posting IAC moved from calling Sacco an "employee" (which she had been for two years) to an "individual," a point we discuss in more detail below.

After the event, a great deal was written about whether Sacco's tweet was a joke (as she claimed) or not, whether the racism in the tweet was intentional or not, and, especially, whether Sacco was a victim of excessive and undeserved shaming (see Blanchfield, 2015; Ronson, 2015a, 2015b).

Sacco's tweet was certainly inappropriate, demonstrating thoughtlessness and either unintentional (or intentional) racism, but what are the implications of this event for business communication ethics? What has not been discussed as much, and what we turn attention to now, are the implications of Sacco's case for business ethics in a digital age. When an employee makes a social media misstep, what factors should be considered when weighing possible responses? How does a company determine an ethical course of action?

Immediate Context: Role Boundaries

A key factor to consider is to identify what role the person is in when communicating. As the Director of Ethics for a multinational corporation with 80,000 employees around the world and 12,000 in the United States explained to us in an interview[4]:

> Most of the ethical issues we [company management] face have to do with professional roles. How a person is functioning and how they are holding themselves out when they communicate is of great importance to us. So when we look at the policies we have, it's clear that they're trying to make a distinction between whether or not a person is authorized to communicate on behalf of the corporation or whether or not they are acting in their private capacity to communicate. [...] It's a question of role: In what role is the person operating in?
>
> And also what do people outside our company—what is a reasonable expectation for them to understand what role that person is speaking in? [...] It's hard to talk about professional ethics without defining what a role is and what a professional role is versus a private role is. Who are you acting on behalf of, and who do people perceive you as acting on behalf of? What is your role, what is your obligation in this particular capacity?

Here is where the question of ethos comes into play. Was Justine Sacco an employee, or a private citizen, or some blend of both when she sent that tweet? Clearly her company considered her an employee and then, once fired, as an individual. But was she tweeting in her role as a public relations executive at the time of that tweet? What if she'd made that comment orally on the plane to a few people or via a telephone call and it never was recorded digitally and thus never available for ubiquitous copying and sharing? Does the very public nature of social media change when and in what role a person communicates? With social media can we ever not be employees? The blurring of role boundaries—when is a person an employee and when is she a private individual—has always occurred in business, but with the digital media those boundaries are blurring even more.

As the Director of Ethics explained, if two employees get in a fight on a Saturday night at a bar "we'd say, not our problem. That is clearly on somebody

else's turf; you were not operating in your capacity as an employee." But if those same employees take to fighting and attacking each other in social media, then that's different:

> Then there is this question: what is that? They're not dragging [the company] into it per se. But they are talking about work in a context in which many of the friends on both sides know that both parties are [company] employees and they are having the fight in a public space. Do we care about the language? Do we care about the threats? Specifically do we care about threats that are made between employees on social media? That's been tough. [...] We do make the assumption that these are being viewed by our employees at work. Then we say, Hey, look, we don't allow threats in the workplace and just because you're doing it on social media, the fact that you're doing it between two employees, we are assuming that it's being viewed by other employees in the workplace and that is a workplace threat. That is something that we have to take seriously.

While Justine Sacco was not fighting with anyone, the analogy applies. Because Sacco was a public relations executive charged with overseeing communications for IAC and their many clients, her digital communications, once retweeted beyond her immediate circle, were being viewed in a very public forum, and IAC had to take her tweets and the public reaction to them seriously, especially because of her role in public relations. If Sacco had been in some other role for IAC than communications—if she'd been, say, part of building maintenance or IT—would her tweet have garnered the firestorm it did, and would IAC have reacted as they did?

In addition to determining the public–private roles of individuals when communicating, the relationship of the individual to the company and how audiences will perceive that individual's communications matters. As the Director of Ethics explained using a nondigital example, if an executive of the company goes to a political rally wearing the company polo shirt with the name and logo prominently displayed, people may think that the political views expressed by the employee are the views of the company too, given the executive's leadership position. But if an hourly employee, one who is not known, wears the same shirt to a political rally, that wearing, while still, perhaps, against company policy, is less of a problem since that hourly employee would be less likely to be seen as representing the company. Every individual then has private roles and employee roles (see Figure 4) but depending on the job the person has for the company the overlap could be significantly higher.

Figure 4. Employee and citizen roles mostly distinct

For Sacco, because of her job as a public relations executive, there was a great deal more overlap between her employee role and her private role (see Figure 5). Given her identity, status, and position in the company, she had less latitude in exercising her rights as a private citizen.

Figure 5. Employee and citizen roles extensively intertwined

Sacco's ethical misstep, in addition to the questionable content of the tweet, was not recognizing how intertwined her roles were. She failed to understand that her ethos as an employee could extend into and overlap with her personal life and that relation to digital communications in public fora. In a sense she could never *not* be seen as an employee.

Significantly, IAC first reacted to Sacco's tweet by calling her "the employee in question" even though she sent that tweet from her personal Twitter account while on vacation. What role a person is in matters, and that is an essential element to figure out, impacting perceptions and understandings of the immediate context, the who, what, when, where, and why of an event. But that is not all: the broader context, including the communication technology, matters tremendously.

Role of ICT/Social Media

If, for example, Sacco had sent her message via e-mail or an auto-deleting message to a few friends rather than having posted it on Twitter, we might never know her name. Her posting appeared in a large publicly accessible forum, and thus was available for broad public distribution. Biddle was the one to first repost her message, but the storm that then ensued was not necessarily his responsibility, or at least not his primarily. Everyone who participated in the storm as poster and onlooker was responsible but no one was directly responsible. The very nature of Twitter itself, its global, public reach, its communicative immediacy, enabled the mob to form and, rereading the tweets, it was indeed a mob mentality out to ridicule and vilify Sacco. As Biddle explained to Jon Ronson (2015), he "was surprised to see how quickly her life was upended." Each person who participated in the twitterstorm was an actant, to use Latour's term, but so too was (and is) the technological medium. As one person noted in a tweet in the midst of the storm, "I remember when you could be utterly stupid without the whole world finding out" (qtd. in Vingiano, 2013, n.p.).

The other technological factor here involves preservation/copying of the event and its publication and distribution. To use the Director of Ethic's example of the barroom fight, the fight does become a problem if somebody videos the fight, posts it on YouTube, and it goes viral and is viewed at work. In that situation the fight becomes published/publicly distributed. It still might not be a problem if the fight in no way involves the company. But what if somebody labels the video with a caption identifying a combatant as "an employee at X Company"?

In other words, what is different here is not just the role or location of the employee, but the captureability (copying) of the event via digital technology, the shareability (pasting) of it via social media, and the velocity and virality of its spread through social media (DeVoss & Ridolfo, 2009; Jenkins et al., 2013). The technology itself changes the determination about when someone is or is not an employee. Copy, paste, publish, it's easy and fast, and it changes everything. Because this technology has incredible breadth and speed of distribution, Sacco's communication to 174 followers gets broadcast in just a few clicks worldwide. In that sort of massively public forum, the chances of someone being able to step away from an employee role and from employment ramifications for inappropriate (and legally not protected) communications are slim.

Broader Context: Company Culture and Policies

But there's much more to the Sacco case than just the event and immediate context; the ethical questions do not pertain to Sacco alone. We would say that there are ethical considerations involved, too, in Sam Biddle's decision to retweet her post, an action he reflects on in a *Valleywag* piece one year after the event (Biddle, 2014). Legally he could do so, but was it an ethical course of action? In pondering the ethics of his decision, Biddle recognizes that it's a "dicey" decision, one fraught with "swamps and thorns." For this chapter, though, we focus more on the corporate response. Was IAC's response to the tweet ethical? In their handling of the Sacco case, was IAC a good company speaking well? Judging by the *chronos* of the event, it seems a point worth analyzing.

While Sacco was still in the air, IAC posted, as we quoted earlier, that her tweet was an "outrageous, offensive comment that does not reflect the views and values of IAC" and that "this is a very serious matter and we are taking appropriate action." They do not specify at what time this "action" happened, but early the next day, IAC announced that they had fired Sacco, repeating the point that "The offensive comment does not reflect the views and values of IAC. We take this issue very seriously, and we have parted ways with the employee in question." Given the swiftness of their action it seems IAC had made up its mind to fire Sacco even before she had landed. They certainly did not give her much time to discuss and reflect with them on her actions. For this chapter, we have not spoken with anyone at IAC, but we also wonder whether their own company culture and their own social media policy might have contributed to the problem? Did offensive comments like that circulate regularly among employees? We don't know, but clearly, in their statements, IAC was a company not looking to talk with Sacco, but rather seeking to cut ties and establish distance as quickly as possible: her brand had gone bad and they didn't want that to tarnish their own or their clients' brands.

Given the type of company IAC is and Sacco's specific job at the company, it makes good business sense that they would want to cut ties as quickly as possible. Would you want to hire a company to manage your brand in a global marketplace if its own public relations executive communicates so ineffectively in digital media? But when thinking about the role of employees and employers and recognizing the widespread prevalence of social media missteps, was such an immediate firing the ethical thing to do?

The Director of Ethics we interviewed, who has worked in ethics and industry for decades, reflected on a change he has noticed in corporate reactions to employee actions:

> We're definitely living in an era where we burn people for the smallest things. We go after them. I found that human resource departments are very quick to fire people in some part because of the fast-moving nature of the modern world. Communications go out quickly, people react quickly, reputations are made and lost quickly. And there's the sense that HR has to react quickly. I don't know if we have to. [...] The last couple of years I've really tried to highlight that the person who has made that mistake is tactically the one you want around because (1) they would probably be willing to talk about their story and be a good learning example, and (2) they're never going to make that mistake again. That's the person now you don't have to worry about. You do have to worry about all the other people. We're not good at dealing with errors. We're not good at dealing with people who have just crossed the line in social media and reputation issues and the like.

Figuring out what the line crossings are and what the consequences for those crossings will be is tricky for both companies and employees. As shown in the Sacco case, the ubiquitous and spreadable nature of digital media (Jenkins et al., 2013) expands where and when employee status kicks in and blurs what is and isn't company business.

Understanding corporate policies and corporate culture is helpful for clarifying the often blurry situations created by employee social media usage and corporate response. We would argue that an ethical responsibility of any company is to ensure that policies—legal, ethical, specific to company culture—are in place that are communicated clearly to employees. But it is important to recognize that the best policies in the world will never be able to address every situation that may arise. Policies around social media usage continually evolve, with new situations and new technologies arising often faster than the policies can be revised. In these revisions, what sometimes can happen, as noted by the Director of Ethics, is an expansion of the overlap between what is company business and what is personal, private business.

Some companies have developed overly broad social media policies that restrict employees from posting (on company or personal accounts) anything that might harm the company, the company's reputation, etc. In the U.S., such overly broad policies have been struck down by the National Labor Relations Board (2015) in numerous cases. Employees have the right to discuss wages and working conditions among fellow employees if the goal or possible goal is concerted action, but "an employee's comments on social media are generally not protected if they are mere gripes not made in relation to group activity among employees" (NLRB, 2015; see also Hill, 2011). And if an employee just makes a really thoughtless and offensive comment, as Justine Sacco did, that is not protected under U.S. law and companies may, legally, fire an employee.

Reflecting on the broader context in the Sacco case, we don't know at the time of her tweet what IAC's policies were regarding social media communications and employee responsibilities. Had IAC communicated to employees their expectations for social media usage? Had they made clear what they would view as company business, and what was personal, private business? Did they have a culture of jokes such as Sacco claimed her tweet was? Examining the company culture and the company role in social media missteps is essential to determining an ethical course of action. With Sacco, IAC clearly was taking the approach that Sacco as an employee was a liability and they distanced themselves from her as much as possible.

Case 2: The Slanderous Blogger

The Event and Immediate Response

IAC's response to Justine Sacco's tweet was to fire her, and that is often the response of many companies. But one chief executive officer and president we interviewed chose a different approach, one based not just on the immediate context of the event but much more on the historical context and culture of the company.

Henry Truslow IV is CEO and president of Sunbury Textile Mills, which in some form has been running since its founding in 1890 in Sunbury, Pennsylvania (Sunbury, 2016)[5] Sunbury employs about 200 people at its mill in Sunbury, Pennsylvania, and at its design and marketing center in New York City. One day in 2014 Truslow received a call from one of his Senior Executives who asked Truslow to Google the executive's name, which Truslow did. One of the top links returned was an anonymous blog with many posts that were, in Truslow's words, "very derogatory and slanderous" to the Senior Executive and "it was obvious the blog was written by somebody in the company, an employee." The Senior Executive told Truslow that something had to be done about this, and Truslow agreed, but he wasn't at first sure what to do.

When Truslow consulted with company lawyers, they told him there was nothing he could to the employee based on their reading of recent U.S. National Labor Relations Board (NLRB) rulings. But Truslow felt strongly that for the good of the company, "I can't do nothing" (Interview, October 15, 2015).

He also understood the difference between law and ethics: perhaps there was no legal course of action he could take, but there were many possible ethical actions that could be taken in response to the situation. As the leader of

the company, responsible for both the individuals in his employment and the culture and brand of his company, he set out to restore company ethos and in doing so, although he would not recognize it in these terms, he set out to be Quintilian's good man speaking well for the greater community.

Truslow also recognized that even if legally he could punish the blogger, he did not want to. Prosecuting or firing someone for slander mattered less to him then (re)establishing clearly for all in the company the company ethos. Given the type of company he ran—one where the average employee had 20 years experience and one that was set up as an Employee Stock Ownership Plan (ESOP)—he felt that prosecution and firing were not the ethical response. All employees were owners of the company and as co-owners he felt it more important that all work together. What Truslow decided was needed instead was a communal response and a communal consideration of what the company stands for. Truslow's response then was shaped very much by the broader historical and cultural context in which his company operated.

"It hurts us universally": Appealing to Communal Values

It is also important to point out what Truslow did *not* do: He did not respond via social media, or blogging, or e-mail; he did not issue an executive memo condemning the blog postings. Rather he responded to the situation face-to-face, in person via a meeting with employees based on his understandings of company culture. Because of the nature of the posts, he deduced that the employee was at the New York City offices, so he traveled from his base at the mill to New York and called a whole headquarters meeting (for about 30 employees).

> I said, "We're here to talk about something that I never imagined in my career that I'd be talking with you all about. But somebody in this room has taken it upon themselves to write slanderous and defaming comments in a blog." And the whole time I'm talking to them I'm going slowly through the thing, so they're reading it while they hear me speak.

> I said, "Whoever has written this. I still can't believe this person is in this room. I'm not pointing fingers and I have no idea: I don't want to know who did it. But what I want everybody to know is that whoever has written this—the obvious person it hurts is [the Senior Executive] because it's slanderous toward him. But beyond this it hurts every single person in this room. It hurts every single person in the factory. It hurts our customers, and it hurts our company. So it hurts us universally."

Truslow emphasized to employees that he did not want to engage in a "witch hunt" because that would be counterproductive and that he simply hoped

that whoever wrote the blog post would consider taking it down. As Truslow
described it, he could tell that employees were very upset by the anonymous
blog posting.

> I wrapped up my talk and everyone is in shock. I could read the faces in the
> crowd, and everyone was in shock. Nobody knew what the heck had just hap-
> pened here. So I packed up my stuff and stayed a few hours and then left. I did
> this purposely on a Wednesday or a Thursday and I was hoping that night it
> would be taken down. Once everyone got home, whoever had written it would
> take it down.

> I woke up the next morning and checked online and the damn thing was still up,
> so I was like, "Oh, damn, it didn't work."

But then the second day after the presentation the blog posts were taken
down.

> Everybody in the office, that's all they were talking about—so the next day we
> think that the person in the office didn't take it down because they wanted to
> gauge the reaction of all the other people. They got there and basically univer-
> sally the employees are saying, "Can you believe what a coward this person is?"
> They're doing their own water cooler talk. And from that, finally that second
> night it was taken down. Now if you do the search it's nowhere to be found. It
> went away.

What Truslow realized was that it was not his statement that swayed the anon-
ymous blogger. Rather it was the collective comments of the community:

> [I did what I did] in an effort to right the ship and correct a wrong [...] We're
> 200 employees total—it's a very tight group, we have a good culture. I don't
> think it's much beyond that. [I said to them] this is just wrong and we've got
> to get it straightened up. I just laid it out for them and let them influence each
> other. And the proof was in the pudding—it took 48 hours instead of 24.

What did not work in this case was a top-down executive order. What did
work was the appeal to collective values.

This case shows the importance of both executive leadership and cor-
porate culture in shaping responses. What constitutes appropriate commu-
nications and appropriate responses to social media missteps depends on
the culture of the company and what the company expectations are for
determining public and private roles. IAC, perhaps because of the nature of
the company and because of Sacco's role in public relations, reacted in an
immediate, fire-the-employee fashion, saying in effect, that employee is not
us. On the other hand, what Truslow did was to remind employees of the
company culture, to show that while the posts were written by an individual,

that the company was not going to go after the individual. In part, pragmatically because of possible NLRB-protected speech, but also in part because the CEO recognized that to engage in "a witch hunt" (as he called it) would further rend rather than mend the company and everyone in it. The unidentified and unknown employee chose to take the posts down, and the matter was settled.

Conclusion

Ethical analysis in the popular media tends to be agent- and event-focused: considering the severity of the ethical lapse or wrongdoing, and the degree of culpability of the individual agent. Was Justine Sacco's tweet offensive, or just a careless joke gone awry? Is she racist, or not? Should she be fired, or shamed, or not? While we certainly agree these are important questions for an analysis, our approach, as represented in Figure 3, extends the parameters of the inquiry to include other questions.

For instance, we could go back in time to reflect on issues related to corporate policy, practice, and culture: Was Justine Sacco simply mimicking attitudes and statements that were common in her work experience, an insensitive kind of joking style that was tolerated and perhaps even encouraged around the water cooler in the corporate culture at IAC (though perhaps not always tweeted or blogged on social media)? Does IAC need to examine its social media usage policy (does it even have one?) in light of the Justine Sacco event?

We also want to go forward in time from the event to examine the ethics of the various responses: IAC's response to Justine Sacco was to distance themselves from her as quickly as possible: to fire her and in so doing to deny any responsibility for the content or effect of her message: in their public postings they quickly changed Sacco from an "employee" to an "individual." IAC certainly had the legal right to do that, but we raise two other questions about that response: (1) Was IAC ethically justified in doing that, given the degree of harm of that tweet? Did the punishment fit the misstep in other words? (2) Even if IAC's overall response was justified, was their process of carrying out that decision fair? And (3) was their response the best possible practice in terms of building and maintaining their corporate ethos with the public? Or in terms of showing corporate leadership and responsibility? Did the company reflect on its possible own contribution to Sacco's post—meaning did their own corporate culture tolerate perspectives like those that Sacco revealed in her post?

These questions about the ethics of corporate response are of course also questions about ethos. Business does not use the term ethos, an ancient term from Greek rhetoric. Even communication and media studies have moved away from using the term. But business certainly does value the qualities that ethos espouses—in particular, image, reputation, credibility, trust, and leadership. Companies sometimes approach social media crises as PR events to be managed, controlled, or stifled as quickly as possible—but that instinct may be misguided given the velocity (DeVoss & Ridolfo, 2009) and circulatory nature of "spreadable media" (Jenkins et al., 2013) and given the rhetorical demands of ethos. Rather than trying to silence the event—hard to do on social media, in any case—perhaps the smarter corporate response is to turn the event into an opportunity to build corporate ethos by demonstrating integrity, leadership, *phronesis, eunoia*?

The ethical ramifications of such events have the potential to play out for a long time, but they can provide corporations the opportunity to reexamine a wide array of communication practices. For instance, when a YouTube video went viral showing a FedEx delivery driver carelessly throwing a package (containing a fragile item) into someone's yard, FedEx figured out how to remix the negative video into a positive message. Instead of firing the employee, they kept the employee, at least through the time of their public apology where they noted that the driver in the video "is not working with customers" (Thornton, 2011). FedEx also took responsibility for the driver's actions, framing it not as an individual error, but a company error as well, one they were addressing in part by repurposing the video for use in employee training (Thornton, 2011). They strategically used the circulatory power of social media participants to help them recast the negative message. Instead of launching an investigative witch hunt to find the offending blogger, Truslow at Sunbury Textile Mills used the derogatory blog post as an opportunity to build a stronger sense of shared corporate responsibility among employees: not setting up an antagonistic relationship between "you" and "me," or between "us" (who care about the company) and "them" (who don't), but rather appealing to the shared values of the collective "we."

In business circles this kind of response is called *leadership*—and one way leadership functions in organizations is by creating an ethical example that should serve as a model and standard for all:

> The analysis of the spread of unethical behavior—almost necessarily—entails the important question of how the spread of unethical behavior in organizations may be halted....First, those responsible for leading and managing organizations can create an environment in which, for the members of the organization, engaging in further unethical behavior becomes a less likely reaction to an initial act of

unethical behavior compared to other reactions. (Zuber, 2015, p. 165; see also Toor & Ofori, 2009)

Social media missteps, especially ones that go viral, are certainly PR crises but they are also opportunities for corporations to exercise leadership, construct an effective corporate ethos, and build stronger relationships, whether externally with the public (as in the FedEx example) or internally within the company (as with the manufacturing company). In these cases what we see are qualities such as: effective leadership, willingness to accept responsibility, display of justice/fairness to those involved, and integrity. In each case we see an example of corporate leadership that cares about the quality of its company and the reputation of its brand and that uses social media missteps to build company culture.

Certainly in some instances, firing an employee is not only a legal action but an ethical one as well, but we would argue that companies and their employees would be better served to never rush to judgment and rush to react. *Phronesis*, or practical wisdom, also applies here. Another important quality of ethos, *phronesis* refers to one's ability to deliberate wisely, given competing options, to arrive at a careful, thoughtful, reflective judgment about what to do and how to do it. With the speed of digital communications comes an intense pressure to act and act quickly, but taking time to analyze a case, from many angles, within many contexts, and forward and backward in time, is essential. With such a careful and multifaceted analysis, the chance for ethical decisions to be made will be greater, thus serving both employees and employers better and strengthening individual and corporate ethos.

Notes

1. This chapter originated as our first write-up for research that was later revised and published in our book *Professional Communication and Network Interaction: A Rhetorical and Ethical Approach* (2017). Our research is based on rhetorical analysis (including ethical analysis) of cases drawn from social media postings, from published accounts in popular and academic media, and from interviews with business professionals from a variety of fields, working primarily for U.S.-based companies or for multinational corporations with large U.S. operations. Interviews were conducted with IRB approval and are reported with real names or pseudonyms, depending on participants' wishes.

2. Research shows the importance of corporate ethos: "Distrust has quantifiable impact on business performance [...] 63% of people who lack trust in an organization will refuse to buy products and services from it, 37% have shared negative comments online, and 18% have sold shares in a company they didn't trust" (Etlinger, 2015, p. 9). Perhaps even more so in the social media age, consumers are especially quick to

react negatively if they feel a company is acting hypocritically—as happened, for example, in 2012 to McDonald's (see Lyon & Montgomery, 2013; Thomases, 2012).
3. In 2013, Ford Motor Company posted a tweet thanking the first responders in the Boston Marathon Bombing: "To the first responders of Boston: Thank you. You are true American heroes." The written message was not per se the problem, but Ford included with the message what amounted to basically a billboard image of a black Ford truck and car. In short, Ford used its message, and the tragedy of the Boston Marathon Bombing, as an opportunity to sell vehicles (Ford, 2013). This tweet, which resulted in a twitterstorm of backlash and criticism, was not an error of chronological timing so much as an error of appropriateness (Ray, 2013).
4. The Director of Ethics we interviewed spoke to us with permission of his company but as an individual and not in his official capacity as an employee of the large multinational corporation for which he works. His views represent his own perspective and opinions and not necessarily those of his company.
5. Henry Truslow IV is author Heidi McKee's first cousin. We did not intend to interview family members for this project, but upon hearing about our research, Heidi's cousin said, "I have a story for you," and we listened.

References

Bennett, J. (2010). *Vibrant matter: A political ecology of things*. Durham: Duke University Press.

Biddle, S. (2013). And now a funny holiday joke from IAC's PR boss. *Gawker*. Retrieved from http://valleywag.gawker.com/and-now-a-funny-holiday-joke-from-iacs-pr-boss-1487284969

Biddle, S. (2014, December 20). Justine Sacco is good at her job, and how I came to peace with her. *Gawker*. Retrieved from http://gawker.com/justine-sacco-is-good-at-her-job-and-how-i-came-to-pea-1653022326

Bitzer, L. F. (1968). The rhetorical situation. *Philosophy & Rhetoric, 1*, 1–14.

Blanchfield, P. (2015). Twitter's outrage machine should be stopped. But Justine Sacco is the wrong poster child. *Washington Post*. Retrieved at https://www.washingtonpost.com/posteverything/wp/2015/02/24/twitters-rage-mob-should-be-stopped-but-justine-sacco-is-the-wrong-poster-child/

Chaput, C. (2010). Rhetorical circulation in late capitalism: Neoliberalism and the overdetermination of affective energy. *Philosophy & Rhetoric, 43*, 1–25.

Cherry, R. D. (1988). Ethos versus persona: Self-representation in written discourse. *Written Communication, 5*, 251–276.

Crushel, B. E., & German, K. (Eds.). (2011). *The ethics of emerging media: Information, social norms, and new media technology*. New York, NY: Continuum.

DeVoss, D. N., & Ridolfo, J. (2009). Composing for recomposition: Rhetorical velocity and delivery. *Kairos, 13*(2). Retrieved at http://kairos.technorhetoric.net/13.2/topoi/ridolfo_devoss

Dimitrova, K., Rahmanzadeh, S., & Lipman, J. (2013). Justine Sacco, fired after tweet on AIDS in Africa, apologizes. *ABC News*. Retrieved from http://abcnews.go.com/International/justine-sacco-fired-tweet-aids-africa-issues-apology/story?id=21301833

Edbauer Rice, J. (2005). Unframing models of public distribution: From rhetorical situation to rhetorical ecologies. *Rhetoric Society Quarterly, 35*(4), 5–24.

Ess, C. (2014). *Digital media ethics* (2nd ed.). Cambridge, UK: Polity Press.

Etlinger, S. (with Groopman, J.). (2015, June 25). The trust imperative: A framework for ethical data use. *Altimeter Group*. Market Definition Report. Retrieved from http://www.altimetergroup.com/2015/06/new-report-the-trust-imperative-a-framework-for-ethical-data-use/

Feenberg, A. (1991). *Critical theory of technology*. New York, NY: Oxford University Press.

Ford, J. (2013, September 17). 5 corporations that used a national tragedy to sell you something. *Policy.mic*. Retrieved from http://mic.com/articles/63827/5-corporations-that-used-a-national-tragedy-to-sell-you-something#.dA9omsbdB

Gardner, O. (2013, January 17). How fast do you respond to your customers on Twitter? *Unbounce*. Retrieved from http://unbounce.com/social-media/fast-customer-response/

Hill, K. (2011, August 25). When you can and can't fire employees for social media misbehavior. *Forbes*. Retrieved from http://www.forbes.com/sites/kashmirhill/2011/08/25/when-you-can-and-cant-fire-employees-for-social-media-misbehavior/

Jenkins, H., Ford, S., & Green, J. (2013). *Spreadable media: Creating value and meaning in a networked culture*. New York, NY: New York University Press.

Johnstone, C. L. (1980). An Aristotelian trilogy: Ethics, rhetoric, politics, and the search for moral truth. *Philosophy & Rhetoric, 13*(1), 1–24.

Jung, J. (2014). Systems rhetoric: A dynamic coupling of explanation and description. *Enculturation, 17*. Retrieved from http://www.enculturation.net/systems-rhetoric

Kinneavy, J. L. (1986). *Kairos:* A neglected concept in classical rhetoric. In Jean Dietz Moss (Ed.), *Rhetoric and praxis: The contribution of classical rhetoric to practical reasoning* (pp. 79–105). Washington, DC: The Catholic University of America Press.

Latour, B. (1996). *Aramis, or the love of technology* (Catherine Porter, Trans.). Cambridge: Harvard University Press.

Latour, B. (2005). *Reassembling the social: An introduction to actor-network-theory.* Oxford: Oxford University Press.

Law, J. (2000). *Objects, spaces, and others*. Centre for Science Studies, Lancaster University, UK. Retrieved from http://www.comp.lancs.ac.uk/sociology/papers/Law-Objects-Spaces-Others.pdf

Lunday, J. (2010, July 21). Managing the workplace ethics of social media. *Corporate Compliance Insights*. Retrieved from http://corporatecomplianceinsights.com/managing-the-workplace-ethics-of-social-media/

Lyon, T. P., & Montgomery, A. W. (2013). Tweetjacked: The impact of social media on corporate greenwash. *Journal of Business Ethics, 118*, 747–757. doi:10.1007/s10551-013-1958-x

McKee, H. A., & Porter, J. E. (2009). *The ethics of Internet research: A rhetorical, case-based approach.* New York, NY: Peter Lang.

McKee, H. A., & Porter, J. E. (2015, November 6). *Business professionals and social media missteps: A rhetorical and ethical lens.* International Symposium on Digital Ethics, Loyola University, Chicago, IL.

McKee, H. A., & Porter, J. E. (2017). *Professional communication and network interaction: A rhetorical and ethical approach.* New York, NY: Routledge.

National Labor Relations Board. (n.d.). *The NLRB and social media.* Retrieved from https://www.nlrb.gov/news-outreach/fact-sheets/nlrb-and-social-media

Porter, J. E. (1998). *Rhetorical ethics and internetworked writing.* Greenwich, CT: Ablex.

Porter, J. E. (2004). Why technology matters to writing: A cyberwriter's tale. *Computers & Composition, 20*(4), 375–394.

Porter, J. E. (2017). Professional communication as phatic: From classical *eunoia* to personal AI. *Business & Professional Communication Quarterly, 80*(2), 174–193.

Poulakos, J. (1983). Toward a sophistic definition of rhetoric. *Philosophy & Rhetoric, 16*(1), 35–48.

Pruchnic, J. (2014). *Rhetoric and ethics in the cybernetic age: The transhuman condition.* New York, NY: Routledge.

Quintilian. (2001). *Institutio oratoria* (Donald A. Russell, Trans.). Cambridge, MA: Harvard University Press.

Ray, A. (2012). Three things every employer and employee need to know about social media. *Baylor Business Review, 22*–23.

Ray, A. (2013, April 23). Ethics in social media marketing: Responding to the Boston tragedy. *Social Media Today.* Retrieved from http://www.socialmediatoday.com/content/ethics-social-media-marketing-responding-boston-tragedy

Rickert, T. (2013). *Ambient rhetoric: The attunements of rhetorical being.* Pittsburg, PA: University of Pittsburgh Press.

Ronson, J. (2015a, February 15). How one stupid tweet blew up Justine Sacco's life. *New York Times Magazine*, p. MM20. Retrieved from http://www.nytimes.com/2015/02/15/magazine/how-one-stupid-tweet-ruined-justine-saccos-life.html?r=0

Ronson, J. (2015b). *So you've been publicly shamed.* New York, NY: Riverhead Books.

Smith, J. E. (2002). Time and qualitative time. In Phillip Sipiora & James S. Baumlin (Eds.), *Rhetoric and kairos: Essays in history, theory, and praxis* (pp. 46–57). Albany, NY: SUNY Press.

Stelter, B. (2013). Company parts ways with PR exec after AIDS in Africa tweet. *CNN.* Retrieved from http://www.cnn.com/2013/12/21/us/sacco-offensive-tweet/

Sunbury Textile Mills. (2016). History. Retrieved from http://sunburytextiles.com/about/history

Thomases, H. (2012). McDonald's twitter mess: What went wrong. *Inc.* Retrieved from http://www.inc.com/hollis-thomases/mcdonalds-mcdstories-twitter-mess.html

Thornton, M. (2011, December 21). Absolutely, positively unacceptable. *FedEx.* Retrieved from http://about.van.fedex.com/blog/absolutely-positively-unacceptable/

Toor, S. R., & Ofori, G. (2009). Ethical leadership: Examining the relationships with full range leadership model, employee outcomes, and organizational culture. *Journal of Business Ethics, 90*, 533–547. doi:10.1007/s10551-009-0059-3

Vanacker, B., & Heider, D. (Eds.). (2016). *Ethics for a digital age*. New York, NY: Peter Lang.

Vingiano, A. (2013). This is how one woman's offensive tweet became the world's top story. *BuzzFeed*. Retrieved from http://www.buzzfeed.com/alisonvingiano/this-is-how-a-womans-offensive-tweet-became-the-worlds-top-s#.ajo157z3y

Zuber, F. (2015). Spread of unethical behavior in organizations: A dynamic social network perspective. *Journal of Business Ethics, 131*, 151–172.

Part II: Technology, Ethics, and the Shifting Role of Journalism

Introduction to Part II

JILL GEISLER

Are there immutable principles of journalism ethics? Have some become as obsolete as reel-to-reel tape recorders in the Digital Age? How do technology and tools influence the ethical obligations of digital journalists? With barriers to entry low and the speed, reach, and influence of digital publication high, what are the ethical imperatives of those who consider themselves digital journalists—and how do they envision their own roles and responsibilities? If they view their primary mission as one of influencing readers and users toward a point of view, rather than serving as neutral fact-finders, are they diminishing or enriching traditional journalism ethics? And has the time come for a major reboot of our core beliefs about the ethics of newsgathering, and storytelling?

Those are provocative questions, each of which is examined in this section's chapters.

Kathleen Bartzen Culver's contribution provides a comprehensive overview of the emerging civilian use of Unmanned Aerial Vehicles and Unmanned Aerial Systems along with the U.S. Federal Aviation Administration's (FAA) evolving regulations on nonmilitary usage of drones. The FAA legal primer is an important foundation. It shows us that those tasked with rule-making for the public welfare focus on two key issues: safety and privacy.

Culver looks beyond the basic question of what is legal to identify the ethical challenges inherent in capturing data from an aerial platform that is inexpensive, efficient, remotely operated, and easily intrusive. She interviews 12 individuals (journalism practitioners or advocates) "who are actively involved in exploring use of drones by news media" to learn the ethical values they believe are essential for drone journalism.

She examines the process they use for making ethical decisions related to the tool. She then conducts focus group interviews with 12 citizens for their views on drone ethics. Comparing the responses from the small samples of

journalists and citizens, she finds a gap that's instructive for contemporary conversations about journalistic credibility: Who decides who's a journalist? Beyond FAA regulations, should the public be more involved in newsrooms' ethical decisions about drones? How does profit influence journalistic decision-making? What's the protection against unethical actors?

Chad Painter and Patrick Ferrucci probe how digital journalists define themselves and their roles. Their study uses four role options, as defined by normative theorists: monitorial disseminator (reporting, verifying, sharing), facilitative-mobilizer (promoting dialogue and civic engagement in news production and community issues), collaborative-interpretive (working with the state and community for mutual civic ends and interpreting information to advance understanding), and radical-adversarial (to give voice to those challenging the powerful and provide oppositional voices to mainstream media). The authors interview digital journalists to determine their self-identified roles and then further question how market forces in today's media business environment influence them.

The study's findings are based on interviews with 53 digital journalists from 49 organizations. All published material only on digital platforms, though their employers ranged from "prestigious and traditional outlets to large digitally native organizations to small digitally native news non-profits." Painter and Ferrucci find their digital subjects less involved in the dissemination of "what's happening" types of news in favor of interpretive stories, more likely to eschew objectivity as a core value, and more disposed to community engagement, especially through the use of social media.

The authors conclude that their interviewees' self-descriptions place them primarily in the radical-adversarial role. Because of the sample size and anonymity afforded the interviewees, it is difficult to determine if the apparent universality of this identification can be extrapolated to all digital journalists.

Stephen J. A. Ward is dissatisfied with the current state of journalism ethics. His chapter is a call to action, with a primary focus on digital ubiquity and global reach.

Ward's treatise covers a wide range of change in media, as he points out that digital technology has eliminated traditional news media's role as gatekeeper, that reportorial neutrality can lead to simplistic, unhelpful reporting, and that parochial focus on the journalists' own backyards limits global understanding. Like many in journalism today, he examines objectivity versus transparency: should the latter replace the former? Building on a body of research, his own and others', Ward issues provocative challenges: Don't just focus on the micro: the individual do's and don'ts of journalism practitioners, look at macro concepts of "political morality—issues of power, inequality,

media ownership and diversity, digital divides and how news media cover global issues." That's but one of many stepping stones on Ward's path to his vision of "radical" ethics.

Those already committed to the continuous updating of journalistic codes of ethics (i.e., The Society of Professional Journalists and The Online News Association) will see their efforts in part embraced but also critiqued as insufficient and outdated in this presentation. Ward's chapter is an invitation for a robust debate about a new ethical mindset. Nothing would please him more.

4. Drones in the National Airspace

KATHLEEN BARTZEN CULVER

Introduction

As a battle began to build in North Dakota in 2016, pitting members of North American Indian tribes against a company planning to build a multi-billion dollar oil pipeline, *The Guardian*, an international news organization, covered the protests. It relied in part on a new technology just recently coming into use in journalism but expected to grow in prominence, thanks to recently clarified Federal regulations. Unmanned Aerial Vehicles (UAVs) or Unmanned Aerial Systems (UAS) are commonly known as drones but have been rarely seen in the production of news stories. A *Guardian* video covering the pipeline protest used drone footage shot by a Native American man who had joined the fray (Whitworth, Lafleur-Vetter, & Dedman, 2016). Fifteen seconds into the *Guardian* video, the audience is taken from ground-level shots to a drone's aerial view of the scene, showing protesters and their vehicles dotted alongside a road, as well as the vastness and emptiness of the surrounding North Dakota terrain. This aerial perspective and the sense it gave of the space added both information and context. However, the use of drones to cover the protest was not without controversy. For instance, just two months later, sheriff's officers claimed the drone "came after" them and shot at it with what they termed "less-than-lethal ammunition" (Morton County Sheriff's Department, 2016). This incident signifies impending controversies and ethical questions that will arise as journalism increases its use of this technology. Is the use of drones for reporting legal? Is it ethical? And is it necessary?

This research combines in-depth interviews with news workers experimenting with drones and focus group conversations with citizens to explore the role of drones in newsgathering, identifying the concerns and tensions related to the application of drone technology. Much as that North Dakota

landscape proved to be a battleground for a debate about oil production versus preservation of native lands, the use of drone technology provides terrain for public and professional deliberation over ethical practices in journalism.

Literature Review

Drones

UAVs (UAS) are an easy sell as an important journalistic tool. Because they offer a relatively inexpensive way to accomplish aerial photography and videography, they have clear advantages over the other available option, helicopters. All but removing cost as a barrier to entry, the technology has the potential to dramatically expand the number of news organizations and individual journalists gathering photos and videos aloft. But drones offer capabilities beyond this, such as detecting air quality or reading radiation levels through sensors. They also can be used for sophisticated digital mapping, such as measuring rising or receding water levels to monitor environmental change. Journalists envision drone use in breaking news—fires, weather events, and the like—as well as longer-term or investigative reporting, such as demonstrating changes in air quality surrounding a mining operation. Far from chasing the latest toy, most journalists interested in drones envision their use in serious reporting (Mullin, 2016).

In the United States, journalistic use of drones is just one element in the discussion surrounding civilian operation of UAVs. Perceived almost entirely as a tool solely for the military throughout the first decade of the 21st century, drones became available to civilians when Congress set the Federal Aviation Administration (FAA) on a breakneck pace to knit them into the national airspace through the FAA Modernization and Reform Act of 2012 (Culver, 2014a). Civilian UAVs represent a multibillion dollar industry in the United States, with some estimating revenues approaching $90 billion sometime in the next decade (Teal Group, 2012).

The uses of nonmilitary UAVs fall into three categories (Choi-Fitzpatrick, 2014). First, governmental uses of drones involve law enforcement surveillance, as well as agency uses, such as the National Oceanic and Atmospheric Administration using a UAV to monitor hurricane activity. The second type, corporate uses, deploys drones for such activities as delivering Amazon packages or Walgreens prescriptions or monitoring turf performance on private golf courses. Finally, examples of civil society uses include journalism, as well as activists monitoring police response to protests, conservationists documenting environmental change, or outdoor enthusiasts capturing video of iconic national parks.

The development of applicable laws in the United States has been the purview of both the FAA and individual state legislatures through other statutes, regulations, and common law. These laws, such as those in the arena of privacy, apply to UAVs even though they were not developed specifically in response to this technology. The FAA Modernization and Reform Act of 2012 set that agency on course to complete rules for allowing UAVs in the National Airspace by 2015, a deadline the FAA missed. FAA rules allowed hobbyist uses of small drones under certain conditions, such as staying at a proper distance from nearby airports, but these rules did not apply to "commercial" drone use, which was not allowed without specific authorization. To the discontent of many within the industry, this included journalism.

In June 2016, the FAA announced new rules for commercial use of small drones, meaning anything weighing less than 55 pounds with all gear—such as cameras and sensors—attached (Federal Aviation Administration—, 2016). Known as Part 107, the regulations require FAA pilot certification for all individuals operating drones commercially, including journalists. This certification involves aeronautical knowledge, as well as a background check. Commercial drone operators are allowed to fly only during daytime hours or within 30 minutes of sunrise or sunset and must keep a clear line of sight to their UAVs at all times. Generally, pilots can fly no more than 400 feet in the air at a maximum speed of 100 mph. Importantly, they are not allowed to fly over any person who is not directly participating in the drone operation, or inside any covered structure, effectively barring all indoor flight. (Some attorneys question the FAA's authority to bar indoor flight, as it is not part of the National Airspace.) Finally, preexisting restrictions, such as bans on UAV flight in and around sports stadiums during events, remained in force.

Many news organizations took exception to the FAA's definition of news work as a commercial use, defined by the agency as use of the technology for "business purposes." Filing a friend-of-the-court brief in an appeal of a fine levied against a drone photographer, a coalition of 18 media organizations and associations argued strongly that defining newsgathering as a business purpose does not comport with First Amendment protections.

> In applying agency posture in the guise of regulatory rule, the FAA has never distinguished between "business operations" and the use of UAS technology for the First Amendment-protected purpose of gathering and disseminating news and information. Indeed, just last month, the FAA indicated that a newspaper's Internet posting of photographs provided to it by a non-commercial UAS hobbyist might subject the media company to federal regulatory fines for using a UAS for "business purposes" (*Amici Curiae Brief: FAA v. Pirker*, 2014).

While news media challenged the FAA's definitions, however, a number of organizations also tried to collaborate with the agency to test and promulgate rules more effective for the industry. In 2015, CNN entered into an agreement with the FAA through a program called Pathfinder. Experimenting with drone newsgathering in urban areas, participation by CNN and at least two other non-news organizations was intended to help the FAA conduct research to aid in the development of effective restrictions and guidelines (Waddell, 2015). In the same year, 10 other news organizations partnered with Virginia Tech to test drones for newsgathering after the university was authorized by Congress as a test site to assist the FAA in development of regulations (Mullin, 2015).

Research on the implications of civil society uses of drones is in nascent stages, with much focused on the law (Blitz, Grimsley, Henderson, & Thai, 2015; Dunlap, 2009; Elias, 2012, 2016; Holton, Lawson, & Love, 2015; McBride, 2009; Radler, 2012; Rapp, 2009; Ravich, 2009; Syed & Berry, 2014; Thompson, 2015; Waite, 2014; Walsh, 2012; Wittes, 2012). An early study of ethical reasoning used by developers working to use drones in journalism by this author found privacy, safety, conflict of interest, and perspective as key concerns among subjects, who largely focused on consequentialist thinking. It argues that the concept of "revenge effects"—blowback from the unintended consequences of technological developments—poses risks for news media credibility (Culver, 2014a).

Finn and Wright (2012) also point to concerns about privacy and other civil liberties while correctly noting the disparity of impact on certain groups, including the poor, communities of color, and protesters. Holton et al. (2015) note the privacy implications, as well, but raise a distinct ethical consideration: news workers' responsibility to defend journalism from government overreach. "(I)f news organizations are to preserve their access to a valuable public forum (i.e., the public airspace), then they must do more to resist FAA overreach and to provide safe pathways for their journalists and for private citizens to gather content with UAVs" (Holton et al., 2015, p. 12). Tremayne and Clark (2014) acknowledge the dangers of government overreach, but also highlight concerns about media overreach. Working from stories covering uses of drones, the authors employed an inductive qualitative approach to examine themes common among eight cases of use of UAVs in journalistic contexts and find evidence of surveillance—the few watching the many. But they also point to evidence of sousveillance—observation "from below"—wherein participants in an event record activities, rather than authorities (Tremayne & Clark, 2014). The authors point to ethics, privacy,

and other matters of law as key concerns regardless of whether those in power or those challenging it use UAVs for reporting activities.

Choi-Fitzpatrick (2014) offers a comprehensive attempt to develop a framework for justifiable civil society drone use, including applications in journalism. He proposes six principles:

- subsidiarity: use drones only when outcomes cannot be achieved by less invasive means
- physical and material security: engage in drone use only when safety can be assured
- do no harm: uses must further, not harm, the public good
- public interest: drone use must be in the public interest (not merely for what may be interesting to the public)
- privacy: the public must be protected from surveillance by the state and commercial actors, but also from civil society uses
- data protection: responsible use involves not only the flight of a drone, but also the security of the data collected by it

Each of these principles calls on journalism to move beyond the rights afforded to it by the law and to weigh the responsibilities demanded of it ethically.

Open vs. Closed Ethics

Journalism ethics is a rich and robust field of inquiry and practice. But that field has often been critiqued for being a closed system, meaning that the establishment of ethical principles and codes has largely been an in-house activity practiced by journalists and news organizations. Critics of the development of codes of journalism ethics and broader conceptions of ethical reasoning by news workers see lack of public participation as particularly problematic. "The public" and "the public interest" are repeatedly—and usually passionately—invoked to justify journalism's roles and activities within society. The "public" is so critical to theories of the press that James Carey called the word the "god term of journalism" (Carey, 1987). Yet the public, Glasser and Ettema (2008) argue, is largely left out of important discourse about journalism, arguing ethics codes are seen as the exclusive providence of journalism professionals and serve to insulate them from accountability (Glasser & Ettema, 2008, p. 528).

Ward and Wasserman challenge this exclusion of the public from the development and practice of media ethics. They used the term "closed ethics" to represent an ethics system that, "places substantial limits on meaningful nonmember participation in discussing, critiquing, and changing the

guidelines" (Ward & Wasserman, 2010, p. 277). The authors urge an "open ethics" orientation instead, one that would involve the public in shaping and reshaping news media practices. Yet despite the many affordances for public participation in a digital age, news workers often sense threats to their gatekeeper role and fail to embrace an open, networked model (Singer, 2010) or include the public in deliberations on ethics issues (Culver, 2016).

In laying out a vision for a radical rethinking of media ethics, Ward (2014) rejects this focus on gatekeeping within a closed system that, he says, ultimately threatens news media accountability to the public. Such accountability is critical in a democracy, but critics, including Glasser, find it a richer concept in theory than in practice.

> (J)ournalists have grown accustomed to a remarkably cramped view of ethics, one that insulates and isolates the press from the larger community in ways that render ethics an entirely private matter. Journalists act as though they and they alone ought to be the final arbiters of the morality of their own conduct, an altogether authoritarian understanding of ethics that only adds to the irony of an institution that preaches democracy but operates as an autocracy. (Glasser, 2014, p. 699)

Little scholarly attention has been paid to the public's expectations of who should be the arbiters of press performance and the norms that guide media practice. Exploring public views of journalism in the Netherlands, van der Wurff and Schoenbach demonstrated that citizens have "Civic Demands" of news workers, focusing on their roles as interpreters, critics, and disseminators. These matched closely with the authors' documentation of traditional views of the profession by practitioners. Yet they also found an area in which citizens differed from practitioners' views. Citizen respondents also had "Citizen Demands," which the authors defined as a demand for responsiveness from journalists and news organizations. "Citizen Demands, in contrast, emphasize more strongly the *populist mobilizer* role. They ask for a responsive journalism, attractive news content, and audience participation in the news process" (Van Der Wurff & Schoenbach, 2014).

This research applies this framework of Civic Demands and Citizen Demands to the case of news media use of drone technology to examine differences between practitioners' and citizens' views of the use and ethics of drone technology for journalistic endeavors. It explores questions of open vs. closed systems in the news and the public's expectations and opportunities to participate in news media ethics, both in terms of the development of standards and their application to UAV use. Specifically, it asks: First, how do citizens and practitioners conceptualize journalistic use of drones in reporting

and producing news? Second, how do these conceptualizations reflect both Civic and Citizen Demands? And, finally, what means are available to the public to contest and shape the norms of news media use of drones?

Methods

This study involved in-depth interviews with 12 journalism practitioners or advocates who are actively involved in exploring use of drones by news media. Interview requests were sent to a panel of 98 people who could be identified through news media coverage, interest groups and associations as having an interest in using drones in journalism, meaning that they would have first-hand knowledge and more informed perspectives about drones than a general population of journalists. Of this panel, 12 consented to an interview, two declined, and the rest did not respond to three requests. The respondents included three women and nine men. The 12 respondents had significant experience in a range of journalism fields, including newspapers, local and national television, public radio, and online-only outlets. Three had moved from industry to other journalism-related activities, one as an advocate and two as educators. No discernable difference between the respondents and nonrespondents was identified. Phone interviews using a standardized in-depth interview questionnaire explored the respondents' uses of UAVs, as well as their thoughts about the public interest, ethics in journalism, and accountability.

In addition, four hours of focus group interviews with a total of 12 citizens used a separate standardized interview questionnaire exploring similar themes. The participants (seven men and five women) were a purposive sample recruited through digital advertising and two community organizations. Citizens in the focus groups built upon each other's threads, often reinforcing and rarely disagreeing. The group format may have had some influence on this dynamic. However, the semi-structured questionnaire included prompts to invite others to take response threads in new directions. In almost all cases, these did not bring a change in the direction of responses and the strength with which points were made.

Interview and focus group transcripts were coded and categorized (Lindlof & Taylor, 2011) to examine themes related to drone use, public participation, and open ethics. Employing an inductive approach, analysis began with specific observations of points made by respondents and moved to broader themes that encompass those observations.

Findings

Journalists

A universal thread running through all interviews with the journalists group involved the pragmatics of UAV use in reporting. Every respondent pointed to matters of low costs, speed of use, location access, and improved safety as advantages to the deployment of drones for news relative to alternatives like the use of helicopters. For those with a background in television, video, or photography, all drew parallels between drones and helicopters. With entry costs now below $1,000 to buy and maintain an advanced civilian use drone capable of carrying cameras and other sensors, the devices are clearly preferable to the tens of thousands spent to rent a helicopter or the millions spent for an organization to buy and maintain one. Beyond cost, respondents noted accidents with helicopters are more dangerous than those involving drones, and UAVs can safely hover more closely to a scene than a helicopter and not disturb the surroundings or people involved via blowback from rotors. These pragmatic concerns factored into interview segments on the benefits of UAV reporting, but a few respondents also mentioned them when naming legal and ethical considerations.

Journalists in the interview pool saw drone use directly related to what they framed as their obligation to serve as a check on government and other institutions. Most listed monitoring environmental damage as an important place for watchdog journalism and characterized drones as uniquely useful for sustained monitoring. Three noted using the devices not merely to capture video and still photography, but also equipping them with other sensors to collect data on air quality or water levels. Despite this emphasis on a fourth-estate role to balance the power of government, half of the respondents specifically mentioned cooperation with authorities as important in legal and ethical use of drones. For that group, this generally meant steering clear of hindering responders to any public safety situation, but for one, it meant grounding the drone whenever asked. Another respondent questioned how he would respond if authorities demanded drone footage without a warrant but had not yet resolved that question in his mind.

In terms of the obligation to the truth, respondents saw drones helping, not hindering that cause. The words "accuracy," "context," and "verification" arose repeatedly in references to truth. Neutrality and countering bias also were connected with truth for some respondents. The interviewees pointed to speed, competition, and ego as threats to the pursuit of truth. One respondent said:

Fact-checking and really backing up and making sure that your story is kind of airtight when it comes under scrutiny. And I think sometimes things are moving so fast, be it because of technology or be it because of expectations. That's where the challenge lies. It is really having, you know, a group of people who can provide perspective on an offense or a person or a place but that they have enough time to kind of examine the work that they did and make sure that it's all correct and explores enough angles on it to be fair.

The respondents universally pointed to pursuit of truth as an ethical obligation though some also tied it to consequentialist concerns, such as loss of credibility when stories are inaccurate. The consensus across the interviewees was effectively framed by one respondent:

Accurate representation of the truth about what's actually out there. For me, as a journalist, the key ethical consideration is accurate representation of the truth because if we can't do that, why are we here? What are we doing? I think that, in large part, the purpose of doing journalism, of telling stories, is to tell true stories and tell them fairly and accurately and do justice to the people and the places that were portrayed.

About a third of the respondents raised matters of perspective in their interviews, tying them to the concept of context. They cited aerial views as often critical to storytelling, particularly in the context of natural and man-made disasters. Respondents raised floods, wildfires, house fires, explosions, tornadoes, hurricanes, and massive crashes as examples of stories where airborne perspective would be beneficial. One said, "The ability to tell a story where an overhead wide shot would tell a better story—help people see, get a better perspective, a bird's eye view...just telling a better story with this high-eye perspective. It's a definite benefit of this technology."

However, two respondents followed their praise of perspective with a key concern often raised in conjunction with military uses of drones: detachment. In battle contexts, some critics argue that military personnel controlling drones are freed of the direct experience of the horrors of war because they are detached from the locations—and people therein—where their lethal force is deployed (Ahmad, 2011). These critics claim ethical reasoning is hindered by detachment from outcomes. Though certainly not thinking about the same lethal consequences, these respondents nonetheless see risk in journalistic detachment from the scenes drones capture. For instance, a reporter using a drone to cover a protest may have a strong sense of the size of a crowd but is detached from its fervor or specific content of chants. She would know scope but lack context. She also may feel more free to invade privacy because she is detached from the feeling she is intruding personally. One respondent said, "When you're flying a drone, it's easy to not realize what you're flying

over. The detachment component—you being separated from the camera, the drone. So, to minimize harm, again, pay attention to what's going on and both the positive and the negative that could result in the work that you're doing."

Another raised the issue specifically in arguing privacy is not only a legal concern, but also an ethical one for journalists:

> Because of the privacy concerns, just because there's that level of detachment, we shouldn't feel the power to go places where you yourself would not go, and always ask permission. There's a sense of freedom that comes with flying a drone because of how it can move through space and just because you're flying over somebody's property. It doesn't feel the same as if you're walking across somebody's property.

When journalist respondents were asked about how to resolve some of the ethical concerns they raised, they most often mentioned ad hoc reasoning, their internal moral sense, and their news organizations' or professional associations' ethics codes as resources they would use to help them resolve a conflict. Of his internal moral sense—his ethics "gut"—one respondent said he would rely on his past experiences deciding whether to capture or run a particular photograph. "If you're uncomfortable showing somebody the original photo or if you're uncomfortable telling them how you got there, it's probably a pretty good sign that you shouldn't do it."

Only three of the respondents made any reference to engagement—a growing movement in journalism—as important to their ethical reasoning and actions. This group cited engagement as a key component of media accountability. Often defined as relational, community-centered practices in reporting (Millbourn & DeVigal, 2016), engagement, its adherents argue, results in enduring connections between journalists, news organizations, and communities, building greater trust in news and solidifying journalism's role within a democracy.

The first subject to raise the concept specifically said, "I think it starts first when you go out into the public, and I think you're accountable to them and if you go with a preconceived notion, then you're doing a disservice to the larger public by painting that story before you even get there, and you know what you want to see."

Another summarized her concerns about news media failures on engagement:

> You know, we need to look pretty closely at what we're doing or how we're doing it or both. And I think we need to recognize who the public are that we're serving, what they want, how they're getting it, what's connecting with them,

what's not connecting with them, why it's not connecting with them, and listening to those things. So, I think we ignore the public, and there's not a whole lot left...for us to do.

Overall, journalists emphasized ethics concepts of the pursuit of truth, minimizing harm, accuracy in context, and thoughtful, careful reporting practices. Almost all of them also focused on these within the context of their own circles or organizations, not as connections between themselves and the public, as proponents of engagement would prefer.

Citizen Focus Groups

All focus groups noted positive aspects to the use of UAVs for news reporting. Most commonly, participants supported the idea of journalists getting increased access to hard-to-reach areas during wildfires or other natural disasters. They saw value in such reporting and connected it to journalism's obligation to serve the public interest.

Participants repeatedly and specifically suggested that drones in journalism must be used to further reporters' search for truth. However, they cautioned against bias, and expressed concern that drones, like any other tool, could be deployed in service of a slanted media agenda. One participant said: "I think that journalism should be neutral on the political scale, and...if journalism tries to pull its readers in one direction or the other, it should try to pull them towards the middle, as opposed to reflecting the community." Multiple participants also suggested drones could increase faulty assumptions journalists make—a problem they argued is already too common—because reporters could document people visiting a location but have no idea why a person was there. This thread appeared to be connected to these participants' feelings about drones used in military contexts, as the example given focused on guilt by association and noncombatants dying in drone strikes of supposed terrorist targets.

Despite participants' general support for use of drones in journalism when focused on unbiased pursuit of truth, the single most dominant theme among all participants was fear. First, many expressed fears that news media UAV use would interfere with public safety, by getting in the way of firefighting crews or by disrupting the flight path of an airplane, for example. In these situations, they expected complete deference to authorities. If a firefighter told a news crew to ground a drone, these participants expected it to be immediately grounded.

Another point of fear expressed involved media saturation. This was directly related to nonmedia drone use. Because focus groups occurred in

autumn—before the holiday season—participants seemed primed to recognize that drones were expected to be a hot gift item. They expected a proliferation of the devices and feared what that would mean for safety. One said, "How would you control that? Say, if there was there was an emergency and you had a journalist there from every television station, every newspaper. How are you going to avoid all these drones from bumping into each other? I could see one person at one event, but how can you control 20 different organizations looking at one battlefield or something?"

In the face of these fears and other concerns, the participants had two initial expectations of journalists and news organizations: restraint and respect. On the theme of restraint, the participants suggested that news organizations should use drones only when no other means were possible to effectively cover a story. However, some expressed doubt that they would see such holding back on the use of a new and dazzling technology. Building off this, participants questioned each other on the level of respect journalists might have for the public or, more specifically, their sources and people swept up into news events. One participants said, "I would hope the word 'respect' would be used by journalists," leading others in her group to respond with expressions of doubt.

The focus groups were unanimous in pointing to what they see as declining standards and practices in journalism. The groups tended to skew older, possibly contributing to feelings that the "good old days" featured more attention to important news and better respect between news organizations and the publics they serve. For instance, one participant said, "Being older, I remember investigative reporting" while another added, "I think it's because we've been around long enough to see what it was compared to what it is."

These groups were similarly united in identifying a prime suspect for the cause of this perceived slippage in news media ethics and service to public interests: profit. The theme came up consistently and repeatedly, with one focus group raising it seven discrete times in a 90-minute conversation. Groups saw profit influencing "how they select which stories to put out there...not by what's really important for people to know." They blamed profit motives for a perceived loss in investigative reporting. They cited it as the reason news is both increasingly biased (ideologically oriented audiences are more loyal and thus a better way to make money) and timid ("If you go after [a controversial story], you'll lose some readers" and "You'll lose the advertisers."). And they said focus on profit hinders any news organization being open and accountable to the public, with two participants responding, "They are accountable to the people who sign their paycheck" and "Yes, and accountable to the people who buy their advertising."

Moving into the specific question of drones in reporting, focus groups still connected use of the technology to news organizations' interest in making money, as well as the competitive nature of the business. After a lengthy discussion in one session, a participant said,

> What purpose would a newspaper have, for example, for wanting to get closer to a flood or get closer to a gas eruption or whatever? What is the purpose? I understand one of the purposes is to be the first and the most sensational and to sell papers. But is there a greater purpose than that? Because I honestly cannot think of one.

Finally, the focus groups drew a strong line between their sense of profit as a primary motive and their view of a news organization's credibility. This applied to reporting and publishing overall, as well as to use of technologies such as UAVs. Two participants, in particular, focused on one news outlet in the state and its purchase by a national chain. They said this damaged the outlet's credibility because the chain would be serving shareholders, not the public, and drone footage would be captured and used to further that service, not to further the interests of their community or the state.

Overall, the citizens clearly valued journalism and privileged truth, courage in reporting, independence, and serving public interests. However, they were equally clear in their critiques of press practices and performance, citing a drive toward profits and a lack of respect and restraint as key concerns. These assessments applied not only to news organizations broadly, but also to the use of UAVs in reporting.

Shared Concerns

The citizen focus group participants and journalist interviewees decidedly had shared concerns about facets of drone use in news reporting, but the two groups diverged—at times markedly—on how they framed and interpreted those concerns. Matters of journalistic judgment, privacy, bad actors, incrementalism, and credibility loomed large between the two groups.

The first area of interest that arose was a disconnection regarding commonly held news values and how members of the public view those as they play out in publications and broadcasts. Journalists consistently argued that, in the main, news organizations use journalistic judgment to cover important issues and events while focus group participants often (at times cynically) responded that profit motives and sensationalism drive story selection and framing. For instance, while the reporters who mentioned aerial perspectives saw these as an essential use of this new technology, citizens questioned why this would be necessary at all. One said, "I think there's a natural tendency in

the journalism profession to push—you know, 'we're going to get as close as we possibly can'...but I would err in the favor of public safety...is that scene on TV that much greater?" Those citizens who raised news judgment as an issue said drones should be used only when they are a *necessity*, not merely to improve a story that could be told through other kinds of reporting.

Both groups repeatedly raised the concept of bad actors and did so in two ways. First, they were concerned about amateurs, particularly youths, getting access to civilian drones. They saw these untrained fliers causing a range of problems, from interfering with first responders to invading privacy. Both groups believed journalists would not be using drones without proper training and found comfort in that belief. One citizen participant, a minister, noted that it is increasingly difficult for the public to understand who is a responsible journalist, yet the law protects reporters regardless of any "official" credential. He used his experience as a faith leader to illustrate:

> One of the [wonders] of the First Amendment, is, unlike doctors—I have a friend who's a doctor, and we're sort of twins and we tease each other [that] he can come preach here some Sunday, and I'll go do surgery on Wednesday. I wouldn't get away with that. But anybody can be a journalist in the breadth of the First Amendment. Whether it's the [local newspaper] or [a civilian blog], we're all protected by the First Amendment. But not everyone adopts the same standards of ethics.'

Second, citizens and journalists believed communities would see a small but potent set of willful bad actors—people purposefully using drones unethically, most often for personal financial gain. The default assumption was that paparazzi would use drones to surveil celebrities and sell salacious and sensational images and video. Both groups expressed clear concerns that these willful bad actors would have virtually no ethics when using UAVs. One former journalist said:

> The downside of it for the public is, there are going to be people that do stupid things. They're going to fly them too low. They're going to fly them too fast. They're going to crash into people. They're going to crash into things. They're going to hurt people—the same thing that happens with cars. It's unfortunate, but it happens.

Both groups grasped the myriad safety concerns involved in drone use, from malfunctions causing injury to interference with emergency responders. But these were almost always framed in terms of legal restrictions, rather than ethical implications. References to liability and insurance were consistent. Both groups seemed equally sure that news organizations and trained journalists would minimize safety risks and carry appropriate insurance to deal with unexpected outcomes.

Both groups similarly trusted "responsible" outlets and reporters to deal with the issue of accidental capture—when a justifiable use of a drone for reporting inadvertently caught other activities a journalist did not intend. For example, one citizen questioned if a reporter were using a drone to cover a wildfire and accidentally caught a person growing marijuana illegally, should the latter be a story? Universal response in his focus group was that it should not be a story. Although subjects did not frame this feeling in these specific words, they were articulating a belief that reporters should have a particularized interest in a subject, deploy the drone to answer questions related to that interest, and discard all data that is irrelevant to that interest (Culver, 2014b). One citizen, however, felt that accidental capture remained an ethical concern even when it did not result in publication:

> Now going back to journalism, they're going over to see a traffic accident and you have a domestic dispute over here that you just so happen to catch as you're flying by. You know, is that something? Or I mean a domestic dispute is an ugly situation (potentially valid news). There's a sexual act being performed there between you and your wife, and they catch it. Now obviously, they probably won't publish it, but I still don't want reporters looking at it.

Far beyond all other concerns, every focus group participant and every journalist interviewee raised privacy as the key issue when news workers are considering using drones. In every instance, discussion of privacy first involved questions of law. Framing of "reasonable expectation of privacy" and property-bound privacy dominated conversations. The legal focus was clear through references to lawsuits and repeated use of the terms "legal" and "illegal." However, privacy in an ethical context was raised in all focus group conversations, yet only by two journalist interviewees. One was directly in line with citizen participants in saying:

> I think the privacy thing goes a lot towards ethics because, you know, there are a lot of things that we are legally allowed to do that we do not do because it's not an ethical thing to do. And I think privacy is another big piece of that. So, realizing again where those legal lines are but also sort of developing some ethical guidelines for the use of these new tools.

In response to all these shared concerns, the journalists and citizens markedly diverged when it came to what should be done to resolve ethical conflicts.

For journalists, the default response began with transparency. For these news workers, communicating *to* the public about drone practices was both necessary and sufficient. One summarized it neatly:

Ethically I guess I think about helping people understand the world around them by presenting facts and context in a way that answers questions and doesn't distort things, doesn't bend the truth, doesn't leave out important parts, doesn't try to hide parts of an issue or whatever. You know, if it's relevant, if it's trying to tell the story we're trying to tell, then I think it's important to present. And I think doing that in a way that is honest about how we did it, how we collected the information, how we analyzed the information, how we presented the information.

Focus groups, however, found transparency necessary but insufficient. They wanted news workers to have communication *with* the public. They sought processes external to news organizations that involved citizens in conversations about when and how drones should be used and what means people have to hold journalists accountable. These accountability demands certainly involved cases when drone journalism goes wrong, such as an accident. But the demands also were more nuanced. Citizens wanted to have the opportunity to shape policies that guide both information gathering and publication decisions. Some focus group participants were far more adamant in these points than others, but including people outside the newsroom in shaping policies for drone use met with no disagreement in the panels. One participant said, "They're going to be doing the same things that they do now, only they're going to be zeroing in a little bit closer... There should be judgment by someone outside the newspaper to decide if this is OK or not."

All but one of the journalists, however, pointed purely to internal processes as the key means to develop, implement, review, and change guidelines and practices in drone journalism. One participant's response is illustrative of the group's responses overall:

Let me preface this by saying that a good news organization has a series of checks and balances at several levels before content is shared with viewers or readers. I would expect a photographer to shoot anything they could out in the field, and editors and producers would make decisions about what is shown, based on the station's guidelines and their philosophies.

One journalist lamented news organizations' closed approach to ethics and suggested this contributed to a lack of trust in journalism:

Within journalism, there was a real move—starting in the '70s—of developing codes of ethics in individual news organizations. And before that, a few places may have had them and professional journalism societies might have something resembling an ethics code, but individual news organizations didn't. So there's been a real lot of struggle...over the last generation to try to develop codes of ethics, be we don't tell anybody that they're there. We keep them a secret. It's our little secret inside.

That inside secret, some interviews showed, involved a sense of paternal-ism—a notion that news organizations know what's best and need to tell the public about that but not involve the public in it. These assumptions never appeared negatively motivated. No interviewee made any reference to pur-posefully locking the public out. To most, it was a simple assumption that professional journalists know better.

> I think that there's going to be a period where journalists are going to have to work to educate their readership—and the public at-large as much as possi-ble—that drones are not things to be feared, that they are tools to help journal-ists do their jobs, and they're a positive development in the onward march of technology.

Both groups in general expressed a belief that drones will be incorporated in reporting practice, demonstrating a sense of the inevitability of technology's march. They saw this incorporation happening incrementally, with pushes and pulls between uses, law, and ethics. None expressed a belief that drones brought something radical to news, instead seeing the devices as yet another tool—albeit one with unprecedented potential to invade privacy. One citi-zen focus group participant was fatalistic about this incrementalism: "I don't know whether any of these rules—or the most important ones—can be final-ized until there are one or more deaths by drone. And I don't want to be one of those examples." Another was more sanguine, comparing UAVs to other advances:

> We seem to do these things, sort of tackle kind of a problem at a time after—first, where do they fly, and then what do they do, and who can do it? You almost have to get in there and sink and swim and use case law and whatever else to do it. I don't know that we should fear the outcome being worse than other outcomes we've had with the introduction of technology.

Journalists were more optimistic in their incrementalism, while recognizing adverse effects. One spoke of using a drone to capture a landscape that a fatally ill patient was no longer able to see. "That's the kind of thing I think drones can do that people aren't ready to think about and embrace yet," he said. "It's simple storytelling. It's nothing fancy, but good storytelling always wins."

Revenge Effects

As discussed earlier, the citizens did see potential for adverse impact on news media credibility if drones are used unethically or illegally. An issue in this author's earlier study of drone developers, this outcome can be usefully

framed through a technology studies concept known as "revenge effects" (Culver, 2014a). These effects are the unintended—and negative—consequences that can arise when a technology is deployed to address a problem. For instance, interceptor missiles are designed to prevent impact of a missile on a population or other target. But if the interceptor blows apart the missile and itself, impact and damage can actually increase if the shrapnel disperses over a wider area. With uses of drone technology in journalism, the potential revenge effects are damage to relationships with the public and resulting loss of trust and credibility.

Journalist respondents, while not naming the concept, repeatedly expressed wariness of these effects. One related revenge effects to broader concerns about drones among the public:

> One big risk is that I think people need to be cognizant of is, you know, keeping the public informed of what we're doing and why we're doing it. I mean there's a lot of concern about drones right now, and there's certainly ways that journalism could be using these tools that could enflame those concerns.

Another noted that failing to use drones responsibly now invites blowback down the road:

> Personally, I really like what I do, and I don't want to jeopardize my ability to fly drones in the future just because I'm impatient now.

A third respondent said larger conversations about ethics and the impact of technology often include concerns about consequences and public reaction. He said project planning includes thoughts about how people will react:

> So, I feel like, with me and the people that I talk to on a regular basis, these kind of ethical questions and what are the pros and cons, they come up because... I think we all care about technology and we want it to advance and we want it to be accepted. And we don't want to piss off people. We want people to be impressed. We want people to—whether it's entertainment or whether we have something higher that we're trying to achieve to inform people—we want there to be value in this work, and we don't want to step on people's toes. We don't want to make people mad, so yeah, we talk about these things. These considerations are baked into the project from the very beginning for those reasons.

Another saw revenge effects in legal terms, arguing that bad actors now can result in bad law later, hindering newsgathering with drones for all:

> I have worked in those (breaking news) environments, and I think that's where it's going to get pretty messy pretty quick as, you know, people want to respond to an event right away, a breaking news event, and that's probably where we're

going to see the most legal decisions being made that will kind of affect things for the rest of us.

Finally, a respondent tied revenge effects to fear of technology and concerns about privacy. Misuse of drones could increase fear, he said, making journalists' jobs more difficult:

> In terms of hindering the public interest, I think that, at times, there's a deep level of fear of letting things like drones or video cameras—or journalists in general—into the lives of private citizens, and sometimes fear on the part of public figures. And so, if we get something wrong with a drone, that fear could increase. That, I think, would hamper our ability to continue to have access. I think people also are very worried about privacy in this country, and I think letting drones fly over wide-open spaces touches on such on some of those concerns. But I think the more people fear access to private spaces, the harder it gets for journalists to do their jobs, particularly in very important situations.

Discussion

The divergence between citizen focus group participants and journalist interviewees in this study involves the divide between Civic Demands and Citizen Demands apparent in van der Wurff and Schoenbach's (2014) examination in the Netherlands. Drones make a useful case to demonstrate that these two strands are apparent not just in the general expectations of news organizations and journalists, but also in the use of emerging technologies to expand journalism practice.

The citizens and journalists had similar views on Civic Demands, that news should involve dissemination of truth, interpretation of key issues, and checks on institutional power. Responses that emphasized obligations to truth and to neutrality aligned with Civic Demands and reinforced the necessity of journalism in a functional democracy. However, focus group respondents saw pursuit of profit as damaging to Civic Demands and causing a diminution in the quality, quantity, and credibility of mainstream news in the United States, regardless of medium.

The true divergence between the groups, however, came in the arena of Citizen Demands. Focus group participants want participation in the news process when it comes to emerging technologies such as drones. They see external checks as important to responsible reporting and journalism in the public interest. Journalist interviewees instead emphasized internal, "walled-garden" approaches, drawing on ethics codes, ad hoc reasoning, and consultation with other news workers to forge an ethical path forward

through the concerns drones will raise. They pointed to transparency as a key element of this path, yet citizens did not view transparency as similarly sufficient.

While this study demonstrates this divergence in the specific case of UAVs, it replicates van der Wurff and Schoenbach's findings in a U.S. context and demonstrates that differing expectations among citizens and journalists should lead to a richer and more critical approach to internally focused consideration of journalism ethics. When news organizations and news workers leave citizens out of the development and contesting of norms and practices in journalism, they appear to do so in contravention of the expectations—the demands—of some citizens. To the extent this drives misperception of such things as the influence of profit motives and damages citizen trust in news, they may also do so at their own peril.

Conclusion

This study sought to understand how news workers and individual citizens frame ethical considerations in the case of news media use of UAVs in reporting. It benefits from an in-depth qualitative approach, employing interview and focus group methods, but sample size is limited. Future research employing a broader survey of public opinion or larger case studies within organizations may augment the findings discussed here.

Journalists and members of the public recognize the potential benefits of drone use in news, from pragmatic matters of cost and access to larger issues of better representing scenes and events in pursuit of truth. They also recognize critical risks, including threats to safety, privacy, and news media credibility itself. While demonstrating a hopeful sense of responsible use of the technology in journalism, most studied here expressed a resignation to an incremental and bumpy road as journalism and the public figure out how drones can be incorporated into news practices. And they demonstrated clear differences in who should have a say in how that road is navigated.

References

Ahmad, M. I. (2011, June 28). The Virtue-less War of the "Nintendo Bomber." *AlJazeera.net*. Retrieved from http://www.aljazeera.com/indepth/opinion/2011/06/201162682825424222.html

Blitz, M. J., Grimsley, J., Henderson, S. E., & Thai, J. (2015). Regulating drones under the First and Fourth Amendments. *William & Mary Law Review, 57*, 49–142.

Brief for Advance Publications, Inc. et al. as Amici Curiae Supporting Respondent, Raphael Pirker, National Transportation Safety Board Docket N. CP-217 (2014).

Carey, J. W. (1987). The press and the public discourse. *Center Magazine, 20*(2), 4–16.

Choi-Fitzpatrick, A. (2014). Drones for good: Technological innovations, social movements, and the state. *Journal of International Affairs, 68*(1), 19–36.

Culver, K. B. (2014a). From battlefield to newsroom: Ethical implications of drone technology in journalism. *Journal of Mass Media Ethics, 29*(1), 52–64.

Culver, K. B. (2014b). Rights, ownership, ethics and sensors in journalism. In F. Pitt (Ed.), *Sensors and journalism* (pp. 144–151). New York, NY: Tow Center for Digital Journalism.

Culver, K. B. (2016). Disengaged ethics: Code development and journalism's relationship with "the public." *Journalism Practice, 11*(4), 1–16.

Dunlap, T. (2009). We've got our eyes on you: When surveillance by unmanned aircraft systems constitutes a fourth amendment search. *Southern Texas Law Review, 51*, 173–204.

Elias, B. (2012). *Pilotless drones: Background and considerations for congress regarding unmanned aircraft operations in the national airspace system.* Washington, DC: Congressional Research Service.

Elias, B. (2016). *Unmanned aircraft operations in domestic airspace: U.S. Policy perspectives and the regulatory landscape.* Washington, DC: Congressional Research Service.

Federal Aviation Administration. (2016). *Fact Sheet—Small Unmanned Aircraft Regulations (Part 107).* Retrieved from https://www.faa.gov/news/fact_sheets/news_story.cfm?newsId=20516.

Finn, R. L., & Wright, D. (2012). Unmanned aircraft systems: Surveillance, ethics and privacy in civil applications. *Computer Law & Security Review, 28*(2), 184–194.

Glasser, T. L. (2014). The privatization of press ethics. *Journalism Studies, 15*(6), 699–703.

Glasser, T. L., & Ettema, J. S. (2008). Ethics and eloquence in journalism. *Journalism Studies, 9*(4), 512–534.

Holton, A. E., Lawson, S., & Love, C. (2015). Unmanned aerial vehicles: Opportunities, barriers, and the future of "drone journalism". *Journalism Practice, 9*(5), 634–650.

Lindlof, T. R., & Taylor, B. C. (2011). *Qualitative communication research methods* (3rd ed.). Thousand Oaks, CA: Sage.

McBride, P. (2009). Beyond Orwell: The application of unmanned aircraft systems in domestic surveillance operations. *Journal of Air Law & Commerce, 74*, 627.

Millbourn, T., & DeVigal, A. (2016, October 31). 5 Lessons Learned in Community Engagement in Oregon. *MediaShift.* Retrieved from http://mediashift.org/2016/10/community-engagement-5-lessons-learned/

Morton County Sheriff's Department. (2016). *Drone operator attacks helicopter using unmanned aircraft.* Mandan, ND. Retrieved from http://www.ndresponse.gov/dakota-access-pipeline/press-releases/drone-operator-attacks-helicopter-using-unmanned-aircraft

Mullin, B. (2015). 10 News Organizations Form Drone Coalition. *Poynter.* Retrieved from https://www.poynter.org/2015/10-news-orgs-form-news-drone-coalition/312769/

Mullin, B. (2016). Why 2016 could be a breakout year for drone journalism. *Poynter.* Retrieved from http://www.poynter.org/2016/why-2016-could-be-a-breakout-year-for-drone-journalism/390386/

Radler, M. (2012). Privacy is the problem: United States v. Maynard and a case for a new regulatory model for police surveillance. *George Washington Law Review, 80,* 1209–1254.

Rapp, G. (2009). Unmanned aerial exposure: Civil liability concerns arising from domestic law enforcement employment of unmanned aerial systems. *North Dakota Law Review, 85,* 623–648.

Ravich, T. (2009). The integration of unmanned aerial vehicles into the National Airspace. *North Dakota Law Review, 85,* 597–622.

Singer, J. B. (2010). Norms and the network: Journalistic ethics in a shared media space. In C. Meyers (Ed.), *Journalism ethics: A philosophical approach* (pp. 117–129). Oxford: Oxford University Press.

Syed, N., & Berry, M. (2014). JournoDrones: A flight over the legal landscape. *Communications Lawyer, 30*(3). Retrieved from http://www.lskslaw.com/documents/CL_Jun14_v30n4_SyedBerry.pdf

Teal Group. (2012). *Teal Group Predicts Worldwide UAV Market Will Total $89 Billion in Its 2012 UAV Market Profile and Forecast.* Retrieved from http://tealgroup.com/index.php/about-teal-group-corporation/press-releases/66-teal-group-predicts-worldwide-uav-market-will-total-89-billion-in-its-2012-uav-market-profile-and-forecast

Thompson, R. M. (2015). *Domestic drones and privacy: A primer.* Washington, DC: Congressional Research Service.

Tremayne, M., & Clark, A. (2014). New perspectives from the sky: Unmanned aerial vehicles and journalism. *Digital journalism, 2*(2), 232–246.

Van der Wurff, R., & Schoenbach, K. (2014). Civic and citizen demands of news media and journalists: What does the audience expect from good journalism? *Journalism & Mass Communication Quarterly, 91*(3), 433–451.

Waddell, K. (2015, May 6). CNN and FAA team up to test drones. *The Atlantic.* Retrieved from https://www.theatlantic.com/politics/archive/2015/05/cnn-and-faa-team-up-to-test-drones/458520/

Waite, M. (2014). Journalism with flying robots. *Xrds, 20*(3), 28–31.

Walsh, C. (2012). Surveillance technology and the loss of something a lot like privacy: An examination of the mosaic theory and the limits of the Fourth Amendment. *St. Thomas Law Review, 24,* 169–247.

Ward, S. J. A. (2014). Radical media ethics. *Digital Journalism, 2*(4), 455–471.

Ward, S. J. A., & Wasserman, H. (2010). Towards an open ethics: Implications of new media platforms for global ethics discourse. *Journal of Mass Media Ethics, 25*(4), 275–292.

Whitworth, C., Lafleur-Vetter, S., & Dedman, D. (2016). *"We're not going home": Inside the North Dakota oil pipeline protest.* Retrieved from https://www.theguardian.com/us-news/video/2016/aug/29/north-dakota-oil-access-pipeline-protest-video

Wittes, B. (2012, September 20). Smacked Down by the FAA! *Lawfare.* Retrieved from http://www.lawfareblog.com/2012/09/smacked-down-by-the-faa/

5. Normative Journalistic Roles in the Digital Age

CHAD PAINTER AND PATRICK FERRUCCI

Introduction

Baseball is an unfair game. Big-market teams such as the New York Yankees and Los Angeles Dodgers have a competitive, monetary advantage against small-market teams such as the Minnesota Twins and Cincinnati Reds. One team, the Oakland A's, decided to play a slightly different game; the team sought out and exploited market inefficiencies to find talented but relatively cheap players in order to field a competitive roster on a limited budget. Chronicled by Michael Lewis in his 2003 book *Moneyball*, the A's, under general manager Billy Beane, reached the playoffs four consecutive years from 2000 to 2003.

Digital journalists, likewise, have a competitive disadvantage against their legacy counterparts. For the purpose of this study, digital journalists are defined as those who publish online only, although these journalists might work for a digitally native news organization or a legacy media organization that publishes across platforms. In the analogy, digital journalists are like the Twins or Reds, while legacy media such as *The Los Angeles Times* are like the Dodgers. A journalist at *MinnPost*, for example, does not necessarily have the sources, monetary resources, or established institutional reputation that a reporter from *The New York Times* enjoys. However, digital journalists might be playing "moneyball" by finding and exploiting those market inefficiencies that enable them to compete journalistically.

The purpose of this study is to explore how journalists conceptualize normative role in the digital age. Normative theorists argue there are four distinct but overlapping media roles: monitorial-disseminator, facilitative-mobilizer, collaborative-interpretive, and radical-adversarial. Shifts in the

media landscape might have created changing ideas about normative roles. For example, Kelly McBride and Tom Rosenstiel (2013) argue for a new approach to ethics codes based on truth, transparency, and community. The Online News Association created an interactive "Build Your Own Ethics Code" that

> addresses the intense interest and concern in the digital journalism community around the growing ethical issues unique to social media, technology and the viral nature and speed of breaking news (2016, p. 1).

Changes in news production and consumption also have influenced ideas of role conceptualization. Media organizations from Gawker to *The New York Times* used a "big board" to monitor story trends and traction with audiences (Mullin, 2015). Buzzfeed attracted audiences with its ever-popular listcicles, and then kept them with hard-hitting investigative journalism (Mullin, 2016). The race to be "first" at times meant getting the story wrong, such as when NPR, CNN, and Fox News all incorrectly reported that the U.S. Supreme Court struck down the Affordable Care Act in 2012. Facebook feeds are littered with posts denouncing the media for not covering stories that, in fact, were covered by news organizations but not extensively shared via social media (Kelly, 2015). Each of these examples could point toward an evolving understand of media role conceptualizations, away from obligations to truth, loyalties to citizens, verifying information, and opening a real public debate (Kovach & Rosenstiel, 2007).

Literature Review

Digital Journalism

Major economic and technological transformations have influenced how journalists do their jobs and how audiences receive news (Briggs & Burke, 2009; Lowrey & Gade, 2011). While most studies of journalism define digital journalists as professionals at media organizations that publish across media (Knight, Geuze, & Gerlis, 2008; Singer, 2003), the sheer amount of digitally native news organizations operating today has led to a distinction between journalists publishing across media and those only publishing on the Internet (Ferrucci & Vos, 2017; Kaye & Quinn, 2010).

The news industry first embraced the digital world in 1980 when Knight Ridder launched "Viewtron," which examined ways the company could send news to subscribers through electronic means (Kaye & Quinn, 2010). In 1994, the *San Jose Mercury News* became the first large-circulation newspaper to launch a daily electronic version (Kaye & Quinn, 2010). Media General

spent more than $40 million combining *The Tampa Tribune* with an NBC affiliate in the early 2000s (Colon, 2000). Other newsrooms adapted to the digital world at their own pace (Lawson-Borders, 2003; Singer, 2004). Newsroom convergence, or the combining of technologies from previously discrete media such as print or broadcast, became the most popular buzzword in the journalism industry starting in the 1990s (Dailey, Demo, & Spillman, 2005; Singer, 2011). Converged media is attractive because it combines the familiar (text and pictures similar to newspapers and magazines, audio similar to radio, video similar to TV) with the new (the capacity for feedback) (Selnow, 2000). In recent years, the adoption of technology has led to "backpack journalists" or "MoJos." Both terms describe journalists working in the field while carrying all of the tools necessary to file multimedia stories away from the newsroom (Lowrey & Latta, 2008; Singer, 2011). These changes ushered in the era of digital journalism (Boczkowski, 2005).

Still, the transition from legacy to multimedia newsrooms has not gone smoothly (Klinenberg, 2005). First, news consumers, as well as print and broadcast journalists themselves, do not find journalists who only publish via the Internet as credible as print and broadcast journalists (Bradley, 2014; Cassidy, 2007; McBride & Rosenstiel, 2013; Mitchell, Gottfried, Kiley, & Matsa, 2014). Second, the effects from the evolution of digital news, such as a decrease in investigative journalism and an increase in less "pure news" such as blogs or social-media-driven snippets, could be considered mostly negative (Perigoe, 2009).

Role of the Media

There are long-standing debates about the role, or more accurately roles, of the media. For example, Walter Lippmann (1922) saw the press as a powerful agent that could manufacture consent while John Dewey (1954) saw communication and the press as necessary tools for improving democracy through better-informed policy outcomes. These philosophically informed polls of the role of the media bracket current thinking about the four primary roles of the press: monitorial-disseminator, facilitative-mobilizer, collaborative-interpretive, and radical-adversarial.

The monitorial role encompasses an organized scanning, evaluation, and interpretation of people, conditions, events, and relevant information (Christians, Glasser, McQuail, Nordenstreng, & White, 2009). The monitorial role also has been conceptualized as a disseminator role, which revolves around determining truth from fiction and then distributing the facts to the public (Weaver, Beam, Brownlee, Voakes, & Wilhoit, 2007; Weaver & Wilhoit,

1991, 1996). The disseminator role is very similar to the monitorial role in that it revolves around gathering information about people in power and retransmitting it.

The central aims of media performing the radical role are to provide press access to protest groups, to provide that access on that protest group's terms, and to invert the power hierarchy of access by developing media spaces where activists and ordinary people can present accounts of their experiences and struggles (Armstrong, 1981; Atton, 2002; Atton & Hamilton, 2008; Christians et al., 2009; Kessler, 1984; McMillian, 2011). Radical media also serve as an alternative source of news (Armstrong, 1981; McMillian, 2011), as well as an oppositional voice to the mainstream media (Atton, 2002). The ultimate goal of radical media is the transformation of roles, responsibilities, ideals, and standards—both in terms of journalism and to the society at large (Atton, 2002). For the purposes of this study, the radical role is nearly synonymous with the adversarial role, which refers to being skeptical adversaries to government and business news sources (Weaver et al., 2007; Weaver & Wilhoit, 1991, 1996).

The collaborative role implies a partnership built on a mutual trust and shared commitment between the media and the state to mutually agreeable means and ends (Christians et al., 2009). The media and the state often work together on matters of public safety (Christians et al., 2009). For example, the state might ask a news organization to withhold or release certain information such as the description of a robbery suspect. Inversely, the government does not want certain news, national security information for example, to be made public. The collaborative role is similar to the conceptualization of the interpretive role (Weaver et al., 2007; Weaver & Wilhoit, 1991, 1996) because, in each, journalists do not only disseminate facts and information but also analyze and interpret those facts so that audiences can better understand the impact.

In the facilitative role, media seek to promote dialogue among readers through communication that engages them and in which they actively participate (Christians et al., 2009; The Commission on the Freedom of the Press, 1947). Journalism, then, serves as a community-building forum by encouraging dialogue in neighborhoods, churches, and other institutions and organizations outside of the state and the market (Christians et al., 2009; Dewey, 1954). The facilitative role is similar to the mobilizer role, which revolves around incorporating regular people into news production and agenda-setting function, because both encourage utilizing the audience in newsgathering processes (Weaver et al., 2007; Weaver & Wilhoit, 1991, 1996).

Research Question

The purpose of this study is to explore how digital journalists conceptualize the normative roles they perform. Media ethicists for decades have debated role performance, and current thought centers on the four distinct but overlapping media roles discussed previously. Changes in news gathering, production, dissemination, and consumption, however, might have led to changing conceptualizations about normative roles, especially among digital journalists. So, the researchers sought to further the understanding of the following research question:

RQ1: How do digital journalists conceptualize the roles they perform?

Methodology

The second author conducted 53 semi-structured interviews with digital journalists between May and August 2015. All interviewees were required to work as digital journalists only, meaning they could not publish material on anything other than a digital platform in their full-time position. The 53 interviewees represented 49 different organizations, everything from prestigious and traditional outlets to large digitally native organizations to small digitally native news nonprofits. The interviewees' experience in journalism ranged from six months to 34 years. The average interview length was 43.5 minutes. All interviewees were promised anonymity and confidentiality. The audio interviews were recorded and transcribed for analysis.

The interviews were part of a larger project examining digital journalism. The second author prepared a long, multipart questionnaire with sections concerning technology, economics, identity, role, and other key issues in digital journalism studies. Each of these sections of questions was prepared with a theoretical framework in mind, as is common in qualitative research (i.e., Creswell & Clark, 2007; Pope, Ziebland, & Mays, 2000). For this study, all data concerning role and economics were analyzed.

The researcher used a semi-structured interview approach, which allowed him to strike a balance between gathering detailed, first-person accounts and ensuring that the concepts organizing this study were addressed by each interviewee. Semi-structured interviews provide researchers with a wealth of details that help to illustrate and uncover complicated processes, patterns, and behaviors (McCracken, 1988; Miles & Huberman, 1994). Interviews were loosely structured around topics, not questions, such that each conversation started and ended wherever necessary to get the richest, most useful information. Conducting interviews also allowed the researchers to dig deeper by

including more specificity during the course of long encounters (Fontana & Prokos, 2007; McCracken, 1988).

Findings

This study's research question asked as to how digital journalists conceive their roles. Through the interviews conducted, three clear roles emerged. Two of the roles discussed by the journalists, the radical-adversarial role and the collaborative-interpreter role, are traditional. But the journalists also discussed a mobilizing marketer role, which, it will be argued, is new and germane to digital journalism. Before these roles are discussed, however, it is important to acknowledge the journalists' almost universal discarding of the monitorial-disseminator role.

Monitorial-Disseminator Role

Of the 53 journalists interviewed for this study, 51 of them explicitly mentioned how, as digital journalists, they no longer subscribe to the traditional monitorial-disseminator role. Most of the interviewees explained that because of the advent and proliferation of digital tools, the journalist is no longer needed as a disseminator. One journalist working for a digitally native general interest organization said,

> Look, you, me and my grandmother is on Twitter at this point. That's how people get breaking news and all news really. I'm not wasting my energy with that. That's not how I'm needed.

Other journalists echoed that statement, essentially arguing that if journalists spend their finite amount of time available looking for breaking news, they will fail more often than not. These interview subjects subscribed to the idea that a journalistic role should change and morph as needed by the public. One digital journalist who produces web content for a large legacy newspaper explained it like this:

> Twenty years ago, the people in this city needed us, my paper's journalists, to tell them about what's happening in the city. Without us, they would have gotten this information by playing elaborate games of telephone or, god forbid, by watching TV news. Not joking anymore, though, people needed us to get information. Now, I really think my role is very different. It's not to get people information because they get that from social media. We as journalists, especially ones who don't deal in spot news, and that's almost all multimedia journalists, we need to adapt and do something more with that information.

Consistently, the journalists interviewed, both implicitly and explicitly, discounted the monitorial role. If they didn't dismiss the role due to the evolving needs of the public, as the vast majority did, they did it out of a need to separate themselves from other nonjournalists disseminating information. Numerous interviewees discussed how the public often thinks anybody can be a journalist today, and to dispel that notion, journalists cannot act on the monitorial role. As one subject said,

> Anybody can go on Twitter and tell people a fire broke out at the corner of Main Street. We need to do better than that. That's not journalism. That guy is not a journalist. A journalist tells people what to do with that information.

Radical-Adversarial Role

The role most often cited by the digital journalists interviewed was the radical-adversarial role. One of the interviewees defined the role thusly:

> I believe my role as a journalist is to be the eyes and ears and loud voice of the people. I'm their representative, and I'm better at it than fucking crooked politicians. I try to make their lives better.

Many others interviewed echoed these sentiments. Numerous interviewees discussed how this role meant ignoring the age-old journalism convention of objectivity. One explained this by arguing, "Objectivity is dead. Not everyone deserves their side, especially when they're lying. My gig is about providing the people's side and making powerful people respond to the people's side."

The radical role, according to the journalists interviewed, necessitates journalists identifying issues in the community that need fixes, and then fighting for those fixes through the power of journalism. One interviewee at a digitally native news nonprofit explained this in idyllic fashion by saying,

> We can make change. I know that people want to say journalism is dying or whatnot, but I think that's bullshit, and I've seen it at my website. We've published stories that have changed policy and made things better for people. I cover my beat by busting my ass out there trying to come up with the things that would make everyone in (my city) better off. If that means more fresh fruit available, that means I'm going to write about fresh fruit and why it's needed, and I'm not going to allow the powers that be to give trite bullshit-y answers that don't say anything. They will respond.

For the journalists interviewed, the radical-adversarial role means discarding objectivity, immersing yourself in your community, and taking it upon yourself to insert your findings into the news by advocating for a stronger community.

Collaborative-Interpretive Role

The collaborative role, according to the journalists interviewed, is the next step after the monitorial role in terms of news dissemination. One journalist explained this idea by saying,

> Anybody can get information out there, but the most obvious next step once information is there is to understand its context and how this matters to the people you cover.

For journalists subscribing to the collaborative role, the concept of context and analysis is key. They believe that the Internet and social media allow the public to consume more information than ever before, but that a journalist must sift through this information and provide context and explanation. Numerous interviewees discussed how social media forces many traditional journalists to compete to be first in breaking news, and this competition minimizes the role of context. As one interviewee said,

> It's all fine and good to be first. I'll admit that sometimes I get a rush breaking a story. But I don't do that often, and I don't think of my job that way. Just because you tell someone something happened, that doesn't mean squat. I want to tell people why that happened and what it means to them, how it does or will matter to them. That's the most important thing a journalist can do, and I really feel like digital journalists like myself are leading this charge. I've been a journalist for more than 20 years and so I've always talked to lots of journalists. I've never heard the word context come up in so many conversations as I do now when I talk to others working on the digital side of things. Newspaper and TV reporters? They don't care about context, but I sense a movement that we do. We understand that's the damn point of journalism. It's not to say something happened, but why it happened and why it matters.

Journalists taking on the collaborative role believe it is their responsibility to make issues as salient and understandable as possible for the public. To them, information is out there, but without the context and without explicitly noting the information's potential impact to the community, the readers do not understand the information's salience. As one journalist at a digitally native political site said,

> I need to make sure people know why they should care about a story. They read and see, for example, a lot of information about the 1,278 people trying to be the Republican nominee for president. But do they understand how their differences will affect them? That's what I want to do.

Mobilizing Marketer, Reconceptualizing the Facilitative-Mobilizer Role

Christians et al. (2009) conceptualized the facilitative role as media organizations actively engaging and utilizing citizens in newsgathering and community-building practices through dialogue and communication. Weaver et al. (2007) identified the mobilizer role as journalists incorporating the public into their routines. Tandoc and Vos (2016), through a study of journalists at two newspapers, identified the marketer role, one that revolves around journalists essentially acting as public relations professionals via social media by promoting their own work. None of these roles, though, comprehensively or effectively describe what digital journalists subscribe to today. While all of the 53 journalists interviewed discussed the importance of social media and how often they use it, they do not use it simply to promote their own stories. Social media has become a far more embedded tool in the digital journalists' toolbox. Many of the interviewees of this study saw it as vital to a role they believe they must enact: the role of the marketing mobilizer.

One journalist interviewed implicitly defined this role by saying,

> What's the point of a journalist? I would say it's to reflect the audience's wants and needs. Twitter and Facebook and those kind of sites allow me to do that. I use social media to empower people. I use it to get them to help me with a story throughout the entirety of me doing it, from getting an idea to finding sources to writing it. The audience is part of it the whole time. That's the dream in journalism. The people and not just a journalist has power. And then I can publish the story and get people to talk about it over social media too.

That journalist, and more than three dozen others interviewed, identified incorporating the people into news production processes as a role. They believe they are the conduit for the people's voice getting heard. Then, as mentioned in the quote above and by numerous other journalists interviewed, they can publish the story on their newsroom's website and utilize social media to have a conversation with readers about the story again. This engagement lets, in the words of one journalist, "the audience critique the hell out of me and, sort of, critique themselves for their input."

One journalist outlined this process explicitly; he described how social media allow him not only to engage the audience before publishing a story, but also after. He said,

> I was doing this story about a neighborhood, a usually safe one, suddenly experiencing numerous break-ins. I went and walked around, but people weren't talking. Really, I came away with very little. Then I went on Facebook and found a little group talking about it. I joined the conversation, mostly to listen and hear

their concerns. I understood how the crimes were affecting the neighborhood better. I used those sources. Once we published the article, I put it up on my own social media places, but also to this group. The thing spread like virally amongst those folks. All the comments. Really, promoting the story also got me two follow-up story ideas, and my sources in the neighborhood did that. Eventually, those stories and the neighborhood's residents got the police to add an extra detail to the area, and they caught some teens doing it.

Other journalists relayed similar anecdotes or general comments about social media allowing for more audience involvement. "There are only so many phone calls you can make," said one journalist. "And usually, after only a few calls, people start saying the same thing. But if I know where to find the right people, meaning the ones the story will be about, I can use social media to attract a much larger swath of potential sources and ideas."

The key to social media, according to digital journalists, is that it can be an integral part of a journalist's process throughout the lifecycle of a story. It allows for this combination of roles, both from a promotional and a mobilizing perspective. In fact, journalists often mentioned performing both roles in the same sentence. Said one, "With Twitter, I get sources to talk to me, and then I give the sources the story so they can get people to talk to them." Essentially, what this journalist meant was that when reporting complicated stories, she uses Twitter to gather essential sources, and then she promotes the published story not just to the general public but also directly to her sources who then can use the piece to catalyze action or conversation around the issue.

This role, then, is more nuanced than newspaper reporters simply promoting stories on Twitter, as Tandoc and Vos (2016) found. Digital journalists believe that part of their role is to incorporate people into the process while also getting stories to the public through tools such as social media.

Discussion

The purpose of this study was to explore journalistic roles in the digital age. Traditional and current thinking about normative role typically assigns four distinct but overlapping roles for the media: monitorial-disseminator, facilitative-mobilizer, collaborative-interpretive, and radical-adversarial. The digital journalists interviewed for this study, however, conceptualize their roles much differently.

The digital journalists almost unanimously said that they do not adhere to the monitorial-disseminator role. In traditional normative theory, the search for and retransmission of certain kinds of news and information is a central

component of any normative definition of journalism (Christians et al., 2009; The Commission on the Freedom of the Press, 1947). However, the digital journalists here emphatically do not adhere to this definition of journalism. Instead, they argue that the public can get news from other sources, such as Facebook and Twitter, so a shift from the monitorial-disseminator role is necessary to distinguish and separate digital journalists—and by extension, all journalists—from nonjournalists disseminating information. This ready availability of news and information consequently necessitates a change in role performance to better serve the needs and wants of the public.

That change in role performance includes a greater emphasis on the collaboration-interpretive role. These digital journalists argue that role performance should shift away from disseminating news and toward interpreting news to better serve the needs of the public. Journalists, then, should report on the context of stories, analyzing why news happened and why it matters to readers. Audience members can have their informational needs met in numerous places outside of traditional mass media, so journalists must shift away from simply disseminating news and toward analyzing and contextualizing news to make the information understandable and relevant to audience members. This shift also points toward a changing performance of the collaborative-interpretive role. The constituent groups involved in the collaboration are very different than the collaboration between the media and the state. The collaboration is between journalists and their community instead of established, mainstream state and economic institutions.

Digital journalists also discussed their relationship with the community in terms of the radical-adversarial role. Indeed, the digital journalists saw themselves performing the radical-adversarial role more than any other normative role. Digital journalists tended to see the role in one of two ways. First, they saw themselves as being responsible for holding the powerful accountable, or, as one digital journalist said, "making powerful people respond to the people's side." Second, they saw a need to identify the issues in the community and seek solutions to any problems. Performing the radical-adversarial role necessitated eschewing the traditional convention of objectivity, or the belief that one can and should separate facts from values (Schudson, 1978). This lack of adherence to objectivity actually mirrors radical, alternative, and underground journalists who argued that it is impossible to separate facts from values, and that it is morally and politically wrong to do so (Atton & Hamilton, 2008). A strict adherence to objectivity could bias news coverage by forcing journalists to rely on official sources, remain impartial and neutral instead of interpreting events through a critical lens, and report fact

claims "even if he or she knows the content of the claim to be false" (Glasser, 1992, p. 176). Here, digital journalists are not passive disseminators of news. Instead, they take an active role in contextualizing and interpreting news to hold power accountable to the public and to identify and attempt to solve societal and community problems.

Digital journalists did not discuss the facilitative-mobilizer role in traditional ways. Instead, they see themselves performing a marketing mobilizer role. Performance of this role is conceptually distinct from the facilitative role, where media seek to promote dialogue among constituent groups (Christians et al., 2009; Dewey, 1954), and the mobilizer role, where non-journalists are incorporated into the news production and agenda-setting function (Weaver et al., 2007; Weaver & Wilhoit, 1991, 1996). It also is distinct from more recent studies of online journalism that found some journalists taking on a marketing role in which part of their responsibilities revolved around serving as public relations professionals promoting their work, typically through social media channels (Tandoc & Vos, 2016). The distinction is the incorporation of audience members via social media in the news production process from the beginning to the end. So, digital journalists are acting as marketing mobilizers to develop ideas, report stories, disseminate information, contextualize and interpret that information, promote their work, and gain feedback from audience members. In essence, these digital journalists conceptualize their role as reflecting the wants and needs of audience members throughout the news gathering and dissemination process.

These changing role conceptualizations and performances are driven, at least in part, by market forces. Digital journalists are, to borrow Michael Lewis's phrase about the Oakland A's, playing "moneyball." They cannot compete with legacy news organizations in performing the monitorial-disseminator role because they do not have the monetary resources and possibly the access to sources and audience. They also cannot compete with the immediacy and accessibility of social media platforms such as Facebook and Twitter for the market for audience. So, instead, digital journalists concentrate on what they view as market inefficiencies. They see other forces in the market competing for breaking news and hard news, so they focus instead on other types of news and information. The inefficiencies discussed by the journalists interviewed for this study are the radical-adversarial role, which digital journalists reconceptualize in market terms instead of ideological terms, and the collaborative-interpretive role. Objectivity is a norm still held by many journalists in legacy newsrooms, so digital journalists practice the radical-adversarial role by foregoing any semblance of objectivity to attract an audience by immersing

themselves in a community and advocating for that community. These digital journalists also saw that they did not have the resources to compete to be first in breaking news, so they instead tried to attract an audience by allocating their sometimes limited resources to providing context, explanation, and salience to stories originally covered by other journalists. Digital journalists also have combined elements from the facilitative role (as conceptualized by Christians et al., 2009) and the mobilizer role (as conceptualized by Weaver et al., 2007; Weaver & Wilhoit, 1991, 1996) with a marketing role (identified by Tandoc & Vos, 2016) to create a new normative role, here dubbed the marketing mobilizer role.

The research might reconceptualize current thinking about normative theory of the media. The digital journalists here only perform two of the traditional roles of journalists, the radical-adversarial and the collaborative-interpretive. Additionally, they reconfigure the facilitative-mobilizer role into a marketing mobilizer role that better accounts for the influence of market forces on newsgathering and dissemination. While a radical rethinking of normative theory is not necessary, the researchers suggest that a more complete and modern understanding of journalistic role should be broadened to incorporate how normative role is conceptualized by digital journalists. The digital journalists interviewed for this study would fit almost any traditional definition of "journalist," but almost all of them make a market-driven decision to forego the monitorial-disseminator role, which traditionally is seen as a key component of any normative definition of journalism. Therefore, market influences on role performance should be taken into account more fully when conceptualizing normative role.

References

Armstrong, D. (1981). *A trumpet to arms: Alternative media in America*. Boston, MA: South End Press.

Atton, C. (2002). News cultures and new social movements: Radical journalism and the mainstream media. *Journalism Studies, 3*(4), 491–505.

Atton, C., & Hamilton, J. F. (2008). *Alternative journalism*. Thousand Oaks, CA: Sage Publications.

Boczkowski, P. J. (2005). *Digitizing the news: Innovation in online newspapers*. Cambridge, MA: MIT Press.

Bradley, G. (2014). Social infomatics and ethics: Toward the good information and communication society. In C. Fuchs & M. Sandoval (Eds.), *Critique, social media and the information society* (pp. 91–107). New York, NY: Routledge.

Briggs, A., & Burke, P. (2009). *A social history of the media: From Gutenberg to the Internet*. Cambridge: Polity Press.

Cassidy, W. P. (2007). Online news credibility: An examination of the perceptions of newspaper journalists. *Journal of Computer-Mediated Communication, 12*(2), 478–498.

Christians, C. G., Glasser, T. L., McQuail, D., Nordenstreng, K., & White, R. A. (2009). *Normative theories of the media: Journalism in democratic societies*. Urbana, IL: University of Illinois Press.

Colon, A. (2000). The multimedia newsroom. *Columbia Journalism Review, 39*(1), 24–27.

The Commission on the Freedom of the Press. (1947). *A free and responsible press*. Chicago, IL: University of Chicago Press.

Creswell, J. W., & Clark, V. L. P. (2007). *Designing and conducting mixed methods research*. London: Sage Publications.

Dailey, L., Demo, L., & Spillman, M. (2005). The convergence continuum: A model for studying collaboration between media newsrooms. *Atlantic Journal of Communication, 13*(3), 150–168.

Dewey, J. (1954). *The public and its problems*. Chicago, IL: Swallow Press.

Ferrucci, P., & Vos, T. (2017). Who's in, Who's out? Constructing the identity of digital journalists. *Digital Journalism, 5*(7), 868–883.

Fontana, A., & Prokos, A. H. (2007). *The interview: From formal to postmodern*. Walnut Creek, CA: Left Coast Press.

Glasser, T. L. (1992). Objectivity and news bias. In E. D. Cohen (Ed.), *Philosophical issues in journalism* (pp. 176–185). Oxford: Oxford University Press.

Kaye, J., & Quinn, S. (2010). *Funding journalism in the digital age: Business models, strategies, issues and trends*. New York, NY: Peter Lang.

Kelly, E. (2015). *The media did cover attacks on *insert country here*. You just weren't reading it*. Retrieved from https://medium.com/re-magazine/the-media-did-cover-attacks-on-insert-country-here-you-just-weren-t-reading-it-1543447db983#.fy3cgmt1e

Kessler, L. (1984). *The dissident press: Alternative journalism in American history*. Beverly Hills, CA: Sage Publications.

Klinenberg, E. (2005). Convergence: News production in a digital age. *Annals of the American Academy of Political and Social Science, 597*, 48–64.

Knight, A., Geuze, C., & Gerlis, A. (2008). Who is a journalist? *Journalism Studies, 9*(1), 117–131.

Kovach, B., & Rosenstiel, T. (2007). *The elements of journalism: What newspeople should know and the public should expect*. New York, NY: Three Rivers Press.

Lawson-Borders, G. (2003). Integrating new media and old media: Seven observations of convergence as a strategy for best practices in media organizations. *International Journal on Media Management, 5*(2), 91–99.

Lippmann, W. (1922). *Public opinion*. New York, NY: Simon & Schuster, Inc.

Lowrey, W., & Gade, P. J. (2011). *Changing the news: The forces shaping journalism in uncertain times*. New York, NY: Routledge.

Lowrey, W., & Latta, J. (2008). The routines of blogging. In C. A. Paterson & D. Domingo (Eds.), *Making online news: The ethnography of new media production* (pp. 185–198). New York, NY: Peter Lang.

McBride, K., & Rosenstiel, T. (2013). *The new ethics of journalism: Principles for the 21st century*. Thousand Oaks, CA: CQ Press.

McCracken, G. D. (1988). *The long interview, qualitative research methods*. Newbury Park, CA: Sage Publications.

McMillian, J. C. (2011). *Smoking typewriters: The sixties underground press and the rise of alternative media in America*. Oxford: Oxford University Press.

Miles, M. B., & Huberman, A. M. (1994). *Qualitative data analysis*. Thousand Oaks, CA: Sage Publications.

Mitchell, A., Gottfried, J., Kiley, J., & Matsa, K. E. (2014). Media sources. *Pew Research Center*. Retrieved from http://www.journalism.org/2014/10/21/political-polarization-media-habits/

Mullin, B. (2015). *The New York Times* gets its own "big board." Retrieved from http://www.poynter.org/2015/the-new-york-times-gets-its-own-big-board/350039/

Mullin, B. (2016). *Digital digging: How Buzzfeed built an investigative team inside a viral hit factory*. Retrieved from http://www.poynter.org/2016/how-buzzfeed-built-an-investigative-team-from-the-ground-up/396656/

Online News Association. (2016). *Build your own ethics code*. Retrieved from http://journalists.org/resources/build-your-own-ethics-code/

Perigoe, R. (2009). Ten-year retrospective: Canada and the United States in the age of digital journalism. *Journal of Media Practice, 10*(2&3), 247–253.

Pope, C., Ziebland, S., & Mays, N. (2000). Analysing qualitative data. *British Medical Journal, 320*(7227), 114–116.

Schudson, M. (1978). *Discovering the news: A social history of American newspapers*. New York, NY: Basic Books.

Selnow, G. W. (2000). Mainstream candidates on the Internet. In D. A. Graber (Ed.), *Media power and politics* (pp. 172–186). Washington, DC: CQ Press.

Singer, J. (2003). Who are these guys? The online challenge to the notion of journalistic professionalism. *Journalism, 4*(2), 139–163.

Singer, J. (2004). More than ink-stained wretches: The resocialization of print journalists in converged newsrooms. *Journalism & Mass Communication Quarterly, 81*(4), 838–856.

Singer, J. (2011). Journalism and digital technologies. In W. Lowrey & P. J. Gade (Eds.), *Changing the news: The forces shaping journalism in uncertain times* (pp. 213–229). New York, NY: Routledge.

Tandoc, E. C., & Vos, T. P. (2016). The journalist is marketing the news: Social media in the gatekeeping process. *Journalism Practice, 10*(8), 950–966.

Weaver, D. H., Beam, R. A., Brownlee, B. J., Voakes, P., & Wilhoit, G. C. (2007). *The American journalist in the 21st century: US news people at the dawn of a new millennium*. New York, NY: Routledge.

Weaver, D. H., & Wilhoit, G. C. (1991). *The American journalist: A portrait of US news people and their work*. Bloomington, IN: Indiana University Press.

Weaver, D. H., & Wilhoit, G. C. (1996). *The American journalist in the 1990s: US news people at the end of an era*. Mahwah, NJ: Erlbaum.

6. Radical Journalism Ethics: Constructing an Ethic for Digital, Global Media

STEPHEN J. A. WARD

Introduction: The Task of Journalism Ethicists

A journalism ethicist today should be part visionary and part pragmatic inventor.

With one eye on the horizon, she should trace the contours of a new and future ethics. With one eye on actual practice and changing conditions, she should propose new aims, reinterpreted principles, and practical guidelines for emerging forms of journalism.

The old framework of journalism ethics inherited from an era of predigital, nonglobal media will be radically redefined and reoriented toward the future.

The aim, some years ahead, is a rich, multileveled, inclusive ethics that weaves old and new into a framework for journalists, whether they practice journalism as a professional or citizen; whether they practice journalism locally or globally, online or offline.

The new framework should be integrative, uniting diverse practitioners under common values. There should be integration in two domains: digital integration—norms applying across media platforms—and global integration—norms applying across borders.

Digital integration: We need a digital media ethics. By digital media I mean the use of digital platforms and technology to do journalism. An integrative digital ethics has principles and aims affirmed by many types of digital practitioners.

Global integration: We need a global media ethics. By global media I mean a media that is global in reach, impact, and culture. An integrative global media ethics provides global aims for journalism and develops norms

for reporting stories with global impact. It seeks principles that journalists from different cultures can affirm.

This approach will involve conceptual reform, consisting in the abandonment of outdated notions and epistemology, while creating a new ethical lexicon meaningful to a journalism increasingly interpretive, personal in voice, and engaged with society.

The new ethicists will speak in terms that traditionalists will find objectionable or impossible: a journalism that can be interpretive yet objective, perspectival yet factual, guided by goals and values yet impartial. We will break down the old and limiting dualisms of journalism ethics—fact versus value, detached reason versus our biased emotions.

While we philosophize about fundamentals, we also must get busy with concrete guidelines for new methods and developments, far beyond what traditional ethics could imagine.

Bringing these strands together will be an overarching political philosophy of journalism that is plural and global: Plural because it recognizes the importance of a diversity of forms of journalism, legacy and nonlegacy, as crucial to democracy; and global because it incorporates global principles and the promotion of human flourishing everywhere.

Finally, the future ethics should be an *ethics for everyone* in two senses:

One, the norms are intended to guide anyone who practices journalism, and they will be part of a larger communication ethic on how all of us should use the powerful new media.

Two, the new ethics will seek to ensure that everyone—that is, the public— will participate in the articulation of the new principles. Press self-regulation will become society-wide regulation—a common responsibility for good journalism that uses public-engaged processes for critique and monitoring. In a global media world, ethical discussion has burst through the walls of professional newsrooms. Everyone has a right to a voice in the debate.

Although more complex and nuanced, radical journalism ethics will have the right mind-set and conceptual resources to again act as a guide to practice.

The key question should not be: How do we maintain and protect existing journalism ethics inherited from another media era? The key question should be: What sort of new journalism ethics can we construct to guide conduct amid a media revolution?

In other words: *What does responsible journalism mean in a digital, global world?*

This is the full and challenging agenda for journalism ethics, and nothing less will do.

This chapter attempts to explain only a few aspects of this agenda: What it means to go radical and why; and how radical reform begins with a new mindset toward ethics.

Section I: What Being Radical Means

Undermining the Framework

I promote the replacement of the traditional framework. What is that framework (see Ward, 2015a)?

This framework, inherited from a nonglobal, predigital journalism, portrays the journalist as a professional gatekeeper who serves the public by reporting the news truthfully, impartially, objectivity, and independently (Ward, 2015b). Reporters uses time-consuming verification procedures, maintains a strict neutrality, avoids comments, and stays close to the facts. Opining and evaluating are the business of journalists whose role is to interpret, not report, the news, for example, columnists. To interpret the news was to go beyond the boundaries and norms of objective reporting—to publish subjective opinion.

This was the framework that was constructed in the early 1900s as journalists, press barons, and their news outlets grew in power, achieving a virtual monopoly on providing news and information to a dependent public. Their monopoly raised questions about the reliability and motives of this class of communicators. Journalists responded by creating explicit codes of journalism ethics to assure the public they acted responsibly. The framework was first expressed by the influential codes of the Society of Professional Journalists and American Society of News Editors, and the guidelines of news agencies such as The Associated Press (Ward, 2015b, pp. 226–237).

The framework was constructed on a now outdated epistemology—a view of how journalism should gather knowledge and justify their reports. The rising professional class of journalists, in constructing their codes, embraced a then popular empirical epistemology in science and philosophy—positivism. Positivism, as developed by philosophers such as Comte and Mill, and then applied to science by Ernst Mach and the "logical" positivists, such as Carnap and Ayer, was a robust empiricism. Historically, it was a reaction against metaphysical speculation in science and philosophy (Passmore, 1966, pp. 367–393; Ward, 2015b, pp. 103–110). Positivists sought to show how all our concepts and knowledge arose from our sensory experience of the world and our experience of empirical fact. Scientific methods and assertions could be trusted to the extent that they could be shown to be based in positive facts

and knowledge. Claims to knowledge that could not be reduced to questions of fact were either empirically meaningless, or false. They violated science's methodological commitment to factual verification. In reducing meaning and knowledge to what could be stated in terms of objective fact, positivism turned a suspicious eye on interpretations that went beyond facts and value statements that could not be reduced to empirical statements.

In journalism, positivism meant that reporters should be objective transmitters of facts. They should inform the public of their pure observations of facts, untainted by and divorced from the reporter's values, perspectives, and goals. Journalistic positivism explains good reporting by setting up dualisms at every turn: observation versus interpretation, facts versus values, information versus analysis; detached reason versus biasing emotions, straight reporting versus taking a perspective, neutrality versus goal-guided conduct. Even the well-worn phrase "straight reporting" hinted that anything beyond this was crooked. Ethics was concerned with policing these dualisms and making sure reporters followed the norms on the left side of the dualisms—facts, information, detachment, and neutrality.

This ethic was constructed on the shaky belief that, in reporting, a setting aside of one's emotional and interpretive powers, as well as one's beliefs and values, was not only possible but desirable. Only in this way could the public be provided with unbiased facts so they could judge for themselves.

The creed was monistic, exclusive, and parochial. It tended to privilege one form of journalism—straight, neutral journalism. It rejected or downplayed the importance of other forms—investigative, opinion, interpretive, advocacy, and explanatory journalism. These latter forms of journalism, of course, continued to exist and in many cases flourish. But from the perspective of journalism ethics—the approach used by most journalism codes—it was reporting that was the main subject of attention, and the subject of most of its norms. The codes said relatively little about the norms for interpretive and opinion journalism, and few indicated that opinion journalism had any distinct norms or standards. Why? Because, given the positivistic dualism of fact and opinion, such writings were presumed to be merely subjective and beyond the restrictions of objective, factual reporting.

The professional ethical framework, based on principles of objectivity and neutrality of reporting, established a temporary but wide-reaching consensus on good journalism, and provided a common framework for evaluating reports. The main principles of the framework appeared in most of the major journalism codes from the 1920s to the 1960s, and beyond. The framework was a somewhat odd combination of positivism and absolutism. While journalists reported the changing world of empirical facts, their ethical principles, such as

objectivity, were considered to be unchanging and even absolute. Part of this came from an assumption of stability. The consensus of journalism ethics in the mid-1900s encouraged the idea that the principles of journalism were fixed and stable, and could be applied through the years to a stable media ecology.

The creed was parochial and inconsistent in stressing objectivity and neutrality—except when it came to patriotism and the national interest. The underlying but often unexpressed principle in these codes was that the journalist's primary duty was to her city, region, or nation. Ethics stopped at the border. In times of conflict, for instance, the objective reporter was expected to be a patriotic citizen and support the war effort. She was expected to cover global issues from her country's perspective. This parochial basis of journalism ethics seemed obvious to many, and was not explicitly stated in many codes.

This view of journalism, as ideally neutral and objective in reporting yet parochial in aim, continues to haunt current debates in journalism ethics. Its familiar principles are part of current codes and its philosophy of journalism is still used in ethical decision making, in teaching journalism, and in public debates about journalism.

However, as I will discuss in more detail below, the framework is frayed, tired, and outdated. New media practitioners have stretched, challenged, or ignored it. Many of them prefer to work on the right side of the dualisms, doing non-neutral, interpretive journalism. Meanwhile, the epistemology on which the framework was constructed, a strict, dualistic, positivism, is passé. Philosophers such as Putnam (2002), among many others, have shown there is no hard line to draw between facts and values, observing and interpreting. And, as a global journalism arose, the importance of nationalism and patriotism in covering global events and war was challenged (Ward, 2010, pp. 213–237).

Philosophically, the professional objective framework is bankrupt yet still influential.

Why Radical?

I have indicated above and elsewhere (Ward, 2015a) why a radical approach is required in journalism ethics. I am tempted to leave it at that. However, people may still question my call for radicalness. Therefore I review my main reasons for this belief. My conviction is based on my reading of the current state of journalism ethics. This reading has two premises:

Premise 1: Difficult transition: We are in the middle of a difficult transition from a predigital, parochial journalism ethics to a digital, global journalism ethics.

Premise 2: Framework in a mess: The traditional framework is a conceptual swamp of disagreement on fundamentals, contending ideas, and questions raised by new practices, some dubious, some not. The framework is, like Humpty Dumpty after his fall, in a mess.

How is the framework in a mess? Here are the main reasons.

1. Breakdown in consensus on fundamentals

Radical reform is needed because there is disagreement on the most basic concepts of journalism ethics. The definitions of journalist and journalism are seriously debated. Principles, from independence to objectivity, are doubted, ignored, or reasserted in traditional guise. The aims of journalism are subject to debate. Is the aim of journalism to inform factually or to analyze from a perspective? Is it to describe the world or change it?

The depth of questioning can be grasped by listing some of the questions asked:

- Questions of identity: If citizens and nonprofessional journalists report and analyze events around the world, who is a journalist?
- Questions about the scope of journalism ethics: If everyone is potentially a publisher, does journalism ethics apply to everyone? If so, how does that change journalism ethics?
- Questions about the content of journalism ethics: What are the appropriate principles?
- Questions about the new journalism: How can new forms of journalism be ethical? For example, how can nonprofit journalism maintain editorial independence from funders?
- Questions about community engagement: What ethical norms should guide the use of citizen content and newsroom partnerships with external groups?
- Questions about global impact: Should journalists see themselves as global communications, or perhaps global agents of change?

2. Problem of applying existing principles

Skeptics of radical reform say there is consensus. Responsible practitioners agree on basic ideas such as telling the truth, being accurate, having editorial independence, and perhaps objectivity. I am not sure all or most responsible practitioners would embrace these ideas. But I set that aside. The trouble is that, even where there is consensus, it is a paper-thin agreement on abstract principles, such as truth-telling and accuracy. There is little agreement on their application to new forms of journalism. What does accuracy mean in an era of instant updates and live blogging of events?

Meanwhile, there is a movement to abandon objectivity for transparency (McBride & Rosenstiel, 2014, pp. 2–6). And corporate-sponsored "brand journalism" and nonprofit journalism find the traditional strict precepts on independence—prohibiting "getting close" to funders or sources—do not work for them.[1]

This is not an argument for eliminating values like accuracy and truth. It is an argument against a false confidence that the problem can be addressed by extending existing principles. No simple extension is possible.

3. Incompleteness: alternate approaches to journalism

The traditional framework is incomplete. Historically, it has said little, or little that is useful, about new or alternate approaches to journalism. Where are the extended discussions in traditional journalism ethics on the norms and aims of interpretive, opinion, or engaged journalism? Where in the codes do we find sections which provide useful guides for evaluating such journalism? There is mostly silence. Only in the past several years have major news organizations, including the U.S.-based Society of Professional Journalists, set out to revise their codes. In many of these cases, the approach has been to extend conservatively the traditional codes to new issues.

We have already seen why this lack of development has existed, until recently: The traditional approach was monistic and exclusive, doubting the validity of these approaches for professional journalism. Moreover, the entrenched positivism left doubts as to whether there really were any objective norms for interpreting and opining, since interpretations and opinions were regarded as merely subjective beliefs. Reform, then, will entail a new epistemology that avoids an objective–subjective dualism and articulates norms for adjudicating interpretations.

4. Incompleteness: New developments

The traditional framework is incomplete in a second way. It struggles to say how to apply existing principles to the new forms of journalism. Here are some samples:

- robot journalism (use of computers to write news reports)
- virtual reality journalism (use of virtual reality to tell stories)
- participatory journalism (use of citizen input such as images, comments or eyewitness accounts)
- crowdsourcing journalism (use of interactive media to allow audiences to fund stories, choose the top stories, find information, and critique stories)

- "partner" and community-engaged journalism (journalists partner on stories with community groups, other news outlets, and individuals)
- global journalism (covering stories with global impact, emerging global issues, and the protection of human rights)
- social media journalism (how journalists should participate in social media and use social media on stories)

With regard to social media journalism, the fatal shooting of a Virginia reporter and her videographer on live television in the summer of 2015 is an example. The killer recorded his actions and put the images and his tweets online before killing himself. Editors faced the question of how to report this case, and whether (or how) to use the killer's images or comments. Citizens at home faced questions of whether they should view the images or read the tweets.

The traditional framework, constructed a century ago, could not foresee these developments. And the dualistic, exclusive approach of the framework is ill-adapted to address these new ethical areas.

I conclude that the traditional framework is in a mess not only because of a lack of consensus but also because it is so conceptually impoverished that it cannot be a plausible guide to digital, global journalism. The current state of journalism ethics meets the conditions I set earlier for adopting a radical approach: the framework is so thoroughly in dispute that only a rethinking of the foundations can help practitioners move beyond an unproductive clash of views.

Section II: Some Features of a Future Ethic

I end my critique of traditional journalism ethics and turn to the more positive task of the ethical futurist. I trace the contours of an emerging journalism ethics. My tracing is both empirical and normative, with an eye on the horizon and current trends. I am influenced by emerging trends in journalism and ethics, as matters of fact. But I am also saying what features a new framework *should* have to guide responsible journalism in a digital era.

A full accounting is far beyond the scope of this chapter. Here I explain only a few features of a future ethic—features having to do with the attitude we need to take toward ethics. Reform starts with changing how we think about ethics. We need to construct a meta-ethics that sees change, reinvention, contestation, and dialogue as a natural and inescapable part of doing ethics. We need an epistemology that rejects the old dualisms of fact and value and explains how journalists can construct informed and well-evidenced

interpretations, and how journalists can adopt impartial stances even though they have journalistic goals and values. Most importantly, we must escape the long legacy of absolutism—that ethics must have unchanging and certain foundations or we face moral chaos. Perhaps no other belief has obstructed a pragmatic view of ethics as exploration and reinvention adapted to changing circumstances.

To accomplish these changes, we need to adopt a new mindset about the nature of ethics and, in particular, journalism ethics.

A New Mindset: Pragmatic Humanism

I call the mindset "pragmatic humanism" because it regards principles as tools for guiding conduct. They are fallible and evolving standards. The attitude is humanistic in that the aim of journalism is to promote the flourishing of global humanity. The new mindset guides the invention of new principles and the reinterpretation of existing values, such as truth-telling, editorial independence, and promoting democracy.

Pragmatic humanism is a holistic set of notions of four kinds: (1) *functional notions* about the nature and aims of journalism; (2) *epistemic notions* about the nature and justification of ethical claims; (3) *structural notions* about how to organize new ethical beliefs into new codes; (4) *critical notions* on new public structures for assessing media performance. The ideas are drawn from many places—philosophy, ethics, sociology, communication studies— and are held by a heterogeneous band of journalists, ethicists, and citizens.

Functional Notions

The new mindset makes process and participation as important as firm content and indoctrination of principle. At a time of cross-border tensions, politically and culturally, *how* journalists discuss, invent, and modify their values should be as much a part of journalism ethics as defending the established ideas of a dominant group or culture. A primary function of journalism ethics in a global era is to encourage dialogue—informed, reasonable, global discourse on journalistic values and practices.

Discourse ethics has been a defining aspect of much contemporary moral theorizing due to the influence of Rawls (1972) and Habermas (2001). Ethical discourse is a genuine "give and take" among moral equals in communication across differences. It is a "communicative form of moral conduct" (Makau & Marty, 2013, p. 79). At the heart of discourse is evolution, enrichment, and fair negotiation. It explores an *ethics-to-be*, able to deal with new conditions, new issues. For a mindset focused on defending preestablished

principles, ethics as evolving discourse is of minor value. Why discourse at length if we already know what our principles are?

Dialogic discourse in journalism ethics is of paramount value. Modern societies are redolent with diverse conceptions of the good that come into conflict through media. Ethics as discourse is an alternative to conflict, dogmatism, or the tyranny of one group's morality. Recasting journalism ethics as open-ended discourse is a step toward an ethics for a plural world.

Journalism ethics as discourse implies that ethics is often emergent—the emergence of new moral values and attitudes. Social and technological change brings forward new practices, priorities, and values. The new values become an emergent ethic that questions existing values. Journalism ethics today is a prime example of emergent ethics. It is a zone of contestation between new and old values. Before the digital revolution, professional practitioners came to think of their ethics as stable and settled. Disagreement and uncertainty were negative signs, indicating some weakness in the accepted ethics. The new mindset takes a contrary position: emergence, disagreement, and uncertainty are a natural part of ethics.

The new mindset also shifts the focus of journalism ethics from the "micro" to the "macro" level. The micro level consists of questions about what an individual journalist should do in specific situations, for example, grant anonymity to a source. The macro level consists of questions about the performance of a nation's news media system or the global news media system. The global nature of today's news media immerses journalism ethics in the macro issues of political morality – issues of power, inequality, media ownership and diversity, digital divides, and how news media cover global issues. For the new mindset, journalism ethics is scarcely distinguishable from the communication policies and norms required by interconnected societies. Therefore, another primary function of journalism ethics is to be a catalyst for discourse on this macro, global level.

Epistemic Notions

An epistemology is a conception of the nature of knowledge, and the standards of good inquiry. An epistemology of ethics is a conception of the nature of ethical knowledge, and the standards of good ethical inquiry. I recommend an epistemic perspective that I call imperfectionism (Ward, 2015a). Imperfectionism develops themes in American pragmatic philosophy (see Albrecht, 2012) from John Dewey to Richard Rorty. My imperfectionism is defined by a commitment to: (1) fallibilism and (2) interpretism.

Falliblism is the view that there are no "metaphysical guarantees to be had that even our most firmly-held beliefs will never need revision" (Putnam, 1995, p. 21). Humans are imperfect inquirers. Their beliefs are fallible and never certain. The complexity of the world resists perfect results. Moreover, the cognitive capacity of humans is flawed by bias and other infelicities. Imperfectionism sees beliefs as hypotheses on how to understand phenomena or proposals on how to regulate conduct. Falliblism is not extreme skepticism. It does not require us to doubt *everything*. It only requires us to be ready to doubt *anything*—if good reason to do so arises.

Falliblism rejects the pervasive metaphor of absolutism, influential in predigital ethics, that our beliefs and standards need infallible, foundational principles, the way a house needs an unmoving foundation. Falliblism prefers the metaphor of knowledge as the current results of ongoing inquiry, where inquiry is a ship already under sail (Quine, 1960, p. 124). As we sail along, some beliefs strike us as questionable. We use some of our beliefs to question other beliefs. But we can't question all of our beliefs at the same time. Falliblism dovetails with the idea of emergent ethics and the value of experiment. If we are fallible and situated, we can expect ethics to be an area of emergent and contested belief. We improve our beliefs through new experiences and discourse with others. We explore and experiment. The imperfectionist respects many forms of thinking, even if they fail to reach certainty or eliminate disagreement. Well-grounded belief and valuable reasoning exists between the absolute and the arbitrary in ethics and other domains.

Interpretism helps to explain why we are fallible and how we evaluate ethical beliefs. Interpretism starts from the premise that humans have no direct cognitive contact with reality, or the world. We always understand the world through conceptual schemes and symbols. We do not first apprehend pure facts about the world, and *then* interpret them. There is no dualism of observation and interpretation. Everything we cognize, describe, explain, or know is an interpretation of experience. Knowledge is a well-tested interpretation. Inquiry is construction of interpretations. Evaluative notions, like objectivity, are standards for evaluating interpretations. Therefore, all forms of journalism and all journalism stories and articles are interpretations, and journalistic norms are tools for evaluating these narratives.

Interpretation is the way that fallible inquiry and belief-formation occur in ethics, and in journalism ethics. At the most general level, ethics is based on normative interpretations of types of action, professions, and practices (Ward, 2015b) A normative interpretation says *how*, ethically speaking, a type of conduct ought to be carried out by stating the social point of the

activity—the activity seen in its best light (Dworkin, 2011). Norms and principles are justified insofar as they promote this purpose.

In Western journalism ethics, the purpose of journalism is normally expressed by what I call "publicism": journalism in its best light advances the public good, not just the interests of individuals or groups. That public good is usually conceived of as the good of a self-governing public in a democracy. Therefore, journalistic norms are justified if they advance democratic journalism. Any value claim, practice, or principle should promote or be consistent with journalism's public responsibilities. We are not free to make up any type of interpretation about an established practice. Our interpretations of journalism, to be taken seriously, need to account for paradigmatic examples of the practice, be consistent with the history of the practice, start from shared understandings, and advance arguments that are plausible to practitioners and resolve problems. Normative interpreters work between the absolute and the arbitrary.

Within the Western tradition, different interpretations of the point of journalism can be found among modern journalists, from Walter Lippmann and Edward R. Murrow to Hunter Thompson and current citizen journalists. The current fragmentation in journalism ethics can be understood as a clash of normative interpretations of journalism.

Why is imperfectionism, with its twin concepts of falliblism and interpretism, important for a mindset tasked with the construction of a new journalism ethics? Because the imperfectionist approach is an epistemology specifically "designed" to make sense of inquiry and ethical belief-formation in a changing, pluralistic world. Imperfectionism avoids the false dilemma of either an unbending absolutism or an arbitrary subjectivism. It encourages us to learn from others, and to enter into dialogue. Rather than look for absolute foundations amid the winds of change, imperfectionism encourages us to participate in a global, open-ended discourse. Imperfectionism reminds us that the task of journalism ethics is not to preserve and protect, but to reflectively engage the future with fresh minds and fresh ideas.

Structural Notions: Integration

I turn to structural issues. To the ideas of discursive method and imperfectionism, I add the idea of an integrative approach to developing multimedia codes of ethics.

A structural inquiry responds to a worry not about content—what will the new norms be?—but about the scope and structure of any new ethics. In terms of scope, the question is: To what extent will any new ethics be able

to gain the agreement of a substantial number of journalists? In terms of structure, the related question is: Will journalism ethics of the future consist only of separate and different codes for specific types of journalism practice, say a code for social media journalism, a code for investigative journalism, a code for newspaper journalism and so on. Or will it be possible to construct, in addition to specific codes, a general or universal code that applies to most journalists, based on common values?

Even the ideal of integration is contested. There is debate whether a journalism-wide ethics is possible or desirable. The debate is between what I call integrationists and fragmentists. An integrated ethics has unifying principles and aims that are widely shared by practitioners. A fragmented ethics lacks unifying notions. It is characterized by deep disagreement among practitioners about aims, principles, and best practices. In journalism, fragmentation is the proliferation of different views about the purpose of journalism and its main norms. To speak metaphorically, a fragmented journalism ethics is not a mainland where values connect to a hub of principles. Instead it is an archipelago of isolated "islands" or value systems embraced by different types of journalists in different cultures.

Integrationists believe journalists should share a set of aims and principles. They believe the reintegration of journalism around shared values is possible and desirable. Fragmentists, on the other hand, believe fragmentation is not only a fact about journalism ethics but is also a positive state of affairs. Integration smacks of journalistic conformity and homogeneity. The current state of journalism ethics tends to resemble a normative archipelago. The islands are the fragments of a former unified, predigital professional ethics.

In journalism, it may appear that only fragmentation is occurring, since the differences attract publicity. However, if we look closer, both integration and fragmentation are occurring. There is a movement toward integration in the revision of codes of ethics. Many major news organizations, from the BBC in the United Kingdom http://www.bbc.co.uk/editorialguidelines/ to the Society of Professional Journalists have, or are working on, substantial updates of their editorial guidelines. These revisions are integrative insofar as they show how their principles apply to new practices. Fragmentation also carries on. The view that social media journalism has its own norms has been a mantra since online journalism emerged (Friend & Singer, 2007).

I reject fragmentism as a negative force. It divides journalists into camps, weakening their ability to join in common cause, for example, against threats to a free press. For the public, fragmentation may be understood as the view that there is no such thing as journalism ethics, only each journalist's values, and this may be a reason to support draconian press laws. Fragmentation

makes a hash of the important idea of journalism self-regulation since the latter requires regulation by a society-wide group of journalists who follow common principles. If each journalist, or each type of journalists, can construct their own ethics, without the restraint of a common code, journalistic self-regulation is not possible. Furthermore, the public will struggle to keep fragmented practitioners accountable because there are no agreed-upon principles for the evaluation of media conduct. Under the flag of fragmentation, dubious forms of journalism can be rationalized by appeal to personal values.

Fragmentism undermines the public basis of journalism ethics, noted above. Fragmentists, in rejecting integration, seem to assume mistakenly that the source of authority for journalism ethics is the good of each individual journalist or each island of journalists. Moreover, fragmentists lack a vocabulary for discussing how journalists, together, promote the public good because, by their own assumption, there are *no* general, "cross-island" principles or duties.

Has the media revolution undermined the validity of publicism in journalism ethics? The answer is no. Journalism remains a social practice with impact on others. Things are less clear today because many citizens journalists do not belong to professional journalism associations and therefore do not fall under the latter's codes of ethics. Yet, this difficulty is not a reason to reject the idea of public journalism ethics. Publicism applies to all forms of journalism practice. Its scope is not limited to professional mainstream journalists.

Publicism, as a regulating norm, needs to be redefined for digital, global journalism. Yet any redefinition must take seriously the responsibilities of journalism on the level of social and institutional practice. Publicism blocks the idea that bloggers, users of Twitter, or anyone who engages in journalism are free to make up their own idiosyncratic ethics—or not bother with ethics at all. Journalism ethics does not "belong" to journalists. It belongs to citizens—what they need from their journalists. Journalists have no special authority to announce, *ex cathedra*, its values and what it will accept as restraints on its publishing. Journalists must face the tribunal of the public, not just their own conscience, when their conduct comes into question. They need to provide reasons that other citizens would accept, from a public point of view.

I am an integrationist. Yet I believe any new integration must be guided by a sophisticated mindset that recognizes unity and diversity as permanent, valuable, and linked features of journalism ethics. An integrative approach should avoid polar opposites—treating ethics as only fragmented islands of value or treating ethics as only homogenized principles that ignore differences. An integrated approach seeks unity in difference. It grounds journalism

ethics in common, general principles that serve the public good and are realized in multiple ways by various forms of journalism in different media cultures. Differences in best practices and norms are allowed, as long as they are consistent with the unifying principles. In short, local differences are ethically permissible variations of common principles. Responsible journalists do not share one, unique set of ethical beliefs. What they share is an *overlap* of basic values such as truth-telling and acting as a watchdog on power. Local media cultures give these abstract principles a concrete (and varying) meaning for specific contexts.

For example, how investigative journalists, daily reporters, and social media journalists honor the unifying principles of truth-seeking, freedom of the press, accuracy, and independence can differ within acceptable limits. Journalists from Canada to South Africa will define differently what they mean by serving the public or the social responsibility of the press. Articulating this nexus of the global and local is an important feature of current theorizing in global ethics (Christians, Rao, Ward, & Wasserman, 2008). It should be part of the reconstruction of journalism ethics.

An integrative approach also must address the widely shared feeling that, in today's media world, codes of ethics that consist mainly of abstract principles no longer provide proper guidance for practice. Such codes say little about the "personalization" of journalism ethics—the need to articulate norms for specific media platforms and specific types of journalism. For example, it is no longer sufficient to ask journalists to be accurate in a general manner, say by checking facts. How is accuracy to be realized in fast-moving online journalism, from "live blogging" events to tracking reports on social media? Here, again, we encounter a debate within journalism ethics. And, again, the choice is often framed in terms of a dilemma: either construct a depersonalized ethics for all journalists or a personalized ethics for types of journalism.

The depersonalized view was evident in the 2014 revision of the SPJ code of ethics. The ethics committee decided to maintain the code's depersonal approach—an approach that characterizes many predigital codes. The code is universal—intended to apply to all journalists in all situations—rich in content with many principles and norms, and depersonal in being platform-neutral. The code does not name specific types of journalism. The committee rejected a personalized approach that expresses norms for types of journalism and their distinct problems.

In contrast, a recent project of the Online News Association (ONA) in the United States used the personalized approach to help members create ethical guidelines. The project, which began in 2014, stressed common process, not common content. The ONA decided that, in an era of multiple

forms of journalism, the best strategy was to personalize the process—to give each online journalist or outlet the "tools" to construct their own editorial guidelines. The ONA web site, http://journalists.org/resources/build-your-own-ethics-code, encouraged its members to "build your own ethics." This process has been dubbed "DYI (Do It Yourself) ethics." The toolkit starts with a small set of common principles that the ONA thinks most journalists would consider fundamental, such as tell the truth, don't plagiarize, and correct your errors. Then journalists are asked to make a choice between (a) traditional objective journalism, where "your personal opinion is kept under wraps"; and (b) transparency journalism, "meaning it's fine to write from a certain political or social point of view as long as you're upfront about it." The toolkit then provides guidance on constructing guidelines for about 40 areas of practice where "honest journalists" might disagree, such as removing items from online archives, use of anonymous sources, and verification of social media sources.

The DIY approach appears to be a positive, inclusive, and democratic approach, suited to a plural media world. To others it is a regressive response since journalism ethics needs strong content. It needs to stand behind principles and not retreat to a "process" that, like a smorgasbord, allows everyone to pick and choose what values they like.

I believe the future of journalism ethics is not a choice between depersonal and personal approaches. That is a false dilemma. Even the ONA approach is not a pure form of personalized ethics. It is an inventive hybrid of depersonal and personalized approaches, although the emphasis is solidly on the latter. Any adequate code in the future will have to combine both approaches in a creative and mind-stretching exercise. What would an integrated code of journalism ethics look like? It would consist of four levels:

Level 1: Depersonalized, general principles expressing what every responsible journalist should affirm insofar as they serve the publics of self-governing democracies.

Level 2: More specific norms that fall under the principles, like the SPJ code, only there is no ban on mentioning forms of journalism or formulating rules for new practices.

Level 3: Case studies and examples of how the norms of Levels 1 and 2 are applied in daily journalism, such as how to minimize harm, without a focus on new media issues.

Level 4: A set of guidelines and protocols for new media practices and platforms. This level would be a work in progress, evolving as we improve our ethical thinking in this area.

This code should be a "living" document, existing online so that it can be constantly improved and updated upon in light of public discussion on issues and trends.

Unlike the personalization approach, the code would be rich in content, from the principles on Levels 1 and 2, to the applications and leading-edge discussions on Levels 3 and 4. Unlike the depersonalized approach, it would do more than state abstract principles for all. It would weave fundamental principles into a multileveled code.

Critical Notions

Open, Global Ethics

The digital revolution has given birth to an ethics discourse that goes beyond the confines of media professions. It transcends borders. The public participate directly in the discussion of journalism ethics. This discursive, public-engaged ethics alters predigital notions of media criticism and reform.

Discussion of journalism ethics is now "open" to all. It is not a "closed" discourse among professionals only (Ward & Wasserman, 2014). It is discussed by online networks of citizens and professionals. The networks discuss everything from shoddy reporting in the mainstream media to the use of cell phones to monitor human rights. This global discourse, whether angry or restrained, reflective or reactionary, misinformed or erudite, is participatory moral reasoning in the form of discourse. Digital media ethics, at this level, is contested, evolving, cross-cultural, and never settled.

This is a form of discourse that researchers and ethicists in digital media ethics need to study and understand, because it is the new global forum for media ethics.

Finally, media ethics is becoming, increasingly, a form of social activism. Today, the critics can join the media players on the field. They can do "media ethics activism." One sense of that term is summed up in the phrase: "If you don't like the media you're getting, create your own media." Media ethics goes beyond criticism. We can create new and counterbalancing media spaces committed to ethical ideals.

Conclusion

This article has argued for two propositions. First, that a radical approach to reform of journalism ethics is necessary to meet the challenging problems of today's journalism. We need a new paradigm, a radical media ethics. Second, this construction includes the adoption of a meta-ethics or mindset that

rejects static dualisms and the weight of tradition, while promoting change in ethics as natural and constant.

The mindset of pragmatic humanism proposes that digital, global journalism ethics be discursive in method, imperfectionist and nondualistic in epistemology, integrationist in structure, and globally open in criticism. While pragmatic humanism stresses the human creative aspect of ethical change, it is not an extreme subjectivism. Whatever principles are proposed are subjected to scrutiny from the perspective of the common good. Pragmatic humanism adopts publicism.

An ethical mindset is only a first step. It is, by nature, a set of abstract ideas and general attitudes. A mindset is an approach to determining ethical content; it is not the content itself. Moreover, this chapter, focused on mindset, does not examine other emerging features of the new journalism ethics, such as the global ethics movement (Ward, 2013). Nor does it delve into developing an "ethics for everyone." These trends will shape developments in journalism and media ethics for years to come.

Radical journalism ethics is truly a work in progress.

Note

1. At a major symposium at the University of Wisconsin on the ethics of nonprofit online investigative centers, center directors and other leaders in the field noted frequently the need for new rules to guide their close relationships with funders. These concerns were reflected in the publication that summarized the ethical recommendations that came out of the meeting. The publication is at: https://ethics.journalism.wisc.edu/resources/new-publications/ethics-for-the-new-investigative-newsroom

References

Albrecht, J. M. (2012). *Reconstructing individualism: A pragmatic tradition from Emerson to Ellison.* New York, NY: Fordham University Press.

Christians, C. G., Rao, S., Ward, S. J. A., & Wasserman, H. (2008). Toward a global media ethics: Exploring new theoretical perspectives. *Ecquid Novi: African Journalism Studies, 29*(2), 135–172. doi:10.3368/ajs.29.2.135

Dewey, J. (2002). *Human nature and conduct.* Mineola, NY: Dover Publications.

Dworkin, R. (2011). *Justice for Hedgehogs.* Cambridge, MA: Harvard University Press.

Friend, C., & Singer, J. (2007). *Online journalism ethics: Traditions and transitions.* Armonk, NY: M. E. Sharpe.

Habermas, J. (2001). Discourse ethics: Notes on a program of philosophical justification. In C. Lenhardt & S. W. Nicholsen (Trans.), *Moral consciousness and communicative action* (pp. 43–115). Cambridge, MA: MIT Press.

Makau, J. M., & Marty, D. L. (2013). *Dialogue and deliberation*. Long Grove, IL: Waveland Press.

McBride, K., & Rosenstiel, T. (2014). *The new ethics of journalism*. Los Angeles, CA: Sage.

Mill, J. S. (2006). *On liberty and the subjection of women*. London: Penguin Classics.

Nietzsche, F. (2003). *Twilight of the idols and the anti-Christ*. London: Penguin Classics.

Passmore, J. (1966). *A hundred years of philosophy*. Harmondsworth: Penguin.

Putnam, H. (1995). *Pragmatism*. Cambridge, MA: Blackwell.

Putnam, H. (2002). *The collapse of the fact/value dichotomy and other essays*. Cambridge, MA: Harvard University Press.

Quine, W. V. O. (1960). *Word and object*. Cambridge, MA: The MIT Press.

Rawls, J. (1972). *A theory of justice*. Oxford: Oxford University Press.

Ward, S. J. A. (2010). *Global journalism ethics*. Montreal, QC: McGill-Queen's University Press.

Ward, S. J. A. (Ed.). (2013). *Global media ethics: Problems and perspectives*. Malden, MA: Wiley-Blackwell.

Ward, S. J. A. (2015a). *Radical media ethics: A global approach*. Malden, MA: Wiley-Blackwell.

Ward, S. J. A. (2015b). *The invention of journalism ethics: The path to objectivity and beyond* (2nd ed.). Montreal, QC: McGill-Queen's University Press.

Ward, S. J. A., & Wasserman, H. (2014). Open ethics: Towards a global media ethics of listening. *Journalism Studies, 16*(6), 834–849. doi:10.1080/1461670X.2014.950882

Part III: Ethics and Ontology

Introduction to Part III

Bastiaan Vanacker

Digital ethics is not about philosophizing about every new technology, app, or gadget that hits the market, but it starts from the realization that the changes we, as a society, have experienced by the rise of digital technologies are somehow sufficiently profound to become philosophically relevant. So consequential that they force us to rethink some of our deeply held beliefs about how we relate to our environment, to each other, and—ultimately— to ourselves. While some might still believe that digital technologies do not fundamentally change anything, or at least not more than, say, the radio, automobile, or the washing machine, it is time to move forward rather than debating this issue to death.

As this field continues to mature, a digital ethic will become more deeply rooted in and connected to other areas of philosophy. It is—and will remain— important and necessary to philosophically address applied ethical questions such as "Should parents put pictures of their children on Facebook?" or "Should Twitter police hate speech more strictly?" but these questions cannot be answered successfully if we do not also question the ontological and epistemological changes precipitated by digital technologies.

And the chapters in this section do exactly this. All four authors in some way argue that the practical ethical questions raised by their work cannot be answered without questioning some of the ontological and epistemological assumptions upon which they are based. At heart, these chapters are philosophical inquiries about "meaning." The meaning of public sphere. The meaning of online vigilantism. The meaning of moral standing. The meaning of efficiency.

In one of the canonical essays in the field of digital ethics, "A Rape in Cyberspace" by Julian Dibbell (1994), the author described how a (relatively) early digital community dealt with a member who had violated the norms

of the community. The violator of the text-based LambdaMOO community had forced some fellow members to undergo sexually degrading acts. While fascinating as a case study of how a digital community develops and enforces norms, the use of the term "rape" in the title of the piece always gave me some pause. Certainly, a case can be made that real significant harm occurred, but is this harm accurately described by this term? And what are the ethical implications of applying this term to this set of circumstances?

Mathias Klang's and Nora Madison's piece is borne out of a similar questioning of conceptual transfers from the "real" world to the realm of digital communities. They wonder if all the acts of what is commonly described as cybervigilantism are in fact vigilantism as it has been traditionally understood. They argue that while they share some similarities, the acts of online shaming discussed in their chapter lack some essential features of vigilantism and therefore cannot make the claims of moral legitimacy of "traditional" vigilantism. By pushing back the question from "Is cybervigilantism ethically justified?" to "Is cybervigilantism vigilantism?" Klang and Madison broaden the ethical debate on this issue in an important way and their conceptual clarification cannot be ignored by anyone exploring the ethics of online shaming.

David Gunkel's chapter engages in a similar reframing of a familiar question: whether or not machines could get moral rights. Rather than answering the question directly, he challenges us to reconsider some of the common assumptions about moral rights, particularly the belief that moral rights should be conveyed on agents based on their possession of certain characteristics. But what if moral rights, Gunkel asks, do not depend on any intrinsic quality or property of an agent, but on their societal and relational ties? By relieving the "machine question" from its ontological requirements to define the exact qualities that would guarantee machines their rights, the questions shifts from "can machine have rights?" to "should machine have rights?" The ontological question has morphed into a moral one.

Gunkel's chapter is limited to proposing this shift as an alternative way to think about this issue, but I wonder if the ontological issue has truly been lifted by this approach. Because if moral consideration emerges through an external relationship instead of an internal property, then the question becomes what characteristics such a relationship must possess in order for the machine involved in this relationship to become worthy of moral consideration. This question about the properties a relationship must have in order to confer moral rights on those engaged in the relationship is, again, an ontological question. Another question I had after reading Gunkel's thought-provoking piece was whether relationships *between* machines instead of between humans and machines can serve as a basis to confer moral consideration.

Of the chapters in this section, Timothy Engström's most explicitly embraces the notion that advances in digital technologies have changed the way we perceive reality and how we frame questions of ethics. But he warns against mindlessly accepting the logic of efficiency, speed, and computational objectivity and the ontological and epistemological assumptions that underpin these technological advances, as they have serious consequences for our ethical thinking. At the risk of oversimplifying his argument, Engström warns that we have come to confuse "what is good" with "what are machines good at?" But rather than giving in to technological dystopianism, he calls upon us to reclaim oversight and governance of the operations that are so prevalent in our lives.

David Allen's contribution, part of his larger research project on the intellectual origins of the public sphere concept, is perhaps less a conceptual clarification as it is a deepening of a concept we all think we know and understand. Until we read Allen, that is. He shows that throughout history, the public sphere has been imagined as a platform or location, on which citizens could engage with one another and engage in the exercise of free speech. In other words, the public sphere exists independent from and is used by citizens. More recent conceptualizations, however, focus on the fact that the public forum is created through speech and action instead of preceding it, an insight that Allen then applies to virtual spaces.

The full consequences of this shift could not be discussed in David Allen's chapter (even though he provides us with a very insightful example), but his call that "a spatial ethics of public life requires cultural and institutional support of both the creation of public space and meaning making" is a great start-off point for further deliberation on how to foster citizen interaction online. However, it also begs the question if the many examples of virulent hate speech that we see online also deserve this institutional support mentioned by Allen. In the traditional public forum conception where the forum is seen as ontologically distinct from the speech activity, protecting the forum did not entail endorsing the speech. But this compartmentalized approach no longer seems possible once the forum is seen as part of the speech activity. I am eager to see how Allen's future writings on the topic address this issue.

Reference

Dibbell, J. (1993). A Rape in Cyberspace: How an Evil Clown, a Haitian Trickster Spirit, Two Wizards, and a Cast of Dozens Turned a Database Into a Society. *The Village Voice*, December 23, 1993, 12–23.

7. Vigilantism or Outrage: An Exploration of Policing Social Norms through Social Media

MATHIAS KLANG AND NORA MADISON

Introduction

The idea of cybervigilantes, or digilantes (Byrne, 2013; Chang & Poon, 2016; Huey et al, 2012; Martin, 2007; Marx, 2013), has been gaining traction, but not enough attention has been paid to the question of the legitimacy of the use of the term *vigilante* and what the use of the term implies in the context of digital media.

This chapter looks at the ways in which acts of online public shaming—often deemed as acts of cybervigilantism—as a reaction to the transgression of a social norm or legal rule may be granted social and ethical legitimacy through the use of the term. Its purpose is to explore the concept of vigilantism and compare it to cybervigilantism in order to better determine the legitimacy of the actors and the accuracy of the term. In connection with this analysis, the alternate and less salubrious term *outrage* will be explored as a way to gain a better understanding of the intentions of the presumptive vigilante. This chapter will show that technology enables levels of manipulation where certain users cultivate the outrage of others, and through this cultivation compromise the legitimacy of the outrage or vigilantism. A wide range of online acts could in one sense or another fit loosely into the description of vigilantism. It is therefore necessary to be more precise about the acts that lie at the heart of this practice. This work studies the often disproportionate social reaction to the mundane actions of a noncelebrity. It excludes reactions to celebrities' actions since these often evoke high emotions and therefore the actions of both fans and haters may be motivated by a range of opaque reasons. Furthermore, by analyzing the reaction to a relatively mundane

act—rather than an obviously egregious one—this work aims to exclude what would generally be considered reasonable reactions to events.

Naturally, whether an act is mundane or egregious is often a matter of opinion. This chapter will define mundane acts as being within the framework of rights as supported by legislation. Therefore, readers need not support these *mundane* acts but should be required to tolerate those who perform them. As much as individuals may disapprove of people using selfie sticks, openly carrying weapons, or public displays of affection, to the extent where these acts are within the law, they are mundane and to be tolerated.

Vigilantism: An Overview

From his criminological analysis of late 20th-century vigilantism, Johnston (1996) derives a set of six necessary features for vigilantism, which will be used as a basis for the discussion of vigilantism in this work, and as a way to analyze how online vigilantism differs from its more traditional counterparts. These necessary features are (i) planning, (ii) voluntary participation, (iii) reacting to norm transgression, (iv) creating a social movement, (v) threatening or using force, and (vi) offering security. The first three features are self-explanatory. Any act of vigilantism is a planned reaction to the transgression of a social norm or legal rule, carried out voluntarily by individuals who are not legally authorized to mete out punishment. However, the latter three criteria require some further exploration.

Despite the seemingly counterintuitive comparison between social movements and vigilantism made by Johnston in his fourth feature, it is important to remember that not all social movements have morally acceptable goals or means. A social movement is a collected, conscious, and continued effort by volunteers to bring about social change (Goodwin & Jasper, 2015). The trope of the lone vigilante seems to counter this idea of vigilantism being a social movement; however, it is important to remember that vigilantism is about affecting social change, even if the vigilante acts on his own. If an act of vigilantism does not have a social purpose it is a self-serving act, and as such not legitimate vigilantism. Online vigilantism may differ from offline social movements in speed and persistence as they can form and disperse much faster than their offline counterparts. Even though the investment in time and energy to gather is negligible and the barriers to participate are low, a gathering online with a clear purpose still should be considered a social movement, albeit a temporary one.

On the question of violence in point (v), history and popular media have taught us to recognize vigilantism as the use of physical force, and this will

need to be reconciled with the less physical actions undertaken in online environments, where threats are common but actual physical force is usually not an option. Therefore, the use of force will need to be explored further when studying online vigilantism in the sections below. The sixth feature identified by Johnston deals with offering security, and refers to vigilantism occurring when the legal and social systems fail to provide desired outcomes. In this view, vigilantism transcends the individual act and creates the groundwork for social change. Therefore, random acts of violence without the intention to reinforce social order do not constitute vigilantism.

Johnston's (1996) six criteria for vigilantism are a great starting point for the discussion on online acts of vigilantism. His work was written on the cusp of the proliferation of the internet and focused only on offline work, begging the question if his criteria are still valid in the online context.

If the online acts of apparent vigilantism fulfill all of Johnston's criteria, then we have no conceptual problem and online acts can easily fit into the vigilante discourse. However, if the online acts do not display the six features, we are left with a choice; (a) the online acts are not vigilantism and we are dealing with a false comparison, or (b) the acts are vigilantism, but not in the way Johnston envisioned it, and we are dealing with a development that requires an update to existing theories of vigilantism. One of the most common forms of online actions that may be understood as vigilantism is the act of naming and shaming, which therefore constitutes a good place to start in an exploration of online vigilantism.

Naming and Shaming

With or without digital technology, norms are a loosely agreed-upon consensus of what is understood as the correct behavior in a given situation. Such agreements can vary to a degree within different social units (Jackson, 1965) but in general are recognizable expressions of acceptable group conduct (Lapinski & Rimal, 2005). These expressions of behavior are closely connected to maintaining group order and social control without the need to resorting to the formal judicial system (Hackman, 1992; Tunick, 2013). Social norms are generally enforced formally through sanctions, or informally through verbal statements or nonverbal cues (Feldman, 1984), that signal the correct or incorrect behavior. Therefore, when people witness a norm transgression they can both actively and passively signal their disapproval. They can choose to verbally rebuke or to show their disapproval through body language. However, when communicating through digital media, the ability of the would-be vigilante to react is altered.

Internet-connected digital technology allows for a greater level of partic-
ipation but limits the scope of this participation to communication acts, that
is, the would-be vigilante cannot physically harm someone over the internet.
The range of acts falls mainly into either insults and threats, or naming and
shaming. All the examples in this chapter include, to a varying degree, a mix-
ture of these two forms of activities. The goal of insult and threat is both to
socially ostracize and to induce a fear that the threats will be carried out. The
naming and shaming focuses on disclosing information about an identified
individual so that judgment can be passed on the person's actions.

The latter either induces a sense of shame in the victim, or indicates to
the victim's social group that he or she should be ashamed. Thus, even if the
victim does not feel shame, punishment is inflicted by damaging the social
status and reputation of the individual (Rowbottom, 2013). Massaro (1997)
argues that there is a great deal of imprecision in the use of the concept
of shaming as a social or legal punishment due to the conflation of: *shame*,
shameful, and *shaming*. He argues: "...*Shame* is the internal reaction: shame
the emotion. What is *shameful* is a normative judgment imposed onto behav-
iors, desires, or other entities. *Shaming* is an external action: shame the verb"
(p. 672, italics in original). The feeling of shame does not require being
shamed, and attempts at shaming may not produce feelings of shame. This is
why naming and shaming is a normative expression of what the victim *ought*
to feel (Massaro, 1997).

Naming and shaming have been common occurrences in mass media;
Daily Mail editor Paul Dacre argues that this is, in part, the duty of mass
media:

> Since time immemorial public shaming has been a vital element in defending
> the parameters of what are considered acceptable standards of social behaviour,
> helping to ensure that citizens—rich and poor—adhere to them for the good of
> the greater community. For hundreds of years, the press has played a role in that
> process. It has the freedom to identify those who have offended public standards
> of decency—the very standards its readers believe in—and hold the transgressors
> up to public condemnation. (Daily Mail editor Paul Dacre, quoted in Rowbot-
> tom, 2013, p. 7)

The internet has played a vital role in challenging the exclusive posi-
tion held by mass media and opens up the ability for nontraditional players
to engage in naming and shaming. Traditional mass media holds a formal
and complex legal position within a society and therefore has, to a certain
extent, license to name and shame. The vigilantism of the internet age is,
in this case, the practice of individuals performing the naming and sham-
ing, and they fall outside the legal framework often awarded to mass media

outlets. The free speech rights of individuals are often not as robust as those of traditional media and their ability to participate in defamation lawsuits is significantly lower.

Examples of Cybervigilantism

Part of the scholarly debate on online communities has centered on the attempt to understand the source and legitimacy of rules and norms. One of the early influential contributions to this discussion is Julian Dibbell's 1993 article "A Rape in Cyberspace," which describes how an online community struggled to develop punitive norms against misbehavior in their world. Almost a quarter century later we still regularly come across actions, enabled by digital technology, that challenge our understanding of socially acceptable behavior.

The following examples are presented in order to gain a better understanding of cybervigilantism. They are chosen for the ways in which they exemplify disproportionate social (over)reactions to the mundane actions of a noncelebrity. Sometimes the actions being reacted to did not take place online, but the acts of vigilantism did.

Korean Dog Poop Girl

One of the early cases of internet outrage took place in South Korea in 2005. It involved a young woman traveling with her lapdog on the subway in Seoul. The dog pooped on the floor of the car, and despite the anger of her fellow travelers, the woman refused to clean up the mess.

The story was shared widely under the moniker gaettongnyeo (dog poop girl), the offender was quickly identified, and her name and other personal information appeared online. This led to large amounts of threats and condemnation from internet users both in Korea and across the globe (Anonymous 1, 2005; Anonymous 2, 2005; Editorial, 2005; Krim, 2005). The shamed woman dropped out of university (Solove, 2007) and wrote an online apology "I know I was wrong, but you guys are so harsh. I'm regret it, but I was so embarrassed so I just wanted to leave there. I was very irritable because many people looked at me and pushed me to clean the poop. Anyhow, I'm sorry. But, if you keep putting me down on the Internet I will sue all the people and at the worst I will commit suicide. So please don't do that anymore. (sic)" (Dennis, 2008).

Commenting on the case, Daniel Solove (2007) argued that most would agree that not cleaning up after your dog is wrong, but that the internet

allows the punishment to be disproportionate to the violation: "But having a permanent record of one's norm violations is upping the sanction to a whole new level…allowing bloggers to act as a cyber-posse, tracking down norm violators and branding them with digital scarlet letters."

The Infamous Tweet

The Justine Sacco affair is arguably the textbook example of extreme outrage discussed in this chapter. In December 2013, Justine Sacco, while traveling to Cape Town, was entertaining herself with social media, tweeting comments and observations to her 170 followers (Ronson, 2015). Before boarding the flight she tweeted "Going to Africa. Hope I don't get AIDS. Just kidding. I'm white!" The tweet is stark, and jokey; many perceived it as racist while others saw it as a comment on white guilt and the privilege of being safe when others are suffering (Bercovici, 2013).

During the hours she was in the air, the racist interpretation prevailed on twitter, especially when Sam Biddle, a journalist at Gawker with 15,000 followers, alerted the internet to this tweet. Reactions were swift. On twitter, people asked how she could work in a PR job, there was a predictable storm of abuse, her employer posted: "This is an outrageous, offensive comment. Employee in question currently unreachable on an intl flight," and the hashtag #HasJustineLandedYet began to trend. Those following the storm delighted in the knowledge that she was oblivious to what was happening online: "We are about to watch this @JustineSacco bitch get fired. In REAL time. Before she even KNOWS she's getting fired" (Ronson, 2015).

The Auschwitz Selfie

On June 20, 2014, a teenager visiting the Auschwitz concentration camp takes a smiling selfie, writes the text "Selfie in the Auschwitz Concentration Camp," adds a smiley face, and posts the content on her Twitter account. Nothing really happened until one month later when the post started making the rounds on twitter with outraged comments pointing out the inappropriateness of smiling in a concentration camp. Predictably, she was mocked, criticized, and threatened with a range of violent acts.

The act of taking a selfie is often derided as being self-centered and narcissistic. Much of the discussions about the selfie have revolved around whether it should be understood as an act of narcissism, empowerment, or a new visual communication (Rettberg Walker, 2014; Wendt, 2014). The positions in the media are often polarizing and unforgiving, as when Ryan writes: "Selfies aren't empowering; they're a high tech reflection of the fucked up way society

teaches women that their most important quality is their physical attractiveness" (2013).

This discussion becomes quickly more heated when selfies are taken in "inappropriate" spaces or events, such as funerals or solemn memorial sites (Meese et al., 2015). However, no matter what personal position may be taken on the selfie, it is important to recognize that it is not only a teenage act, as evidenced when President Obama, British Prime Minister David Cameron, and Danish Prime Minister Helle Thorning-Schmidt took a group selfie at Nelson Mandela's memorial service.

The Hashtag Protest

In 2014, in an attempt to pacify sentiments over the Washington Redskins name controversy, team owner Daniel Snyder launched the Washington Redskins Original Americans Foundation. According to the nonprofit's website, the mission is "...to provide resources that offer genuine opportunities for Tribal communities." In a comment on this move, The Colbert Report tweeted "I am willing to show #Asian community I care by introducing the Ching-Chong Ding-Dong Foundation for Sensitivity to Orientals or Whatever."

Upon reading this, Suey Park took offence and tweeted "The Ching-Chong Ding-Dong Foundation for Sensitivity to Orientals has decided to call for #CancelColbert. Trend it." This tweet was spread widely and she was asked to participate in a Huffington Post video to explain her position. Cybervigilantes were not pacified and Park was accused of racism. As outrage grew, Park was threatened with violence, violent rape, and death. Park was doxxed (had her personal information spread online) and she judged these threats as credible enough for her to change her appearance, leave Chicago for New York, and switch to burner phones. Even after Stephen Colbert asked his fans to leave Park alone, the threats kept coming (Bruenig, 2015; Watercutter, 2016; Wong, 2014).

The Lion Hunter

In 2015, an American dentist hunted, killed, decapitated, and skinned a 13-year-old black male lion named Cecil. His actions were far from unique or extraordinary and yet he quickly became the target of massive online outrage, online and offline abuse, and had to temporarily close his practice for fear of retribution (Cronin, 2015).

On Facebook, groups and pages were created with the express purpose of shaming the dentist. On the review site yelp.com, the dentist has one star out

of five and his reviews remain filled with a critique of his hunting rather than his skills as a dentist, insults and threats.

It Is Digital, but Is It Vigilantism?

While the acts above have been described as instances of online vigilantism or cybervigilantism by mass media, it is important to attempt to apply a more rigorous approach to the discussion. If we are to be satisfied with the traditional view that the vigilante is an individual or group taking the law into their own hands, then we may argue that all the above examples are vigilantism. The first step is to distinguish vigilantism, which may be illegal but arguably morally justifiable, from opportunism, bullying, or self-serving actions. This will be done by comparing cybervigilantism to Johnston's (1996) six criteria mentioned earlier.

The first three criteria define vigilantism as planned reactions to norm violations in which actors participate voluntarily. The examples above generally fit these criteria.

The online vigilantes demonstrated some level of planning and forethought into their actions as they set up websites and social media accounts, and even started petitions. However, these examples of planning are also illustrations of a need to create wider support for the action. Once the action gets started, the widespread campaign does not require planning or deep conviction on the part of the group participating in the action. All the examples also demonstrate that the participants are taking part voluntarily and are generally investing their own time and equipment.

Additionally, all the participants are reacting to the transgression of a law or social norm. The expression of outrage involved in the dog poop incident, infamous tweet, Auschwitz selfie, and antiracism vigilantism are excellent examples of individuals coming together to express their outrage at the perceived violation of a social norm. In the dog poop incident, infamous tweet, Auschwitz selfie, and hashtag protest examples, the participants conducting the online shaming, outing, and judging were not required to do more than to comment from their preexisting social media accounts. This raises the question about the level of deeper conscientious thought about the participation and its consequences. This ease of participation is problematic as it brings into question the underlying motivations for participation. Just as the way in which some forms of online activism are criticized for being slacker activism (Klang & Madison, 2016), it is arguable that this is slacker vigilantism.

The fourth characteristic Johnston associates with vigilantism is the creation of a social movement. This is more controversial than the first three

criteria, as the term *movement* may be less applicable to these social media acts. A social movement is a collected, conscious, and continued effort by volunteers to bring about social change (Goodwin & Jasper, 2015), and while it is easy to see how several people tweeting their anger and even threats of violence may be collected under a topic or even a hashtag, it is less clear whether they should be seen as conscious or continued.

Beginning with the latter, the very ephemeral nature of social media almost negates the idea of continued effort. The infinite flow of ideas and information on social media does little to support sustained and continued campaigns, so cybervigilantism does not meet the criterion of a continued effort. But should this lack of continued effort really serve as a disqualifying factor when assessing whether or not a collective action amounts to a social movement? The internet in general and social media in particular are redefining many of our social interactions, and this is also true of our concept of social movement.

The speed at which social media enable people to organize around a cause can make it seem spontaneous and unorganized. However, when groups of people are following a hashtag or gathering (virtually or otherwise) around a cause they are forming a collected, conscious, and continued effort. What constitutes continued effort in the online world is different from offline spaces, but this work rejects the criticism that these groups are too temporary to be designated movements. Whether online naming and shaming campaign constitutes a social movement depends on commitment and consciousness of the participants, not on duration.

But to what extent are the examples mentioned above really conscious and indicative of a high level of commitment? The threats of (sexual) violence and death spread via social media aimed at the dog poop girl, Auschwitz selfie, and infamous tweet are conscious in the sense that they were not committed unconsciously. Despite this, it is fair to question (1) the level of thought that precluded the critique, derogatory remark, or threat, and (2) the actual intent of the vigilante. Technology makes it easy to like or share without much effort and there is evidence indicating that many users don't take the time to read the information they are sharing on social media (Jeffries, 2014).

Criterion number five is the (threat of) use of force. If we allow the definition of force to include the emotional or social pain caused by social ostracism, threats of violence, and loss of income through termination, then it is easy to see how online vigilantism easily fulfills this criterion. But are these outcomes really intentional? The cybervigilante's hateful or harmful remarks may cause pain, but what level of pain was intended? And if there is a desire to cause pain, what is the reason behind it? Is the person acting to uphold some form

of social norm he or she believes has been transgressed (i.e., vigilantism), or is there a desire to cause harm to a person whose actions he or she dislikes (i.e., bullying), or is there a level of pleasure in harassing a person online (i.e., trolling)? While bullying and trolling might motivate some participants, it is clear that many others want to threaten the perceived transgressors or intentionally cause them harm in reaction to a violated norm.

Finally, vigilantism purports to offer security by acting as a policing and punishing factor to alleged transgressors. It may be argued that those doxxing dog poop girl are acting to ensure that transgressors of rules and social norms cannot do so without fearing punishment. However, could the same argument be made of the infamous tweet, the hashtag protest, and the Auschwitz selfie? In each of these cases, no law was broken but the conflict is over a social norm that the vigilante believes has been violated. The policing and punishing therefore is taking place over social norms that are not shared by the stakeholders.

This analysis shows that the online actions explored here largely fall within the scope of vigilantism as defined by Johnston's six criteria. However, the use of technology to mediate the action does affect the ways in which online vigilantism is carried out. Most of the changes are minor and insubstantial, but as mentioned earlier, the ease of participation in the online social movement forces us to question to what extent these actions and their consequences are intentional. This is particularly interesting as the question of intent in the offline world was easier to discern because of the obvious investments in time and energy required. As the question of intent is vital to the discussion it will be explored further below.

Intent and Knowledge: Vigilantism, Outrage, or Outrage Porn?

The use of the term *vigilante* grants a level of legitimacy onto the perpetrator. The vigilante does take the law into his or her own hands and in doing so generally breaks the law, but is not seen as a simple criminal. The vigilante is breaking the law but does so for the greater good. If Robin Hood had stolen from the evil rich and kept the rewards solely for himself, he would not have been a vigilante but a criminal. What we see is that vigilantism requires a level of altruism, in the sense that the vigilante is not acting out of a desire for personal gains. This intent and de facto result may become more complex when dealing with the cybervigilante.

The rapid flows of online information, and the ease at which groups or networks can form and disband are one of its defining qualities. To participate together with a group of people in a Facebook group or following a

Twitter hashtag requires next to no effort. In the context of online activism, critiques of this low-level investment have spawned the discussion on slacktivism (Klang & Madison, 2016) where some argue that true activism requires a greater investment than participating in social media (Morozov, 2009).

An analogy could be drawn with cybervigilantism, where one would argue it is not vigilantism at all, but some form of slacktivism where the participants have a low level of physical investment in reacting to an easily forgettable transgression. However, the resulting storm of users through their sheer numbers and language use make it seem like the online vigilante group is cohesive, coordinated, and legitimately angry.

This legitimate anger is not the defining factor of vigilantism, but it is the essence of outrage. Indeed, the difference between anger at being personally wronged is different from the anger aroused by experiencing others' being wronged. "Anger at unfair treatment has been called moral outrage. However, moral outrage—anger at the violation of a moral standard—should be distinguished from personal anger at being harmed and empathic anger at seeing another for whom one cares harmed" (Batson et al., 2007, p. 1272). Outrage does not require the taking of the law into one's own hands, but if moral outrage is anger provoked by an unfair situation or the violation of a moral standard or principle (Batson et al., 2007), then vigilantism could be a resulting reaction.

An alternate interpretation is that the online actions are less coordinated, less social movement (which are some of the criteria to qualify as vigilantism) and more a collective of outrage. This moral outrage is still directed at transgressors of social norms or legal rules but lacks the legitimacy of coordination and some of the altruism involved in vigilantism. Outrage is less for the greater good than for serving the need for self-expression in the face of inequality.

This then becomes even more troubling when we look at the ways in which the outraged treat the target of their attack. The targets, who are the transgressors of a real or perceived social norm (such as Auschwitz selfie), are seen as fair game and no taunt, insult, or threat is too far. In this, the outraged group moves as a mob spurring each other on. The outraged are more concerned with their intentions than the effects of their actions. It was more important to express outrage against dog poop girl than to consider the impact of the communication.

In this outrage we can see that anonymity as a cause for action is not as important as previously envisioned. The outraged are not people doing bad things from the cover of vague user names. Many are openly using their normal accounts to harass and communicate—in some instances—prosecutable threats. It would seem that they do not feel the need for anonymity, as

they are part of a larger group collectively acting in a similar fashion. The group creates a false consensus that enables its members to overestimate how common their words, ideas, and opinions are. Therefore, the power they feel within the outrage group trumps their need to mask their identities.

Both Dougherty (2014) and Holiday (2014) argue that the outrage is not quite as natural as we would believe. In the case of the Auschwitz selfie, a month passed before any reactions occurred, and in the infamous tweet example, Sacco barely had enough followers to carry out sustained outrage. Indeed in many of the vigilante/outrage cases online there is evidence that the outrage is curated by a third party, someone is creating the trigger for the larger online group to become outraged.

This then is more than outrage, it is outrage porn; the participants have a platform, are given a target, and find a release for their moral outrage. Dougherty (2014) writes that the participation in the outrage "…makes him feel like an actor in a great moral struggle, either as victim or as triumphant voice of justice." It is easy to see that in an attention economy (Davenport & Beck, 2001) where clicks are rewarded (Blom & Hansen, 2015), the cultivation of social outrage plays an integral part of the ways in which online writing is shaping journalism.

When the outrage is cultivated and curated, the target of the resulting abuse is chosen for effect rather than the actual transgression of a social norm. Take, for example, the shooting of Cecil the Lion, where the hunter was massively criticized online and offline, was subjected to abuse and even vandalism (Capecchi & Rogers, 2015). The anger at this hunter should be put into perspective of the information that "…every year foreign hunters export the carcasses (usually just the head and hide) of 665 wild lions from Africa—an average of nearly two lions each day" (Cronin, 2015). Not to mention the wide range of other big cats and endangered species killed daily without the popular outrage generated for Cecil.

This selective outrage, when not selected by the outraged, based on incomplete or factually incorrect information skews the notion of vigilantism and turns it into a tool for the instigator of the outrage rather than the good of the community.

Conclusion

The goal of this chapter has been to study acts of social (over)reactions to the mundane actions of a noncelebrity in order to develop an understanding of the concept of cybervigilantism. It began with a brief foray into the literature on vigilantism and then took those criteria and looked at them in the light of

our digital infrastructure. The findings in this work show that technology has far increased the reach of everyday actors to participate in shaming of individuals online. This is most certainly one factor to account for the instances of online shaming and also an important element in the need to revisit the concept of vigilantism in the online environment. Through technological mediation the cybervigilante needs few special skills and faces next to no physical or emotional challenges in their acts of vigilantism. The latter is important as it brings into question the moral legitimation of the act.

Additionally, the haphazard choice of the victims of cybervigilantism and the mob-like nature of the cybervigilantes make it difficult or impossible for the victims to understand why they are being targeted. Therefore, this chapter finds that the claims to legitimacy are vague at best and as the phenomenon does not seem to be disappearing it should be the focus of further legal and ethical study.

References

Anonymous 1. (2005, July 8). "Trial by internet" casts spotlight on Korean cyber mobs. *The Chosun Ilbo*. Retrieved from http://english.chosun.com/site/data/html_dir/2005/07/08/2005070861017.html

Anonymous 2. (2005, July 9). Dog excrement girl story debated in U.S. *Dong-A Ilbo*. Retrieved from http://english.donga.com/List/3/all/26/242321/1

Batson, C. D., Kennedy, C. L., Nord, L. A., Stocks, E. L., Fleming, D. Y. A., Marzette, C. M., ... Zerger, T. (2007). Anger at unfairness: Is it moral outrage? *European Journal of Social Psychology, 37*(6), 1272–1285.

Bercovici, J. (2013, December 23). Justine Sacco and the self-inflicted perils of Twitter. *Forbes*. Retrieved from http://www.forbes.com/sites/jeffbercovici/2013/12/23/justine-sacco-and-the-self-inflicted-perils-of-twitter/#74f916c15c4e

Blom, J. N., & Hansen, K. R. (2015). Click bait: Forward-reference as lure in online news headlines. *Journal of Pragmatics, 76*, 87–100.

Bruenig, E. (2015, May 20). Why won't Twitter forgive Suey Park? *New Republic*. Retrieved from https://newrepublic.com/article/121861/suey-parkof-cancelcol bert-fame-has-stopped-fighting-twitter

Byrne, D. N. (2013). 419 digilantes and the frontier of radical justice online. *Radical History Review, 2013*(117), 70–82.

Capecchi, C., & Rogers, K. (2015, July 29). Killer of Cecil the lion finds out that he is a target now, of internet vigilantism. *The New York Times*. Retrieved from http://www.nytimes.com/2015/07/30/us/cecil-the-lion-walter-palmer.html

Chang, L. Y., & Poon, R. (2016). Internet vigilantism attitudes and experiences of university students toward cyber crowdsourcing in Hong Kong. *International Journal of Offender Therapy and Comparative Criminology, 61*(16), 1912–1932.

Cronin, M. (2015, July). Shameful sport: Trophy hunting is surprisingly popular, but that could be about to change. *Slate*. Retrieved from http://www.slate.com/blogs/ bad_astronomy/2016/07/25/new_research_shows_two_catastrophes_together_ killed_the_dinosaurs.html

Davenport, T. H., & Beck, J. C. (2001). *The attention economy: Understanding the new currency of business*. Boston, MA: Harvard Business School Press.

Dennis, K. (2008). Viewpoint: Keeping a close watch—The rise of self-surveillance and the threat of digital exposure. *The Sociological Review, 56*(3), 347–357.

Dibbell, J. (1993). A rape in cyberspace: How an evil clown, a Haitian trickster spirit, two wizards, and a cast of dozens turned a database into a society. *The Village Voice*, December 23, 1993, 12–23.

Dougherty, M. B. (2014, March 13). Why we're addicted to online outrage. *This Week*. Retrieved from http://theweek.com/articles/449473/why-addicted-online-outrage

Editorial (2005, June 17). Netizens need "ethical guidelines". *The Hankyoreh*. Retrieved from http://english.hani.co.kr/arti/english_edition/e_editorial/42947.html

Feldman, D. C. (1984). The development and enforcement of group norms. *Academy of Management Review, 9*(1), 47–55.

Goodwin, J., & Jasper, J. (2015). Editors' introduction. In J. Goodwin & J. Jasper (Eds.), *The social movements reader: Cases and concepts* (3rd ed.), pp. 3–7. New York, NY: Wiley-Blackwell.

Hackman, J. R. (1992). Group influences on individuals in organizations. In M. D. Dunnette & L. M. Hough (Eds.), *Handbook of industrial and organizational psychology* (Vol. 3), pp. 234–245. Palo Alto, CA: Consulting Psychologists Press.

Holiday, R. (2014, February 26). Outrage porn: How the need for "perpetual indignation" manufactures phony offense. *Observer*. Retrieved from http://observer. com/2014/02/outrage-porn-how-the-need-for-perpetual-indignation-manufac tures-phony-offense/

Huey, L., Nhan, J., & Broll, R. (2013). 'Uppity civilians' and 'cyber-vigilantes': The role of the general public in policing cyber-crime. *Criminology & Criminal Justice, 13*(1), 81–97.

Jackson, J. (1965). Structural characteristics of norms. In I. D. Steiner & M. Fishbein (Eds.), *Current studies in social psychology*, pp. 301–309. New York, NY: Holt, Rinehart and Winston.

Jeffries, A. (2014, February 14). You're not going to read this: But you'll probably share it anyway. *The Verge*. Retrieved from http://www.theverge.com/2014/2/14/5411934/ youre-not-going-to-read-this

Johnston, L. (1996). What is vigilantism? *British Journal of Criminology, 36*(2), 220–236.

Klang, M., & Madison, N. (2016, June 6). The domestication of online activism. *First Monday, 21*(6). Retrieved from http://firstmonday.org/ojs/index.php/fm/article/ view/6790

Krim, J. (2005, July 7). Subway fracas escalates into test of the internet's power to shame. *The Washington Post*. Retrieved from http://www.washingtonpost.com/wp-dyn/content/article/2005/07/06/AR2005070601953.html?sub=AR

Lapinski, M. K., & Rimal, R. N. (2005). An explication of social norms. *Communication Theory*, *15*(2), 127–147.

Martin, R. (2007). Digilante justice: Citizenship in cyberspace. *The New Atlantis*, *16*, 124–127.

Marx, G. T. (2013). The public as partner? Technology can make us auxiliaries as well as vigilantes. *IEEE Security & Privacy*, *11*(5), 56–61.

Massaro, T. (1997). The meanings of shame: Implications for legal reform. *Psychology, Public Policy, and Law*, *3*(4), 645.

Meese, J., Gibbs, M., Carter, M., Arnold, M., Nansen, B., & Kohn, T. (2015). Selfies at funerals: Mourning and presencing on social media platforms. *International Journal of Communication*, *9*, Feature 1818–1831.

Morozov, E. (2009, May 19). The brave new world of slacktivism. *Foreign Policy*. Retrieved from http://neteffect.foreignpolicy.com/posts/2009/05/19/the_brave_new_world_of_slacktivism

Rettberg Walker, J. (2014). *Seeing ourselves through technology: How we use selfies, blogs and wearable devices to see and shape ourselves*. London: Palgrave Macmillan.

Ronson, J. (2015, February 12). How one stupid tweet blew up Justine Sacco's life. *The New York Times Magazine*. Retrieved from http://www.nytimes.com/2015/02/15/magazine/how-one-stupid-tweet-ruined-justine-saccos-life.html

Rowbottom, J. (2013). To punish, inform, and criticise: The goals of naming and shaming. In J. Petley (Ed.), *Media and public shaming: Drawing the boundaries of disclosure*, pp. 1–18. London: I. B. Tauris.

Ryan, E. G. (2013, November 21). Selfies aren't empowering. They're a cry for help. *Jezebel*. Retrieved from http://jezebel.com/selfies-arent-empowering-theyre-a-cry-for-help-1468965365

Solove, D. J. (2007). *The future of reputation: Gossip, rumor, and privacy on the Internet*. New Haven, CT: Yale University Press.

Tunick, M. (2013). Privacy and punishment. *Social Theory and Practice*, *39*(4), 643–668.

Watercutter, A. (2016, February 22). Here's what happened to the woman who started #CancelColbert. *Wired Magazine*. Retrieved from http://www.wired.com/2016/02/cancelcolbert-what-happened/

Wendt, B. (2014). *The allure of the selfie: Instagram and the new self-portrait*. Institute of Network Cultures, Hogeschool van Amsterdam.

Wong, J. C. (2014, March 31). Who's afraid of Suey Park? *The Nation*. Retrieved from http://www.thenation.com/article/whos-afraid-suey-park/

8. The Machine Question: Can or Should Machines Have Rights?

David J. Gunkel

Whether one is inclined to admit it or not, we currently occupy the world science fiction has been predicting for decades—a world populated by and increasingly reliant on intelligent or semi-intelligent artifacts. These artificial autonomous agents are everywhere and doing everything. We chat with them online, we play with them in digital games, we collaborate with them at work, and we rely on their capabilities to help us manage all aspects of our increasingly data-rich, digital lives. The machines are already here, but our understanding of the social significance and ethical consequences of this "robot invasion" is something that is still in need of considerable development.

Work in the new fields of machine morality (Wallach & Allen, 2009), machine ethics (Anderson & Anderson, 2011), and robot ethics (Lin, Abney, & Bekey, 2012) generally focuses attention on the decision-making capabilities and actions of autonomous machines and the consequences of this behavior for human beings and human social institutions. We have, for instance, recently seen a number of articles concerning Google's self-driving automobile and the perennial ethical challenge called the "trolley problem" (Chipman, 2015; Jaipuria, 2015; Lin, 2013). We have evaluated efforts to engineer artificial intelligence systems designed to value human life or what is often called "friendly AI" (Muehlhauser & Bostrom, 2014; Rubin, 2011; Yudkowsky, 2001). And we currently have access to a seemingly inexhaustible supply of predictions of "technological unemployment" and the potentially adverse effects of increased automation on individuals and human society (Barrett, 2015; Ford, 2015; Frey & Osborne, 2013).

Absent from the current literature, however, is a consideration of the other side of the issue—that is, the question of machine moral standing. As these mechanisms come to play an increasingly important role in contemporary

social life, taking up positions where they are not just another technological instrument but a kind of social actor or participant in their own right, how will we respond to them? How will we, or how should we, treat the various robots and artificial intelligences that come to occupy our world and interact with us? What is, or what will be, their social position and status? This chapter takes up and investigates this other question. Specifically it asks whether it is possible (and even desirable) for a machine—defined broadly and including artifacts like software bots, algorithms, embodied robots—to have or be ascribed anything like rights, understood as the entitlements or interests of a social subject that needs to be respected and taken into account.

Machine Rights? You Have Got to Be Kidding

From the usual way of understanding things, the question regarding machine rights or machine moral standing not only would be answered in the negative but the question itself risks incoherence. "To many people," David Levy (2008, p. 393) writes, "the notion of robots having rights is unthinkable." This common sense evaluation is structured and informed by the answer that is typically provided for the question concerning technology.

> We ask the question concerning technology when we ask what it is. Everyone knows the two statements that answer our question. One says: Technology is a means to an end. The other says: Technology is a human activity. The two definitions of technology belong together. For to posit ends and procure and utilize the means to them is a human activity. The manufacture and utilization of equipment, tools, and machines, the manufactured and used things themselves, and the needs and ends that they serve, all belong to what technology is. (Heidegger, 1977, pp. 4–5)

According to Heidegger's insightful analysis, the presumed role and function of any kind of technology, whether it be the product of handicraft or industrialized manufacture, is that it is a means employed by human users for specific ends. Heidegger terms this particular characterization of technology "the instrumental definition" and indicates that it forms what is considered to be the "correct" understanding of any kind of technological contrivance (p. 5). As Andrew Feenberg (1991, p. 5) characterizes it in the introduction to his *Critical Theory of Technology*, "the instrumentalist theory offers the most widely accepted view of technology. It is based on the common sense idea that technologies are 'tools' standing ready to serve the purposes of users." And because an instrument "is deemed 'neutral,' without valuative content of its own" (Feenberg, 1991, p. 5) a technological artifact is evaluated not in

and of itself, but on the basis of the particular employments that have been decided by its human designer or user.

The consequences of this are succinctly articulated by Jean-François Lyotard in *The Postmodern Condition*:

> Technical devices originated as prosthetic aids for the human organs or as physiological systems whose function it is to receive data or condition the context. They follow a principle, and it is the principle of optimal performance: maximizing output (the information or modification obtained) and minimizing input (the energy expended in the process). Technology is therefore a game pertaining not to the true, the just, or the beautiful, etc., but to efficiency: a technical "move" is "good" when it does better and/or expends less energy than another. (Lyotard, 1993, p. 44)

Here Lyotard begins by affirming the traditional understanding of technology as an instrument or extension of human activity. Given this "fact," which is stated as if it were something beyond question, he proceeds to provide an explanation of the proper place of the technological apparatus in epistemology, ethics, and aesthetics. According to his analysis, a technological device, whether it be a simple cork screw, a mechanical clock, or a digital computer, does not in and of itself participate in the big questions of truth, justice, or beauty. Technology is simply and indisputably about efficiency. A particular technological "move" or innovation is considered "good," if, and only if, it proves to be a more effective means to accomplishing a user-specified end. For this reason, when it comes to asking about the moral standing of machines, the question would not only be considered nonsense but, more importantly, has rarely, if ever, been asked as such. "We have never," as J. Storrs Hall (2011, p. 1) concludes, "considered ourselves to have 'moral' duties to our machines, or them to us."

Standard Operating Presumptions

In order for a machine (or any entity for that matter) to have anything like moral standing or "rights," it would need to be recognized as another moral subject and not just a tool or instrument of human endeavor. Standard approaches to deciding this matter typically focus on what Mark Coeckelbergh (2012, p. 13) calls "(intrinsic) properties." This method is rather straightforward and intuitive: "you identify one or more morally relevant properties and then find out if the entity in question has them" or not. Or as Coeckelbergh (2012, p. 14) explains:

Put in a more formal way, the argument for giving moral status to entities runs as follows:

1) Having property p is sufficient for moral status s
2) Entity e has property p
 Conclusion: entity e has moral status s

According to this approach, the question concerning machine moral standing—or "robot rights," if you prefer—would need to be decided by first identifying which property or properties would be necessary and sufficient for moral standing and then determining whether a particular machine or class of machines possess these properties or not. If they do, in fact, possess the morally significant property, then they pass the test for inclusion in the community of moral subjects. If not, then they can be excluded from moral consideration. Deciding things in this fashion, although entirely reasonable and expedient, encounters at least four critical difficulties.

First, how does one ascertain which exact property or properties are both necessary and sufficient for moral status? In other words, which one, or ones, count? The history of moral philosophy can, in fact, be read as something of an ongoing debate and struggle over this matter with different properties vying for attention at different times. And in this process many properties—that at one time seemed both necessary and sufficient—have turned out to be spurious, prejudicial, or both. Take for example a rather brutal action recalled by Aldo Leopold in *The Sand County Almanac*: "When god-like Odysseus, returned from the wars in Troy, he hanged all on one rope a dozen slave-girls of his household whom he suspected of misbehavior during his absence. This hanging involved no question of propriety. The girls were property. The disposal of property was then, as now, a matter of expediency, not of right and wrong" (Leopold, 1966, p. 237). At the time Odysseus is reported to have done this, only male heads of the household were considered legitimate moral and legal subjects. Everything else—his women, his children, and his animals—were property that could be disposed of without any moral consideration whatsoever. But from where we stand now, the property "male head of the household" is clearly a spurious and rather prejudicial criteria for determining moral standing.

Second, irrespective of which property is selected, they each have terminological troubles insofar as things like rationality, consciousness, and sentience mean different things to different people and seem to resist univocal definition. Consciousness, for example, is one of the properties that is most often cited as a necessary conditions for moral agency. The argument usually goes something like this: "Machines are just tools. If and when they achieve *consciousness*, then we might need to worry about them. But until that time, the question of machine rights is neither pertinent nor worthy of consideration."

This argument makes sense, as long as we know and can agree upon what we mean by "consciousness." And that's the source of the difficulty. The problem, as Max Velman (2000, p. 5) points out, is that this term unfortunately "means many different things to many different people, and no universally agreed core meaning exists." In fact, if there is any general agreement among philosophers, psychologists, cognitive scientists, neurobiologists, AI researchers, and robotics engineers regarding consciousness, it is that there is little or no agreement when it comes to defining and characterizing the concept.

Third, there is an epistemological problem. Once the morally significant property or properties have been identified, how can one be entirely certain that a particular entity possesses it, and actually possesses it instead of merely simulating it? This is tricky business, especially because most of the properties that are considered morally relevant tend to be internal mental or subjective states that are not immediately accessible or directly observable. As Paul Churchland (1999, p. 67) famously asked: "How does one determine whether something other than oneself—an alien creature, a sophisticated robot, a socially active computer, or even another human—is really a thinking, feeling, conscious being; rather than, for example, an unconscious automaton whose behavior arises from something other than genuine mental states?" This is, of course, what philosophers call the other minds problem. Although this problem is not necessarily intractable, as Steve Torrance (2013) has persuasively argued, the fact of the matter is we cannot, as Donna Haraway (2008, p. 226) describes it, "climb into the heads of others to get the full story from the inside." And the supposed solutions to this "other minds problem," from reworkings and modifications of the Turing Test (Sparrow, 2004) to functionalist approaches that endeavor to work around this problem altogether (Wallach & Allen, 2009, p. 58), only make things more complicated and confused. "There is," as Daniel Dennett (1998, p. 172) points out, "no proving that something that seems to have an inner life does in fact have one—if by 'proving' we understand, as we often do, the evincing of evidence that can be seen to establish by principles already agreed upon that something is the case."

Finally, there is a moral problem. Any decision concerning qualifying properties is necessarily a normative operation and an exercise of power over others. In making a determination about the criteria, or the set of qualifying properties, for moral inclusion, someone or some group normalizes their particular experience or situation and imposes this decision on others as the universal condition for moral consideration. "The institution of *any* practice of *any* criterion of moral considerability," the environmental philosopher Thomas Birch (1993, p. 317) writes, "is an act of power over, and

ultimately an act of violence toward, those others who turn out to fail the test of the criterion and are therefore not permitted to enjoy the membership benefits of the club of *consideranda*." Consequently, every set of criteria for moral inclusion, no matter how neutral, objective, or universal it appears, is an imposition of power insofar as it consists in the universalization of a particular value or set of values made by someone from particular position of power and imposed (sometimes with considerable violence) on others.

Thinking Otherwise

In response to these problems, moral philosophers have advanced alternative approaches that can be called, for lack of a better description, thinking otherwise. This phrase, which borrows from the ethical innovations of Emmanuel Levinas (1969), signifies different ways to formulate questions concerning moral standing that are open to and able to accommodate others—and other forms of morally significant otherness. These efforts do not endeavor to establish ontological criteria for inclusion or exclusion but begin from the existential fact that we always and already find ourselves in situations facing and needing to respond to others—not just other human beings but animals, the environment, organizations, and machines. In fact, recent debates concerning the moral status of corporations turn on the question whether rights derive from intrinsic properties at all or are in fact a socially constructed and conferred honorarium.

This "relational turn" in moral thinking, as Anne Gerdes (2015) has called it, is clearly a game changer. As we interact with machines, whether they be online chatterbots and nonplayer characters in the virtual space of a MMORPG (Massively Multiplayer Online Role Playing Game), pleasant digital assistants like Apple's Siri or Amazon's Alexa, or socially interactive robots like Nao or PARO, the mechanism is first and foremost situated and encountered in relationship to us. In this case, moral consideration is no longer determined on the basis of "intrinsic" ontological properties possessed (or not) by a particular entity. It is "extrinsic"; it is attributed to entities as a result of actually social interactions and involvements. Or as Mark Coeckelbergh (2010, p. 214) explains, "moral consideration is no longer seen as being 'intrinsic' to the entity: instead it is seen as something that is 'extrinsic': it is attributed to entities within social relations and within a social context."

This "social/relational approach" is not just a theoretical proposal but has been experimentally confirmed in a number of empirical investigations. The computer as social actor (CASA) studies undertaken by Byron Reeves and Clifford Nass demonstrate that human users will accord computers social

standing similar to that of another human person and this occurs as a product of the social interaction, irrespective of the ontological properties (actually known or not) of the machine in question. "Computers, in the way that they communicate, instruct, and take turns interacting, are close enough to human that they encourage social responses. The encouragement necessary for such a reaction need not be much. As long as there are some behaviors that suggest a social presence, people will respond accordingly.... Consequently, any medium that is close enough will get human treatment, even though people know it's foolish and even though they likely will deny it afterwards" (Reeves & Nass, 1996, p. 22).

The CASA model, which was developed in response to numerous experiments with human subjects, describes how users of computers, irrespective of the actual intelligence possessed (or not) by the machine, tend to respond to technology as another socially aware and interactive subject. In other words, even when experienced users know quite well that they are engaged with using a machine, they make the "conservative error" and tend to respond to it in ways that afford this other thing social standing. Consequently, in order for something to be recognized and treated as a social actor, "it is not necessary," as Reeves and Nass (1996) conclude, "to have artificial intelligence" (p. 28).

This outcome is evident not only in the tightly constrained experimental studies conducted by Nass and his associates but also in the mundane interactions with "mindless" (Nass & Moon, 2000) objects like online chatter bots and nonplayer characters, which are encountered in online communities and MMORPGs.

> The rise of online communities has led to a phenomenon of real-time, multi-person interaction via online personas. Some online community technologies allow the creation of bots (personas that act according to a software programme rather than being directly controlled by a human user) in such a way that it is not always easy to tell a bot from a human within an online social space. It is also possible for a persona to be partly controlled by a software programme and partly directly by a human…This leads to theoretical and practical problems for ethical arguments (not to mention policing) in these spaces, since the usual one-to-one correspondence between actors and moral agents can be lost. (Mowbray, 2002, p. 2)

Software bots complicate the one-to-one correspondence between actor and agent and make it increasingly difficult to decide who or what is responsible for actions in the virtual space of an online community. Although these bots, like Rob Dubbin's "Olivia Taters" (Madrigal, 2014), which emulates the behavior of a teenage Twitter user, are by no means close to achieving

anything that looks remotely like intelligence or even basic machine learning, they can still be mistaken for and pass as other human users. They are, in the words of Nass and Reeves, "*close enough* to human to encourage *social* responses." And this approximation, Miranda Mowbray (2002) points out, is not necessarily "a feature of the sophistication of bot design, but of the low bandwidth communication of the online social space" where it is "much easier to convincingly simulate a human agent" (p. 2).

Despite this knowledge, these software implementations cannot be written off as mere instruments or tools. "The examples in this paper," Mowbray (2002, p. 4) concludes, "show that a bot may cause harm to other users or to the community as a whole by the will of its programmers or other users, but that it also may cause harm through nobody's fault because of the combination of circumstances involving some combination of its programming, the actions and mental or emotional states of human users who interact with it, behavior of other bots and of the environment, and the social economy of the community." Unlike artificial general intelligence, which would occupy a position that would, at least, be reasonably close to that of a human user and therefore not be able to be dismissed as a mere tool, bots simply muddy the water (which is probably worse) by leaving undecided the question whether they are or are not tools. And in the process, they leave the question of social standing both unsettled and unsettling.

Conclusions

So what does this mean for us, for those of us interested in technology and digital ethics? Let me answer this question by recalling something from the "ancient days" of the Internet. During the first conference on cyberspace, held at the University of Texas in 1990, Sandy Stone provided articulation of what can, in retrospect, be identified as one of the guiding principles of life on the Internet. "No matter how virtual the subject becomes, there is always a body attached" (Stone, 1991, p. 111). What Stone sought to point out with this brief but insightful comment is the fact that despite what appears online, users of computer networks and digital information systems should remember that behind the scenes or the screen there is always another human user. This other may appear in the guise of different virtual characters, screen names, profiles, or avatars, but there is always somebody behind it all.

This Internet folk wisdom has served us well. It has helped users navigate the increasingly complicated social relationships made possible by computer-mediated communication. It has assisted law enforcement agencies in hunting

down con men, scam artists, and online predators. And, perhaps most importantly, it has helped us sort out difficult ethical questions concerning individual responsibility and the rights of others. But all of that is over. And it is over, precisely because we can no longer be entirely certain that "there is always a body attached." In fact, the majority of online activity is no longer (and perhaps never really was) communication with other human users but interactions with machines. Even if one doubts the possibility of ever achieving what has traditionally been called artificial general intelligence, the fact is our world is already populated by semi-intelligent artifacts, social robots, autonomous algorithms, and other smart devices that occupy the place of the Other in social relationships and communicative interaction.

As our world becomes increasingly populated by these socially interactive machines—devices that are not just instruments of human action but designed to be a kind of social actor in their own right—we will need to grapple with difficult questions concerning the status and moral standing of these nonhuman, machinic others. Although this has been one of the perennial concerns of robot science fiction, it is now part and parcel of our social reality. In formulating responses to these questions we can obviously deploy the standard properties approach to deciding questions of moral standing. This method has considerable historical precedent behind it and constitutes what can be called the default setting for making sense of who counts as another moral subject and what does not. But this approach, for all its advantages, also has considerable difficulties. There are historical problems with inconsistencies in the selected properties, terminological problems with the definition of the morally significant property or properties, epistemological problems with detecting the presence of these properties in another, and moral complications caused by the very effort to define moral criteria in the first place.

As an alternative, I have proposed an approach to addressing the question of moral standing that is oriented otherwise. This alternative, which focuses attention on the social relationship, circumvents many of the problems encountered in the properties approach by arranging for an ethics that is socially situated and responsive to others. What is important here is that this alternative shifts the focus of the question and changes the terms of the debate. Here it is no longer a matter of, for example, "can machines have rights?" which is largely an ontological query concerned with the prior discovery of intrinsic or ontological properties. Instead it is something like "should machines have rights?" which is a moral question and one that is decided not on the basis of what things are but on how we relate and respond to them in actual social situations and circumstances.

This does not mean, however, that this alternative is a panacea or some kind of moral theory of everything. It just arranges for other kinds of questions and modes of inquiry that are, I would argue, more attentive to the very real situation in which we currently find ourselves. Consequently, my objective in this chapter has not been to resolve the question of machine moral standing once and for all, but to ask about and evaluate the means by which we have situated and pursued this inquiry. And it is for this reason—in an effort to formulate better and more precise questions regarding the social position and status of the machine—that my own research in this area has been situated under the title "the machine question."

References

Anderson, M., & Anderson, S. L. (Eds.). (2011). *Machine ethics.* Cambridge: Cambridge University Press.

Barrett, J. (2015). *Our final invention: Artificial intelligence and the end of the human era.* New York, NY: St. Martin's Press.

Birch, T. (1993). Moral considerability and universal consideration. *Environmental Ethics, 15,* 313–332.

Chipman, I. (2015, August). Exploring the ethics behind self-driving cars. *Stanford Business.* Retrieved from https://www.gsb.stanford.edu/insights/exploring-ethics-behind-self-driving-cars

Churchland, P. M. (1999). *Matter and consciousness* (Rev. ed.). Cambridge, MA: MIT Press.

Coeckelbergh, M. (2010). Moral appearances: Emotions, robots, and human morality. *Ethics and Information Technology, 12*(3), 235–241.

Coeckelbergh, M. (2012). *Growing moral relations: Critique of moral status ascription.* New York, NY: Palgrave MacMillan.

Dennett, D. C. (1998). *Brainstorms: Philosophical essays on mind and psychology.* Cambridge, MA: MIT Press.

Feenberg, A. (1991). *Critical theory of technology.* Oxford: Oxford University Press.

Ford, M. (2015). *The rise of the robots: Technology and the threat of a jobless future.* New York, NY: Basic Books.

Frey, C. B., & Osborne, M. A. (2013, September). *The future of employment: How susceptible are jobs to computerization.* Oxford Martin School, University of Oxford. Retrieved from http://www.oxfordmartin.ox.ac.uk/downloads/academic/The_Future_of_Employment.pdf

Gerdes, A. (2015). The issue of moral consideration in robot ethics. *ACM SIGCAS Computers & Society, 45*(3), 274–280.

Hall, J. S. (2011). Ethics for machines. In M. Anderson & S. L. Anderson (Eds.), *Machine ethics* (pp. 28–44). Cambridge: Cambridge University Press.

Haraway, D. J. (2008). *When species meet.* Minneapolis, MN: University of Minnesota Press.

Heidegger, M. (1977). *The question concerning technology and other essays* (W. Lovitt, Trans.). New York, NY: Harper & Row.

Jaipuria, T. (2015, December). Self-driving cars and the trolley problem. *Huffington Post.* Retrieved from http://www.huffingtonpost.com/tanay-jaipuria/self-driving-cars-and-the-trolley-problem_b_7472560.html

Leopold, A. (1966). *A sand county almanac.* Oxford: Oxford University Press.

Levinas, E. (1969). *Totality and infinity: An essay on exteriority* (A. Lingis, Trans.). Pittsburgh, PA: Duquesne University.

Levy, D. (2008). *Robots unlimited: Life in virtual age.* Wellesley, MA: A K Peters.

Lin, P. (2013, October). The ethics of autonomous cars. *The Atlantic.* Retrieved from http://www.theatlantic.com/technology/archive/2013/10/the-ethics-of-autonomous-cars/280360/

Lin, P., Abney, K., & Bekey, G. A. (Eds.). (2012). *Robot ethics: The ethical and social implications of robotics.* Cambridge, MA: MIT Press.

Lyotard, J.-F. (1993). *The postmodern condition: A report on knowledge* (G. Bennington & B. Massumi, Trans.). Minneapolis, MN: University of Minnesota Press.

Madrigal, A. C. (2014). That time 2 bots were talking, and bank of America butted in. *The Atlantic.* Retrieved from http://www.theatlantic.com/technology/archive/2014/07/that-time-2-bots-were-talking-and-bank-of-america-butted-in/374023/

Mowbray, M. (2002). *Ethics for bots.* Paper presented at the 14th International Conference on System Research, Informatics, and Cybernetics, Baden-Baden, Germany, July 29–August 3. Retrieved from http://www.hpl.hp.com/techreports/2002/HPL-2002-48R1.pdf.

Muehlhauser, L., & Bostrom, N. (2014, March). Why we need friendly AI. *Think, 13*(36), 41–47. Retrieved from http://www.nickbostrom.com/views/whyfriendlyai.pdf

Nass, C., & Moon, Y. (2000). Machines and mindlessness: Social responses to computers. *Journal of Social Issues, 56*(1), 81–103.

Reeves, B., & Nass, C. (1996). *The media equation: How people treat computers, television, and new media like real people and places.* Cambridge: Cambridge University Press.

Rubin, C. T. (2011). Machine morality and human responsibility. *The New Atlantis, 32,* 58–79. Retrieved from http://www.thenewatlantis.com/publications/machine-morality-and-human-responsibility

Sparrow, R. (2004). The Turing triage test. *Ethics and Information Technology, 6*(4), 203–213.

Stone, A. R. (1991). Will the real body please stand up? Boundary stories about virtual culture. In M. Benedikt (Ed.) *Cyberspace: First steps* (pp. 81–118). Cambridge, MA: MIT Press.

Torrance, S. (2013). Artificial consciousness and artificial ethics: Between realism and social relationism. *Philosophy & Technology, 27*(1), 9–29.

Velmans, M. (2000). *Understanding consciousness.* London: Routledge.

Wallach, W., & Allen, C. (2009). *Moral machines: Teaching robots right from wrong.* Oxford: Oxford University Press.

Yudkowsky, E. (2001). *Creating friendly AI 1.0: The analysis and design of benevolent goal architectures.* San Francisco, CA: The Singularity Institute. Retrieved from https://intelligence.org/files/CFAI.pdf

9. *Making and Managing Bodies: The Computational Turn, Ethics, and Governance*

Timothy H. Engström

Introduction

It has become commonplace to think of digital technologies as permitting us to see what lies beyond normal thresholds of sight. Furthermore, computation allows us not only to capture but also to construct properties of the "real" that are otherwise not available. As an extension of these technological possibilities, it has become normal to think of medicine as permitting us not only to penetrate bodies but to see brains, and, through a series of ontological and epistemological assumptions, translations and inferences, to see "where" properties of consciousness and identity reside within the brain.

Such imaging and inferential practices have encouraged medicine to adopt a computational and visibility paradigm that has, in turn, become associated with a device-driven economy and, thus, with commercially encouraged opportunities for prosthetic and networked enhancements that go beyond traditional conceptions of medical–biological normalization. In effect, medicine is increasingly dependent upon a series of informational and translation assumptions regarding the functions and meanings of embodiment and biology that are available only as a result of the production of data (and the related production of statistical maps and models of bodies and brains), and which have been made possible by algorithmic coding and the (proprietary) devices that convert such code into visibility. Identity has thus become increasingly understood as a distributed function of what computation can confirm by statistical demonstration, and in relation to appliances whose happy science is a function of a lucrative informational economy.

This chapter will analyze the ontological assumptions of certain digital technologies and practices, and consider some ethical consequences that these assumptions generate. More concretely, these assumptions are intimately related to a relatively new and still developing commercial alliance between computational ontology, visibility, and a proprietary economy of digital devices. In effect, the nature and operations of code are not transparent to the medical professionals deploying them; their implications are certainly not available to a patient in need and, therefore, they are not part of any meaningful notion of "consent." This alliance thus warrants serious ethical consideration.

In overcoming the representational and diagnostic limitations of the flesh, identity is no longer confined to the parameters of the skin-bag: Andy Clark's delightful term for the negotiability of bodily limitation. The body is increasingly diagnosed, represented, monitored, and managed remotely in ways that transform traditional categories of individual autonomy and integrity. Armed both with computational conceptions of mind-body and ever-improving digital appliances for deploying these conceptions, the philosophy of embodiment and identity have become implicitly associated with a set of reductive yet universalizing theories and practices. We will explore some ethical implications of this computational turn on the production of knowledge, the production of bodies, and our experience of identity and embodiment. In doing so, we will also consider the alliance that has emerged between computational constructions of our embodiment and the feedback loops and interests of political economy that frame and direct this alliance. Agency and interests are embedded in the devices with which we interact, which translate various forms of being into number, into information flow and utility. Similar forces of agency and interest are embedded in a range of otherwise disparate practices that increasingly connect, across traditional boundaries of culture, context and human ecology, functionalist and utilitarian conceptions of the body; they represent a kind of digital (algorithmic) governmentality that requires careful ethical and ideological examination.

Objectivity as Code

Constructions of objectivity have a long history. Peter Galison has given us a very useful and historically grounded schema of how objectivity has been related to both changing technological modes of visualization and representation, as well as to specific scientific persona as they have changed in relation to these technologies. He has demonstrated that our constructions of objectivity come about in relation to modes of representation and in relation to

the larger social currency these modes acquire (Galison, 1999). There is new mode, however, that didn't find its way into Galison's typology at this point, and the ethical implications of this new mode are significant.

Traditionally, in the pre-photographic era, we relied on aesthetic skill to intervene on the concrete and particular, so that the underlying "essences" or more general forms of things could be illustrated—Galison calls this, perhaps with a lingering nod to the influence of Aristotle, a "metaphysical image." For a picture to be medically useful, it was important to have an image that generalized particulars and idealized the properties that mattered most. Utility was a function not of the "accuracy" with which a particular image was rendered but instead was determined by the artist's intervention and idealization. It was the ethical responsibility of the physician or surgeon to interpret the concrete and real in terms of such schema, to see not what was there but to see what he was trained to see, so as to be able to find what the illustrations had selected as important (Gombrich, 1960). But in this case, the "useful realism" such acts of "correspondence" provided required an interpretive interaction with the real. The difference between the image and the real was not in doubt. The aesthetic properties and utilities—and limitations—of the image were a given; "essences" were aesthetically rendered but the real was still there and bleeding.

This changes with the advent of photography, with the belief that the more automatic the transfer of the real to the image, the more objective and accurate the representation. Thus, the ontology of the image was reversed; the token needed to stand for the type, and the epistemic legitimacy (objectivity) of the image was a function of the self-denial and restraint of the image maker—the image maker humbly avoided any intervention in the image production. The more mechanical, the less room for interpretation and thus the greater the reliability. While such images were often less useful—Galison recounts many, often ironic instances when such images were fuzzier than the classical illustration and thus the objectivity was useless—the concept of objectivity nevertheless migrated in the direction of what the manufacturer does automatically, rather than what the skilled illustrator does interpretively and pragmatically.

Galison offers a third move in his genealogy of objectivity in relation to schema of visualization. "Judgmental objectivity" is the result of what only the trained expert can interpret (Galison, 1998). In these cases—the use of multispectral imaging in physics is a standard example—the interpreted image replaces the mechanical image as the foundation of scientific objectivity, in part because the visualization is itself not a mere isomorphic copy of what is seen, but a translation or transformation of data of one kind into a

visualization of another kind, and, in such cases, it is only the trained expert who can account for what is "seen" (Ihde, 2009).

My interest is to add to Galison's very helpful genealogy by identifying a forth and increasingly ubiquitous concept of objectivity, "computational objectivity," which has also emerged in relation to a new form of imaging, "digital imaging." However, in this case, the scientific persona (or "expert technician") that emerges with this computational objectivity is decentered; the persona is not centered on the scientist or single technician but is instead distributed across a network of anonymous writers of code. Furthermore, I want to suggest that this alliance between a form of imaging and a construction of objectivity tends to suppress ethically problematic trade-offs; and these trade-offs are all the more difficult to identify precisely because they are often buried in the norming assumptions of the algorithms in play, and because such algorithms and the software packages through which they are made available are proprietary. Thus, a key feature of the peer review processes that have traditionally characterized scientific processes is, at best, transformed or, worse, entirely absent. We review the images produced, but we do not generally have available the algorithms themselves or the software packages themselves for scrutiny. Thus, the translations, conversions, and assumptions built into the tools are not under interpretive consideration. In effect, as Bruno Latour has argued, agency, intentionality, and interpretive and ethical responsibility have shifted. They have become distributed properties of institutions and apparatuses. Latour writes:

> We must learn to attribute—redistribute—action to many more agents than are acceptable in either the materialist or sociological account... Purposeful action and intentionality may not be properties of objects, but they are not properties of humans either. They are properties of institutions, or apparatuses.... (Latour, 2009)

Furthermore, I want to argue that the ethical framework that implicitly operates within this computational episteme, when applied to the medical domain, is inevitably utilitarian, consequentialist, and statistical. That is, the very same assumptions that are operating ontologically in the computational construction of, for example, the brain as imaged by fMRI visualizations are also in play in the ethical assessments of its application. I hope to illustrate that these moves are problematic ontologically—such imaging operates on the assumption that particular brains are not violated in relation to the statistical model and brain mapping that governs the imaging—and that they are, therefore, also problematic ethically: there is no way to compare the adequacy of the image to an actual particular, and there is no scientifically or

ethically consistent process by which the norming assumptions of the algorithms can be submitted to epistemic or ethical evaluation when the software is proprietary.

The Digital Brain; the Computational Body; the Device Economy

In Galison's genealogy of objectivity in relation to the image, he points out, with judicious hints of Marx and Foucault, that the currency of photography in the era of "mechanical objectivity" was directly related to and ideologically assisted by the larger context of mechanization and discipline that was taking place in the 19th century. Mechanical objectivity and the impersonal, mechanized labor of the factory found their most committed apologists arguing for the same thing. The more mechanical the process, the better; the least likely the product would be the result of human variability or human intervention. Truth and the image, like efficiency in the automation of labor, are of a piece in the march of epistemic discipline and economic progress. I want to suggest an analogous set of relations in the present. As one can see in arguments for automated and driverless cars, automation ensures not only the most consistent and reliable outcomes, it is argued that such outcomes are also, therefore, the most ethical. I want to challenge this elision, both in terms of the ontological assumptions that induce it and the larger political economy of the digital that promotes it.

Megan Delehanty has argued convincingly that the fMRI of the brain is a curious hybrid. Our use of it tends to trade on features of both photographic picturing and mathematical modeling. In effect, we tend to fudge the gap between the production of data and the interpretation of data, between thinking photographically that the image is derived and epistemically justified in relation to an object, and thinking about "accuracy" in relation to how one mathematical image relates to a statistical norm, in the absence of any actual seeing at all. In effect, the fMRI is not a picture; it is a computational artifact all the way down. The image is not compared to a brain; it is compared to a statistical and generalized model of a brain, against which the particular image is normed for the sake of comparison (Delehanty, 2009). What I wish to do is employ Delehanty's analysis of this ontological and epistemic sleight of hand somewhat allegorically, in order to raise more general concerns about the elision of computational modes of imaging with computational ontology, and the elision of these with ethical considerations about the unstated norming and ethical evasions that follow symbiotically in the wake of a commercially and diagnostically supportive industry.

An fMRI of a brain is predicated upon a statistical and digital artefact that has not been derived from any normal practice of observation. It is derived from a mathematical model, not a photograph, nor any instrumentally assisted (analogue) act of sight. Thus, what it produces—the data—is blurred with the interpretation that generally follows *from* the collection of data. What it therefore acquires in precision and accuracy needs to be seen against a background of complicated digital translations and conversions that permit the visualization of nonvisible and empirically inaccessible phenomena. "Warping algorithms" are used to ensure that what is measured in one brain will be comparable to a standard, computationally produced reference space that is determined in advance. Such assumptions of statistical standardization and ontological homogeneity make not only the nature of reference and resemblance unclear—standard epistemic concerns—but the kinds of difference that might matter to us ethically are cancelled preemptively by virtue of the statistical aggregate that is in operation.

That there are different classes of complex reconstruction algorithms required to move from multiple planes of data collection to the production of a three-dimensional space, or that these in turn require trade-offs and approximations, is not the primary issue here. There are good pragmatic and consequentialist justifications for deploying such images. The ethical concern is that fMRIs are often treated as if they *were* pictures, produced as a result of an optically mediated correspondence between an actual brain and the properties of the image. This is not the case. In addition, the image–brain relation requires the eclipse of time. In this (temporal) sense, the imaged brain is deeply discontinuous with a basic phenomenological condition we associate with the neurologically and ecologically longitudinal dimensions of brains in relation to identity. The image suggests an atomic conception of embrainment that alters the actual conditions within which different brains come to be and to operate. The brain's developmental history and the already anticipated horizons toward which it strives operate in the present but they are absent in any atomic picture of the present.

Even more, however, such imaging is part of a larger ontological tendency to see the brain *as* a computational device all the way down. This is assisted by the computational theory of mind (CTM). An ambitious and enthusiastic alliance has emerged between the CTM and cyborg theory more generally, in which one can discern a literalization of technological—in this case computational—metaphors that frame conceptions of the brain and cognition. These metaphors also shape normative perspectives on how minds and bodies should be transformed in order to capitalize on technology's

capacity to automate, regulate, and represent the brain and body. The CTM latches onto computation as the master metaphor shaping its entire model of nature and, therefore, its concept of the brain/mind (Engström & Selinger, 2008).

Thus, the metaphorical slippage between technology and ontology lends the result—the computational brain—all the more happily to the forms of inquiry, representation, and intervention associated with a digital device economy, one that is happy to support the alliance. I am not arguing that we prevent the CTM from facilitating scientific utility; I am arguing only that we not unwittingly facilitate and translate scientific utility into a questionable commercial domain whose statistical and market-driven conceptions of identity are happy to exploit the ontology and so slip the question of ethics.

Consider Steven Pinker's not unrepresentative cyber-evangelism. He advertises CTM as "one of the greatest ideas in intellectual history" (Pinker, 1997, p. 24). He claims it "has solved millennia-old problems in philosophy, kicked off the computer revolution, posed the significant questions of neuroscience, and provided psychology with a magnificently fruitful agenda" (p. 77). Without CTM, he says, "it is impossible to make sense of the evolution of the mind" (pp. 24,27). In short: "The computational theory of mind…says that beliefs and desires are *information*, incarnated as configurations of symbols. The symbols are the physical brain states of bits of matter, like chips in a computer or neurons in the brain" (p. 25). By eliding symbols *with* matter, chips *with* neurons—all with the help of mysterious theological metaphors such as "incarnated"—we have moved from comparative "likeness" or simile to an identity between them that is confused. In effect, Pinker's view suggests that technological metaphors can slip their metaphoricity and serve as mirrors of nature, as points of correspondence with the real—a deeply problematic constellation of assumptions that were decisively critiqued by Richard Rorty (1979) in his now canonical account in *Philosophy and the Mirror of Nature*. The equivocation between insisting on this or that technology, metaphor, or model—on something we invent—and insisting at the same time that we treat them not as successful inventions but as "accurate representations"—as something we discover "corresponds" to or "mirrors" nature—simply evades the kind of analysis required by any philosophy of science and technology since Thomas Kuhn's *The Structure of Scientific Revolutions* (Kuhn, 1962).

Moreover, the ontological/metaphorical equivocations are comfortably compatible with a constellation of other larger forces: with the general political

economy of device production; with the increased marketing of informational ontologies; and with the development of interwoven corporate, medical, and political machineries of surveillance and bodily as well as social management systems that increasingly constitute the present. There is, in effect, a feedback loop between the commercial and the medical that transforms bodies and brains into statistical aggregates that appear, in their cumulative force, to lend them increasingly to this device economy and, in turn, to significantly alter and diminish the space of difference and deliberation where, I want to argue, the ethical resides. That is, once the brain/mind is construed as a computational device, it is a small step to see it as not only not ontologically different from the devices one might be persuaded to buy, but to see it at its best and most functional when intimately interwoven and integrated with them—as one device linked to another. The implications of such linkages are not innocent or unmotivated. See, for example, Andy Clark's *Natural-Born Cyborgs: Minds, Technologies and the Future of Human Intelligence* for a comprehensive and enthusiastic account of brain-technology mergers that is, on the reading offered here, blissfully unworried about the feedback loop among political economy, marketing, identity-technology mergers, and the ethical that is being considered here (Clark, 2003).

For thinking about the ethical, the absence of a deliberative space between thinking and algorithmic processing suggests a conversion of the ethical itself into a calculus. The brain-as-computational-device becomes one object among many that are being shaped by the interests of a device-driven economy, by consumption more than by ethical reflection. When commercially promoted tools and instruments become the dominant metaphors of identity—informational and digital—we are at risk of increasingly adopting the kinds of tasks and projects such tools are particularly good at: projects that can be increasingly automated or, at the very least, placed within the algorithmic setting that will provide the speediest and most efficient outcome. The space and slowness we might hope to associate with ethical deliberation is not one of those settings. The risk, in effect, is a kind of false transitivity: brain=informational and computational thing; and this is essentially the same ontological stuff of digital devices; thus, one might assume an increasing equivalence between the concerns devices are good at addressing and those ethical projects that concern us. We risk instrumentalizing ourselves and attending primarily to those tasks that are already concentrated within the technological sphere.

Deciding at the Speed of Light: Governmentality, Ethics, and Governance

Medical representation can become its own form of decision-making, algorithmically automatic, inducing a sense of objectivity, speed, and efficiency that the challenged professional, let alone the untrained and dependent patient, cannot keep up with. The agency of software is at play; speed itself becomes not only a form of agency, but it operates moreover on the premise that our agency, our slowness gets in the way of its operations.

In *The Speed of Light and the Virtualization of Reality*, Martin Jay explores the metaphysical consequences and implications of Roemer's 1676 discovery that light *has* velocity, that astronomical seeing is astronomical hindsight, that we do not share an immediate present with the distant objects we see (Jay, 2000). We don't have the real, even when bathed in light, as something immediately and instantaneously present to us. Jay takes this initial shock, displacement, and "virtualization of reality" and converts it into some potential advantages. Contra Jean Baudrillard et al., indexicality is *not* lost in this virtualization. Seeing a star is seeing a real trace of the past, and this kind of time-seeing is thus also a kind of foreknowledge; we gain time for adaptation to what has occurred light years away. In effect, for Jay, material embodiment is not left behind. The contrast at issue for Jay is not the virtual vs. the real but the virtual vs. the actual and immediately present; the virtual, on this view, provides an additional space for the possible. I want to suggest, however, that while Jay very helpfully rescues the indexical and the possible from the virtual, the virtualization of bodies and brains within the sphere of the digital image does run a risk, not of losing the indexical but of replacing it. A statistical model absorbs it, reconstructs it, and returns the index as something else. Its own ontology is not recoverable, even as a remote and informationally converted appearance of it is.

But I also want to add another and more operational concern regarding the speed of light, one that has been explored in a variety of provocative and ominous ways by Paul Virilio, "the philosopher of speed" (Virilio, 1977 [1986]). There is, perhaps, a double and compounding effect regarding the digitization of medical imaging. Not only are bodies and brains being produced by data and being transformed informationally into statistically normed entities, and made available via models that are not themselves particular entities. But in addition, the processes for monitoring and/or acting upon the real are increasingly taking place at the speed of light. This speed is increasingly establishing the norm for what counts as efficient and reliable process, while at the same time such processes move too fast for the kind of deliberative time we might hope to associate with interpretive and ethical intervention.

An Analogy: Being Driven by Automation

The driverless car, a popular issue of late, raises a usefully analogous concern regarding the ethical as automated, as a built-in statistical utility function, which short-circuits precisely what counts most in the domain of the ethical: deliberation, possibility, and imagining beyond or outside the parameters of the already calculated. In effect, the automated is a kind of governmentality. It operates not only with its own intentionality, but it shapes, and in the name of efficiency and safety, diminishes or circumvents altogether the parameters of deliberation. It squeezes into the speed of light the space required for thought, for intervention, for the kind of surprise and reframing that ethically motivated rethinking requires.

As an example of where the calculative can be confused with the ethical, it is occasionally argued that driverless cars—that is, cars that are not driven at all, but determined by automated software—are ethically superior to cars with drivers because they are safer, make "decisions" instantaneously, and avoid human errors of judgment which cost lives. There is no doubt a lot of truth in this, as well as some confusion. Such a view confuses programmable improvements in safety with ethics. Automated systems are not ethical, they are not unethical; they are calculations, algorithms, and these are by their very nature nondeliberative, that is, nonethical operations. We should beware of arguments that conflate the utterly indifferent and disinterested operation of a program with the deliberative and deeply interested—nonautomated— qualities of response that we associate with the ethical. As I have been argu- ing, this conflation, like the conflation of brain-image with photograph, rests on a thick tissue of metaphorical transference. We tend to anthropomorphize systems when we talk about what they do better than people. They do lots of things better than people, but being ethical is not one of them. So why beware of what's "merely" a slippage of language?

Programmed and driverless cars remind us of the classical dilemma of utilitarian calculus: "the trolley problem" first proposed and discussed by Philippa Foot and revisited often in relation to driverless cars (Foot, 1967). If the only option for the brakeless trolley or correctly programmed car is to "decide" to veer to the right and kill two or to the left and kill five—it is only the number, not the people that matter—we know what it will do. Insofar as a program is a computational device, it will compute. It will kill two. Of course, the automated car might "decide" to career head-on into a concrete wall and kill the "driver," but who's going to buy a car that could "decide" to sacrifice the driver? The ethical point here is that an actual driver might very well make such a decision. We might very well admire her for such an ethical choice.

The ethical occupies us, sometimes astonishes us, precisely because it transcends computation. What people will sometimes find themselves doing is the extraordinary, that is, doing something that defies any reasonable calculation. To put it in the extreme, think of the soldier who defies reason and self-regard to save others; the parent who does likewise to save a child; the lover whose care and spontaneous actions become devoted, beyond the calculable, to the welfare of the beloved? Clichéd and dramatic examples, but they should drive the point home: Automated cars don't love, don't care, aren't capable of the truly ethical. But the increased application of artificial intelligence or computational systems to the ethical—i.e., how to make driving safe and fMRI's diagnostically and therapeutically trustworthy and not just "more accurate"—requires that we not model the ethics of decision-making on the basis of the calculative processes by which such systems operate.

After all is said and done within the domain of utility and efficiency and automated calculation, the ethical is a form of imagination. It allows us to take leaps beyond what can be foreseen and programmed or known and calculated in advance; it allows us to suddenly fall upon a course of action or invent a course of action that has never been seen or taken before—we couldn't have calculated it. I'm implying here that many medical successes too rely precisely upon the kinds of imaginative leaps and inferences that are not the direct result of any linear logic of technical calculation or application. In a moment of imaginative flight or utter care for the other, a movement is made that defies the odds, that is, that defies the probabilities or odds upon which programs rely. And this we rightly honor as an example of the ethical, as a moment that took time. Automation takes no time; it is instantaneous time; it thus forecloses on the time-consuming business of the ethical. And medical decision-making is a context where such time is often essential.

But not only time. We know that one of the most essential elements of the ethical in medicine is its inseparability from empathy. And empathy has its roots in the contingency and vulnerability of life. A computational system doesn't experience vulnerability or empathy—it doesn't have a guiding disposition formed in relation to others—and so can't make an ethical judgment that relies on this cluster of psychological dispositions and relations. In effect, programs, and the increasing capacities they do indeed acquire through machine learning, don't have any of those properties we associate with our empathetic capacity to learn, or to learn to care, and subsequently reimagine or reframe what it can mean to be ethical.

Of course, when an automated car is tooling down a freeway or a monitoring machine is tooling away in the ICU, awake and never tired, vigilant

and never lazy, we understandably think in terms of efficiency over empathy—we happily deploy a host of anthropomorphizing metaphors to capture the benefit. The automated car will no doubt do a more predictably reliable job than I with the task of driving. But this doesn't make it ethically superior; it makes it calculatively more reliable. This is a good thing, but it is not an ethical thing. The car is not making better ethical decisions than we would. It is performing a task in which vulnerability and empathy play no role, thankfully. To construe a decision it might make as entailing vulnerability and empathy, or risk and imagination, or fear, sacrifice and agony, is not just a metaphorical projection of human ethical agency. The expectation of this kind of decision-making could only confuse it, only delay what it does so well: compute automatically. How many skills and capacities of our own might we be unwittingly diminishing, especially over time, if we increasingly hand off deliberation and responsibility to systems whose "smartness"—because of their speed—are detached from the ethically deliberative?

Perhaps the rhetorical question is too grand, too dramatic. The smaller point is that we don't live at the speed of light. We're slow. And such slowness may be both a phenomenological condition of being human and, therefore, a condition of the ethical. Perhaps the novel and not the program driving a car is the best genre for exploring and exemplifying the philosophical nature and value of slowness. See, for example, Milan Kundera's *Slowness* for a meditation on the value of slowness to the life of memory, history, and human connection at a time when we are increasingly submitted to systems of speed (Kundera, 1996). In effect, deliberation and ethical concern is increasingly at risk in a world that is ceding the domain of "decision-making" to the systematic encroachment of automation. We increasingly prize the continuous present of automated systems because that's what they're good at. They appear to relieve us of the anxiety of time, of the responsibility to decide. And it's profitable. Stock market decisions are automated, life-support systems are automated, automated systems now interact directly with other automated systems. Machines learn a lot from each other. There doesn't seem to be a dimension of life that isn't now vulnerable to a new and unprecedented condition: speed. And it is a speed that purposely excludes human intervention and deliberation: the ethical. Again, it's not that automation is bad, it's that it may sometimes work at the expense of something else that matters: deliberative slowness, and the trained responsibility that comes with attending to nonautomated and sometimes necessarily contested dimensions of decision-making. Automation is also a form of acceleration, an acceleration that "digital capitalism" produces and depends upon. In its wake comes an acceleration of life

more generally, an acceleration that is increasingly impervious to deliberative questioning or to any kind of external governance at all.

The risk is not that a significant proportion of public transportation or medical technology will become successfully automated. It is that having invented really successful digital technologies, we'll begin to privilege only those tasks they perform well, that we'll begin to favor behaviors and self-descriptions that are framed *by* such technologies—"neurobiology is just a form of computation"—and that we'll see the human as just so many information bits that are well or recalcitrantly aligned with digital devices. A position many computational evangelicals already espouse. But the more digital we become, the more difficult it might become to explain what the ethical is. Especially if it is explained as something more or less well calculated, programmed and executed.

Governance, Redux

Thus, speed can become its own kind of ontological drive and its own form of governmentality—in their operations, programs are by design not intended to be delayed by the kinds of deliberations we might wish to make. A logical connection I wish to suggest here is that the ethical can only be properly connected with—rather than overwhelmed by—the governmentality of speed if there is governance. By governance I mean a nonoperational space where the assumptions of an operation (whether a business operation or a software operation) are made available for deliberation, for intervention, for potential revision by policy. There are, of course, numerous models of governance in the political, corporate, and nonprofit domains. In this context, I am not intending to lay out a particular model, but only to suggest a space in which the ethical can find some meaningful purchase regarding the domain of the technical, operational, and automated; and this space I am conjoining with some principles and practices associated with governance. Loosely understood, I have university governance in mind as a general model:

- An academic senate is constituted not by those who profit from the involvement or manage the operation but by those who are elected for their representative competency;
- It is cross-disciplinary and thus represents multiple epistemic, normative, and institutional perspectives on a given issue;
- It operates and functions in the open, with transparency—like academic research itself, ideally—thus overcoming the privacy and secrecy

concerns that are built into software systems and whose assumptions
are not available to this kind of scrutiny and oversight;

- It recommends policies that help develop and sustain the kinds of
oversight that ensure the ethical dimension and integrity of an insti-
tution, and that ensure that its practices live up to some expressed
ethical standards;

- It is slow, purposely slower than administrative and operational sys-
tems, for the sake of providing a quality of participatory deliberation
and oversight that is entitled to question those systems.

The schematic and rather skeletal point here is that at a time when com-
putational systems are becoming increasingly central—epistemically, onto-
logically, and operationally—in making and managing our brains (through
fMRIs) and regulating our most vulnerable movements (in transportation
and military surveillance systems), their normatively built-in assumptions are
also becoming more hidden, more proprietary, and less available for scrutiny
and oversight. The argument here is that such scrutiny and oversight, espe-
cially regarding the ethical, would be best secured by being coupled directly
with governance systems.

For the conceptual purposes of this chapter, the question is not what
kind of governance system is best—whether national, corporate, academic, or
other—but, rather, what prospects does the full evaluation of operating at the
speed of light, and of submitting to the statistically norming consequences
of such operations have, in the absence of systemic slowness, of deliberation?
In effect, how do we make such operations and their underlying assumptions
and consequences systemically accountable to a form of deliberation, rather
than allowing them to be the result of mere market forces of advertising and
consumption? These are not rhetorical questions. The accumulating power
and effects of computational systems amount to a form of governmentality
that, in the present, resides well outside the reach of governance.

In shifting from the ontological and ethical questions raised by brain
imaging and the medical management of bodies to issues of automation,
speed, and governmentality more generally, my hope is that some ethical con-
necting tissue has been established. In both cases, systems of governance—of
purposeful and deliberative slowness—seem required if there is to be a real
space where sustained ethical reflection on the challenges of digital technol-
ogies can take place.

References

Clark, A. (2003). *Natural-born cyborgs: Minds, technologies and the future of human intelligence.* New York, NY: Oxford University Press.

Delehanty, M. (2009). The epistemic function of brain images. In T. Engström & E. Selinger (Eds.), *Rethinking theories & practices of imaging* (pp. 146–163). London: Palgrave Macmillan.

Engström, T., & Selinger, E. (2008). A moratorium on cyborgs: Computation, cognition, and commerce. *Phenomenology and the Cognitive Sciences, 7*(3), 327–341.

Foot, P. (1967). The problem of abortion and the doctrine of the double effect. *Oxford Review, 5,* 5–15.

Galison, P. (1998). Judgment against objectivity. In P. Galison & C. A. Jones (Eds.), *Picturing science, producing art.* New York, NY: Routledge Press.

Galison, P. (1999). Objectivity as romantic. In J. Friedman, P. Galison, & S. Haack (Eds.), *The humanities and the sciences* (American Council of Learned Societies). Occasional Paper No. 47:15–43.

Gombrich, E. H. (1960). *Art and illusion: A study in the psychology of pictorial representation,* Princeton, NJ: Princeton University Press.

Ihde, D. (2009). Phenomenology and imaging: Interpreting the material. In T. Engström & E. Selinger (Eds.), *Rethinking theories & practices of imaging* (pp. 94–110). London: Palgrave Macmillan.

Jay, M. (2000). The speed of light and the virtualization of reality. In K. Goldberg (Ed.), *The robot in the garden: Tele-robotics and telepresence in the age of the internet* (pp. 144–163). Boston, MA: MIT Press.

Kuhn, T. (1962). *The structure of scientific revolutions.* Chicago, IL: University of Chicago Press.

Kundera, M. (1996). *Slowness.* New York, NY: Harper Collins.

Latour, B. (2009). A collective of humans and nonhumans: Following Daedalus's labyrinth. In D. Kaplan (Ed.), *Readings in the philosophy of technology* (pp. 156–172). New York, NY: Rowan & Littlefield.

Pinker, S. (1997). *How the mind works.* New York, NY: Norton & Company.

Rorty, R. (1979). *Philosophy and the mirror of nature.* Princeton, NJ: Princeton University Press.

Virilio, P. (1977 [1986]). *Speed and politics.* New York, NY: Semiotext(e).

10. Spatial Ethics and the Public Forum: Protecting the Process of Creating Public Space and Meaning

David S. Allen

Introduction

Citizens have long sought spaces to discuss the issues of the day (Inazu, 2015, p. 1165). From coffee houses to street corners, those spaces, whether public or private, have been viewed as being vital to democratic life. As histories of these spaces demonstrate, citizenship requires not only the passive reception of information, but also space for citizens to actively discuss and make sense of that information (e.g., Carp, 2007; Habermas, 1989b; and Wallace, 2012).

Historically, media have struggled to find ways to meet both of those requirements. For example, New York newspaper companies in the early 1900s used spaces outside of their buildings to attract crowds, providing evidence that they had the "ability to convene a public" (Wallace, 2012, p. 88). In the 1990s, the public journalism movement used town meetings and listening sessions to encourage citizens to become more active citizens (Charity, 1995).

Social media is the latest attempt to meet these diverse spatial requirements of democracy. While news organizations and newsmakers use social media to gain attention and influence, citizens use these platforms to reinterpret these messages and create meaning. All across the social-media stage citizens struggle to create meaning from the events of the day. It is emblematic of the traditional American idea of a public forum—a place where citizens come together to exchange ideas. Yet, by legal definition, these social media spaces are far from being a public forum. They are, rather, private space that has been opened to citizens, but still under the control of corporate entities, such as Facebook and Twitter.

This chapter explores the spatial questions that arise around the American idea of the public forum and the construction of meaning. Despite general agreement that some type of public forum is vital to democratic life, its ethical contours are rarely examined and remain hidden behind a layer of legal and regulatory rhetoric. Much of the legal literature is devoted to tracking the often-confusing definitional problems associated with the development of today's public forum doctrine,[1] making questions of expressive freedom dependent upon the type of property a citizen uses (Post, 1987). The idea of the public forum provides both a descriptive and normative foundation for democracy. It seeks to capture some normative democratic goal, while also describing actual physical space that exists within society. Much of the legal discussion focuses on the descriptive nature of the problem. However, hidden behind that legal rhetoric are complex ethical arguments about the role that public space ought to play in the realization of democracy. And while the ethics of the public forum have either been generally ignored or forgotten, this chapter suggests that an increased attention to the spatiality of public life helps identify the possibilities and challenges presented by a digital public forum.

The first part of the chapter argues that ideas about the public forum are constructed on frameworks that see public space as something that exists independent of citizens. As such, space is a fixed object that is enlisted in the pursuit of some given end, whether it be to create more virtuous citizens, build community, or control expressive activities.

More recent space theorists, however, suggest that digital technologies have given rise to a new understanding of the spatiality of the public forum. Rather than space being something citizens use, space is something that citizens create through their interactions with other citizens in order to create meaning. Space, as such, is dynamic, ever changing, and participatory. The second part of this chapter suggests that this rethinking of space fundamentally changes the ethical foundation upon which the public forum is built. As a result, social-media discussions are a public forum, but not because of the existing space it uses, but rather because citizens create democratic space through their interactions. It will be suggested that retheorizing public space in this way raises interesting questions and new possibilities about the spatial ethics of the public forum.

The Ethical Roots of the Public Forum

The ethical assumptions that lie at the heart of the idea of the public forum have long been ignored. While scholars have generally viewed the idea of the public forum as being central to the realization of democracy (Kalven,

1965), scholarly discussion about the public forum is most commonly viewed through the lens of legal and policy analyses (see Zick, 2009b). This is especially troublesome when legal discussion about the public forum does not seriously begin until the late 1930s (see *Hague v. CIO*, 1939), while popular discourse concerning something called the public forum can be found in the United States as early as the 1800s.[2] This suggests that the public forum's roots lie deeper in American democratic thought than most legal scholarship suggests.

My previous research has mapped not only the legal history of the public forum, but its broader ethical, social, and cultural development (see Allen, 2011, 2014). Rather than discovering *the* idea of the public forum, however, that research revealed complex, shifting ideas about the role the public forum plays within society. Responding to discourses about the role of public space and democratic life, those shifts brought with them fundamental assumptions about the ethics of public life and the public forum. I refer to those shifts as spatial frameworks[3] in an attempt to capture the connections between expression, the space within which that expression is performed, the regulatory and cultural constraints that are imposed on both expression and space, and the ethical role public space is envisioned as playing in democracy. These spatial frameworks allow us to see that the public forum, rather than being a fixed and stable concept, is an idea that changes along with American culture. It also allows us to see that the public forum, rather than being primarily a legal or policy construction, is a concept that tells us much about the changing ideas about the ethics of public life.

Research shows that three spatial frameworks have dominated ideas about the public forum in American history (Allen, 2011). *The Property Framework*, dominant in the United States until about the 1920s, viewed governmental ownership and control of public space as being vital to the creation of virtuous citizens. *The Place Framework*, achieving prominence in the 1930s, had strong connections to American Pragmatism. It viewed public space as being vital to the creation of an active community based on discussion and sought to identify distinct areas where citizens would come together to debate the issues of the day. *The Planning Framework* dominates current thinking about the public forum. It is concerned with the categorization of public expressive space and acts as a form of social control. The following describes the ethical assumptions about public space articulated in each spatial framework.

The Property Framework

The Property Framework carved out a role for public space to play in training people to be virtuous citizens. This was accomplished by encouraging citizens to become property owners. Granted constitutional status in 1791 (see U.S. Const., amend. V), property rights were originally viewed as being the central way of protecting all other rights of citizenship (Ely, 1992). As such, property rights were not simply a way of securing the control of space and territory, or of securing financial resources, but also a way of creating more virtuous citizens. In the eyes of people such as Thomas Jefferson and John Adams, it was through land ownership that citizens would feel connected to the land and work to become responsible citizens (Alexander, 1997, pp. 43–59). Property rights also enabled citizens to become involved in public life, allowing them to express their ideas freely (Alexander, 1997, p. 31).

For some, this period was viewed as a period of intense individualism. However, that individualism was also guided by the notion that those private interests were embedded in ideas about the common welfare (Alexander, 1997, p. 29). Property was vital to the realization of that goal, for the free circulation of property became the way for citizens to realize virtue and to have the freedom to participate in public life (Alexander, 1997, p. 31). These ideas brought with them assumptions about how democracy ought to function, where property-owning citizens have freedom of entry with an absence of limits, where social mobility is possible, and, perhaps most importantly, where possessions are used not only for individual gain but also for the creation of the common good (Fisher, 1988, p. 66).

Some have argued that the connections between virtue and property, so central to early American legal thought, diminished by the late 19th century, replaced by *laissez-faire* constitutionalism, a doctrine that was far more interested in creating economic freedom for individuals in the marketplace than it was for developing virtuous citizens (see Jones, 1967; McCurdy, 1975). However, more recent scholarship has demonstrated that this movement was more complex than originally thought and that *laissez-faire* constitutionalism still brought with it ideas about the public good (Alexander, 1997, p. 249). That notion was officially recognized by the U.S. Supreme Court when it ruled that the government could regulate private property affected with a public interest. Known as the "affectation doctrine," it recognized that certain kinds of property helped "maintain a proper social order" within society (Alexander, 1997, p. 263).

Maintenance of that proper social order was achieved through the primary legal tool used to manage public space, the police power. It gave government

the right to act in ways that promoted the public welfare (Freund, 1976/1904, p. 3). Much of the discussion of the police power in those years was shaped by the Ernst Freund's classic work, *The Police Power* (1976/1904). Freund, a progressive University of Chicago law professor who is often credited with beginning the administrative law movement, divided ideas about the police power into three spheres or categories: (1) a "conceded sphere" where ever-increasing levels of regulation affect the safety, order and morals of society, (2) a "debatable sphere" concerned with the regulation of production and distribution of wealth, and (3) an "exempt sphere" where moral, intellectual and political movements are protected by individual liberty (Freund, 1976/1904, p. 11). While Freund admitted that these spheres often overlap, this categorization was intended to make administrative law not only easier for government to use, but also as a way to constrain government.[4] For Freund, "speech and press are primarily free, but that does not prevent them from being subject to restraints in the interest of good order or morality" (1976/1904, p. 11). This management of the speech and press was acceptable as long as it was done in a way that was "uniform, impartial and reasonable" (Freund, 1976/1904, p. 521).

Flowing from the police power, parks and streets were viewed as government property, with the government making decisions about what uses would contribute to the creation of a more virtuous citizenry. This is reflected not only in the dominant test of freedom of speech used during this period, the bad tendency test,[5] but also in ideas about the use of public parks. Following the landscape architecture movement in the late 1800s and early 1900s, public space was vital to improving people's health, but also to providing moral uplift and teaching them to be better citizens. As a result, Frederick Law Olmsted, after designing the great public space that is New York's Central Park, instituted a police force to teach people how to properly use the space (Schuyler, 1986, p. 114). This idea is also reflected in the dominant U.S. Supreme Court decision of the era, *Davis v. Massachusetts*, where it was ruled that a city could control its parks much as a homeowner controls his/her house (*Davis v. Massachusetts*, 1897, p. 47).

The Property Framework, then, was built on a number of normative assumptions. While seeing individual property rights as the best way to create more ethical citizens, it also recognized the ethical responsibilities those citizens had as being a member of society. Public space was little more than private space—whether owned by private or governmental parties—that could, for the right purposes, be opened for use by citizens. At the heart of the Property Framework was the idea that citizens would be made better through their engagement with property, whether privately or publicly owned.

The Place Framework

The property-based idea that public space was under the control of an owner, either public or private, was challenged in the early 1900s. Heavily influenced by ideas linked to the Progressive movement and American pragmatism, the purpose of public space was re-imagined. Rather than simply being seen as a tool for creating better citizens, public space was envisioned as the place where citizens put those hard-earned skills into practice—space where democracy was realized.

This transition required a fundamental redefinition of the very idea of property. Led by Progressive challenges in the early 1900s, property was not simply about some relationship between a person and thing (either tangible or intangible), but rather property involved a bundle of associated rights that went far beyond traditional limits of property. Viewing property as being inherently relational and social (Ely, 1914, p. 96), Progressives argued that property could be used to achieve a variety of public goods. Morris R. Cohen, for example, argued for the elimination of the idea that property existed prior to government. As such, property rights were a creation of government, giving government a greater ability to regulate society. Cohen preferred a more positive role for government that was aimed at finding ways for government to use property to improve society (Cohen, 1927, p. 19).

The recognition that government was heavily embedded in the very creation of property rights was also recognized in judicial decisions, with courts increasingly recognizing that all property was embedded with a public interest. This growing awareness of the social component of property also had ties to suspicions about the power of property. For some, property was no longer the way to protect individual liberty, but property, held by both individual and corporate interests, was being used by the powerful to limit the freedom of other citizens (Reich, 1994, p. 772). Within the legal community, this criticism was recognized by the U.S. Supreme Court in 1934, with Justice Owen Roberts arguing that it is difficult to imagine a private property right that does not in some way "affect the public" (*Nebbia v. New York*, 1934, pp. 524–525).

In the late 1930s, a committee of the American Bar Association, led by Grenville Clark and Zechariah Chafee, Jr., set out to change the legal precedents that were central to the establishment of the Property Framework. In an influential legal brief submitted to the U.S. Supreme Court in *Hague v. CIO* (1939), where the Court for the first time recognized the idea of the public forum, Clark and Chafee argued that a city, as owner of public space, should not be allowed to prevent labor unions from engaging in public organizing

activities. Rather than allowing government to decide how parks and streets ought to be used, they argued that proper use should be determined by how citizens actually used public space. As a way of distinguishing this new definition of public space from the idea of property, Clark and Chafee simply referred to it is "place" (see Allen, 2014). As a result, for a short period of time streets and parks were widely opened to expressive activities in the United States.[6]

By the late 1930s, then, both the legal and cultural notion of public space had been transformed. Gone was the idea that property ownership was central to creating more virtuous citizens and protecting individual freedom. Gone as well was the idea that exposing citizens to open spaces would lead to moral uplift. It was replaced by the idea that embedded in all property was a social component that invited society to figure out how to best manage that property. Public space was no longer something to be admired from afar, but was something to be used and engaged with. The government's role in the Place Framework was not to make determinations about what types of activities would create more virtuous citizens, but rather it was to serve as an independent traffic cop, making sure that all citizens and viewpoints had access to public space. Virtue was to be created through discussion and interaction, and public space was the venue where that discussion would take place.

The Planning Framework

As the Place Framework was being established and legitimized within American society, a rival framework was already in its formative years. With roots in ideas about the police power and older notions of property, critics of the Place Framework began to look for answers in the increasingly popular planning and zoning movements. Zoning can be traced to the late 1800s, but the adoption of a zoning ordinance in New York in 1916 gave the planning movement a significant boost (Hall, 2002, p. 60). While the desire for democratic discourse drove the advocates of the Place Framework, the need for order, organization, and efficiency was at the heart of the Planning Framework. As a result, today's Planning Framework brings together older notions of control central to the Property Framework, while building on the idea from Place theorists that government ought to play an important role in management of public space.

Planning and zoning require a clear articulation of not only the *space* in which expression will be allowed, but also *definitions* of the expression that will be allowed within that space. As a result, the public forum increasingly came to be defined by the categorization of not only expressive acts, but the

space where those acts occurred (see Abbott, 1995; Blocher, 2009; Jones, 2009, 2010; Lamont & Molnár, 2002; and Sullivan, 1992). The Place Framework neither offered nor required such definitions. Expressive freedom was based more on the use citizens brought to public space. The Planning Framework instead created a public sphere that was heavily managed by government through defined space and rules about how citizens might use that space.

In the Place Framework, public space was envisioned as being transparent and permeable, allowing citizens free access to space to increase the diversity of information. In the Planning Framework boundaries tend to be more secure and far less permeable. Rather than being envisioned as a way to bring groups together, space is viewed as a way to contain dissent to achieve some desired end. This means-end perspective is at the heart of the planning movement itself. Robert Upton has argued that the practice of planning is nothing more or less than "spatial ethics" (2002, p. 254). Scholars have noted the importance of utilitarian thinking to the practice of planning. Or, as Upton writes, planning is a "value-rational approach to assessing the outcomes of various courses of action with a view to maximizing well-being" (2002, p. 256).

The Planning Framework provided not only a spatial organization of society, but also a way to use surveillance as a form of control. As the boundaries of public space became harder and more secure, improving surveillance and control, space became a way to separate those who are engaged in expressive activities from those who are not. The public forum in the Planning Framework was not a place to bring people together but rather a space intended to isolate and control nuisances. As a result, the Planning Framework provides a justification for limits of expression such as free speech zones (see Allen, 2011).

The legal foundation for the Planning Framework was established in the early 1970s with the categorization of public space. This categorization, which has come to be called the public forum doctrine, puts forward, in Robert C. Post's words, a "byzantine scheme of constitutional rules" to determine when citizens can use public space for expressive purposes (Post, 1987, p. 1715). The U.S. Supreme Court formally began the categorization of space in *Police Department of Chicago v. Mosley* (1972), but the basic categories that exist today were formalized in *Perry Educational Association v. Perry Local Educators' Association* (1983). Those categories are: traditional public forum (a place that is by tradition or government fiat open to public assembly and debate), a limited public forum (government space open to some members of the public to discuss a limited range of topics), and a nonpublic forum (government-controlled property that is not open to the public) (*Cornelius v. NAACP Legal Defense and Educational Fund*, 1985).

As legal scholars have noted, the dominant line of public forum cases suggest that the type of space that a speaker elects to use determines the amount of expressive freedom that citizens enjoy (Zick, 2009b, p. 53). Within these types of cases, value judgments about the expressive act were often not a part of the equation (see Nimmer, 1984). The public forum doctrine frees government, much as it was in the Property Framework, to determine what constitutes the public welfare. As Post sums up the public forum doctrine, "In the end the public realm created by the public forum doctrine is nothing other than a governmentally protected public space for the achievement of private ordering" (Post, 1987, p. 1800).

The Planning Framework draws on many of the same ideas that were central to the Property Framework but also changes them in important ways. Both make explicit moral claims about the purpose of public space within society. However, those moral claims in the Planning Framework are hidden behind a complex, highly rationalized layer of spatial ordering that few can understand. Using the establishment of "value-neutral" categories and boundaries, public life in the Planning Framework becomes little more than a government-shaped arena for the display of individual expression. For many advocates of the Planning Framework, viewing public space as an area capable of bringing people together into a community was little more than naïve idealism.

Toward a New Spatial Ethic: The Process Framework

The ideas that shaped the American public forum are filled with ethical assumptions about the role public space plays in democracy. Dominant interpretations of public space have changed from being about the socialization of citizens, to the formation of community, to the control and maintenance of individual expressive acts in pursuit of order and efficiency. And while each framework articulates different values central to public life, they share a general assumption about public space. That is, that public space is something that is *used* by citizens and exists independent of citizens.

Newer ideas about space, driven by the development and popularization of digital technologies, require us to ask different questions about the space that is the public forum. Following Henri Lefebvre, it is suggested that to truly understand the problems facing today's public forum requires that we shift our analysis from investigating how citizens *use* public space and begin thinking about how citizens *create* public space (Lefebvre, 1984, p. 37).

Ideas about the production of space have a long history and a number of scholars have recognized that citizens play an active role in creating or forming public space. Some have attacked the question through the actions of citizens themselves, preferring to find ways to privilege the conditions that citizens need to create democratic space. While John Dewey did not directly address the question of public space in his work, it is clear that his notion of community was not contained by physical boundaries. Seeing community as constituted through communication, Dewey recognized the constructed nature of both public spaces and the idea of the public itself (1927, p. 142). As Dewey noted, the public is "unorganized and formless," and is brought into existence only through "associated activity" (1927, p. 67).

Hannah Arendt brought much of the same spatial conception of public space to her thinking—ideas that she traced directly to ancient Greece. For Arendt, the *polis*[7] was not confined or defined by the physical contours of the city-state. As she wrote, "[I]t is the organization of the people as it arises out of acting and speaking together, and its true space lies between people living together for this purpose, no matter where they happen to be" (1958, p. 198). Arendt noted that this space is constituted through speech and action, differing from physical space because it "does not always exist" (1958, p. 199).

Following Arendt, Jürgen Habermas has offered one of the more complete theories for the role citizens play in constructing their world. In his detailed account of the public sphere, both historical (Habermas, 1989b) and theoretical (Habermas, 1996), he demonstrates how public space is created through the interaction of citizens. For Habermas, the idea of the public sphere as a social space refers "neither to the *functions* nor to the *contents* of everyday communication but to the *social space* generated in communicative action" (Habermas, 1996, p. 360).

This social space is built on a number of ethical assumptions for Habermas. In the ideal speech situation citizens would be motivated not by the desire to win, but by the goal of trying to achieve understanding. And while that goal might be rarely achieved, it is an assumption that enables us to continue to engage in discursive acts (McCarthy, 1988, p. 309). Closely related to the ideal speech situation is the idea of the discourse ethics. Here Habermas develops moral principles that serve as a guide for interpreters and actors engaged in discourse. In short, discourse ethics suggests that a norm can only be considered to be valid if all who would be affected have consented to it, after considering consequences and side effects, and if it is universally valid (see Habermas, 1990). All of this presupposes that citizens can reach mutual consent on controversial issues not because of some naïve idealism, but rather because it points us to the ethics that ought to guide our interactions with

other citizens. Habermas, then, reminds us that at the heart of the construction of social space are essential ethical ideals. Flowing from those ideas is a discourse, as Habermas notes, that "unfolds in a linguistically constituted public space" (1996, p. 361).

Citizens do not, however, enter into relationships with others simply to create public space. In democratic theory, public space, which is a part of a larger public sphere, exists to allow people to share ideas and create meaning. At the root of these interactions is the need to create meaning about their activities, both public and private, that comprises the world of citizens. As Habermas has noted, meaning is created within discursive communities (Habermas, 1989a/1981, p. 7). Sut Jhally has noted the importance of the "human need for meaning," especially in a capitalist society that empties most products and productions of meaning. Society requires a "cultural process" to give meaning to our lives (Jhally, 1987, p. 189). As Jhally notes, "Meaning is not secondary. It is constitutive of human experience" (1987, p. 189).

The creation of meaning is vital not only to the political world, but to a range of discourses central to public life. Those discourses center on a variety of topics and occupy a range of spaces, often serving to empower citizens. Giroux noted the importance of meaning to the creation of "active and critical citizens capable of fighting for and reconstructing democratic public life" (Giroux, 1992, p. 199). Cohen argued that the more highly developed critical viewing skills are among TV watchers, the better able they are to participate in democratic life. Part of critical viewing is learning to acknowledge the idea that there might be multiple meanings of an expressive act (Cohen, 1994, p. 107). Similar conclusions are drawn by Jenkins, who found the reconstruction of TV narratives by fans to be a spark to participatory culture. Although Jenkins stopped short of saying that fandom makes all audiences active, he argued it does prove that not all audiences are passive (1992). While critics of contemporary culture point to manipulative forms of communication as the desire to create audiences where none exist, Jenkins argued that fans work to carve out participatory space from a cultural enterprise that is intended to isolate them (Jenkins, 1992, p. 284). Today, often through technology, citizens struggle to create that space where they can create the meanings that are vital to democratic life.

Scholars have approached the creation of that participatory space not only from the perspective of citizens, but also by investigating the changing notion of public and private space itself, especially with the introduction and popularization of digital technologies. Rather than envisioning space as being fixed and static, these newer ideas see space as being contingent and active.

Virtual Space and the Process Framework

Kitchin and Dodge have noted that it is not simply citizen actions that create space, but also the increasing interaction of citizens with digital technologies. When "software and the spatiality of everyday life become mutually constituted," code/space is created (Kitchin & Dodge, 2011, p. 16). Code/space lacks a fixed ontology, but operates as an unfolding practice. As a result, in comparison to traditional notions of space, code/space is contingent, relational and active (Kitchin & Dodge, 2011, p. 67). Kitchin and Dodge do not see code/space as being inert, or simply good or bad, but rather as productive. As they write, "Software opens up new spaces as much as it closes existing ones" (2011, p. 19). As such, control and surveillance is inherently a part of code/space, just as that process also opens up new venues for democratic opportunities. They note that little thought has been given to the normative ethical questions associated with the rise of code/space, often focusing solely on questions of data collection (2011, p. 254).

While there is disagreement about the relationship between real and virtual space, and whether these spaces exist in opposition to each other or operate in conjunction with each other (see Kellerman, 2014), some have suggested that digital technologies have at the very least offered another venue for citizens. Labeling virtual space as "second action space," Kellerman suggests that virtual space is more flexible than real space in "both its construction and in moving through it" (2014, p. 151).

Ideas about the way citizens create space through their interactions, through the way space is created by engaging with newer technologies, challenge assumptions about space that are at the root of theorizing about the public forum. It can no longer be assumed that public space is simply space citizens occupy for a period of time in order to engage in expressive acts, an idea shared by the Property, Place, and Planning frameworks. Rather it is becoming increasingly clear that citizens create space through their interaction with other citizens and technology. And while that constructed nature of space has long been recognized, theorizing about the public forum has failed to account for that insight. While the Property, Place, and Planning frameworks shared many differences, they all relied on the ability to permanently fix spatial boundaries and clearly articulate how public space was to be used. As a result, theorizing about the public forum has been unable to adequately account for the technological changes that have transformed the public forum. Much of the space citizens use for discussion today defies attempts to contain it within physical boundaries and as a result it is difficult to control.

What is needed is a new spatial framework that guides the ethical assumptions about the foundation of the public forum. Rather than envisioning public space as something to be used in the pursuit of some end (whether it be creating better citizens, creating community, or as a system of control), this framework, which I call the Process Framework, would work to protect the process of the production of social space and meaning making.

The Process Framework not only changes our understanding of the public forum, but it also changes ideas about what needs to be protected. As citizens produce space, it is no longer simply enough to protect the expressive acts that occur in the public forum, but we also need to find ways to protect the process of creating public space.

If we take seriously the idea that public space is not something that exists independent of citizens, but rather something that citizens create through their daily interactions, the ethical foundation of the idea of the public forum shifts in important ways. It moves from identifying spaces where citizens might meet, to trying to protect the process vital to the formation of public space and meaning. As such, a spatial ethics of public life requires cultural and institutional support of both the creation of public space and meaning making. This is accomplished not only by protecting these processes, but also by recognizing the openness of the meaning of expressive activities. Too often forces within democratic society, such as judicial, political, and media institutions, work to establish the dominant meaning of expressive activities (see White, 1990). By doing so, they close off the possibility of alternative-meaning formation. The Process Framework is an attempt to protect the ability of citizens to create meaning and the space within which that meaning is created. Central to this Process Framework is a new spatial ethic. The Process Framework changes our ethical focus to the creation of meaning and space, recognizing that democratic life is no longer bound by place and that through technology lies an opportunity for greater expressive freedom.

Applying the Process Framework

While an in-depth examination of the Process Framework is beyond the scope of this chapter, the following uses the 2011 protests against the Bay Area Rapid Transit (BART) in the San Francisco area as an example of how it leads to a rethinking of the public forum and to new and different protections for expressive activities.

The BART protest was organized by No Justice No Bart (NJNB), a group that formed in 2009 to protest the killing by BART police of a homeless man. In July 2011, BART police shot and killed another man, who was

wielding a knife and refused to comply with their orders. Police had claimed the man charged officers. As a result, NJNB organized a protest that resulted in about 100 people standing on BART platforms and holding train doors open, effectively preventing the trains from continuing onto the next stop (Fleming, 2012, p. 634).

In August 2011 NJNB began using mobile devices to organize a second protest, apparently hoping to disrupt train service through the use of flash mobs. In an effort to disrupt the protests, BART shutdown its underground wireless communication network from 4 to 7 p.m. in a stretch of the tunnels. Since BART owned and controlled the network, it was able to stop cell phone and wireless communication in its underground tunnels (Fleming, 2012, p. 634).[8] BART officials claimed the "temporary interruption of cell phone service was not intended to and did not affect any First Amendment rights of any person to protest in a lawful manner in areas at BART stations that are open for expressive activity. The interruption did prevent the planned coordination of illegal activity on the BART platforms, and the resulting threat to public safety" (Lackert, 2012, p. 594). The wireless network shutdown apparently worked, as the protest never occurred (Pitzel, 2013, p. 790).

While no lawsuits were filed after BART's actions, scholars have wrestled with its legality. Not unexpectedly, most analyses begin with the foundational legal question of whether the BART wireless system qualifies as a public forum and, if so, what kind of public forum. For example, Rachel Lackert, while arguing for more protection for a virtual public forum, concluded that BART stations are "government-owned and created for transportation purposes." As a result, the stations will generally be considered to be a nonpublic forum (Lackert, 2012, p. 595). First Amendment scholar Eugene Volokh suggested that BART was only limiting cellphone service on its own property, and "the government has a good deal of authority to impose content-based but viewpoint-neutral and reasonable restrictions" (2011). Pitzel suggested the public-forum issue was more complicated, seeing the platforms themselves as nonpublic forums but the wireless network as a designated public forum (2013, pp. 805–806). Others found the public forum tests inadequate for dealing with the problem, calling on courts to "catch up to modern technology" (Fleming, 2012, p. 661).

All were operating from the traditional understanding of space that dominated discussions about the Property, Place, and Planning frameworks. Public space has clearly established boundaries that bring with it clearly defined ideas about appropriate use. Following the Planning Framework, spatial boundaries that limit expressive activities are sufficient as long as they provide adequate opportunities for dissent in some other location.[9] As the BART officials

noted, if citizens wanted to protest they would only need to move to those spaces where expressive activities were allowed. What is most noteworthy about the discussion about BART's actions, then, is the inability of the system's critics to move beyond ideas central to the public forum doctrine and its dated ideas about public space.

The Process Framework requires that we think about this problem in a very different way. Rather than seeing the public forum as a space that citizens need to enter into, it sees citizens as creating space as they engage in discussions and actions central to their lives. The Process Framework calls on society—both institutionally and culturally—to not only protect the discussions about the protest, but also the space that emerges through that citizen interaction. As such, the Process Framework begins with the assumption that people, in using the wireless network to communicate and discuss the issues of the day, create a wide range of public *fora*. All are to be valued as discursive opportunities. In the Process Framework, once a wireless system has been established, it is vital that authorities remove themselves from making decisions about the content of those discussions. That is not only a regulatory, but an ethical requirement that is vital to democratic discourse.

The value that ought to be protected is the ability of people to come together and discuss and act on the issues of the day. Might the network be used by some to organize a protest? Yes, it probably will. But that is unlikely to be its only use. Through the sharing of information and views, the community—the network—plays a role in shaping that community's reaction to it, as well as a role in shaping the protest itself. BART itself noted the important role public space plays in community formation and security. BART's wireless network was created in 2004 at least partly in response to the September 11, 2001, terrorist attacks. In doing so, it recognized the value of a virtual community serving as an important element of public safety (Galperin, 2011). Elaine Scarry, who has suggested that the 9/11 terrorist attacks demonstrated that citizen action might be our best defense against terrorist attacks, has noted this important role of the community. Scarry has argued that proposals to allow government to take over wireless networks during times of emergencies pre-empts "the very form of defense that did work (the citizenry) and [gives] their tools to the form of defense that did not work (the official government)" (2006, pp. 198–199).

Rather than valuing the BART protest as the beginning of a process for forming both meaning and public space, shutting down the wireless system served to establish an entirely different meaning. Rather than a democratic, discursive opportunity, shutting down the wireless system helped establish the meaning of the event as a threat to order and efficiency. Closing down the

wireless network not only disrupted potential protesters, but it also limited the options available to citizens to make sense of the events that were happening around them. Facing a perceived threat to the system's order and efficiency, BART turned to the one place that has long served as an instrument of control—the control of public space.

Conclusion

While the public forum remains a vital part of democratic life, newer technologies continue to reshape the way citizens use/create public space to create meaning in their lives. Despite this, theorizing about the public forum has fallen behind how citizens are actually using and engaging with public space. The history of the American public forum demonstrates that rather than being a singular experience, it has been shaped by political, economic, social and cultural forces. As such, today's public forum needs to take seriously the impact that technology has on the ability of citizens to not only engage with public space to create meaning, but how citizens also use those technologies to create the very space that citizens need for the realization of democracy. The Process Framework is an attempt to begin that conversation about not only the regulatory structure of the public forum, but also the important ethical role that needs to be identified for citizens and institutions to play in the process of creating an active, vital public forum.

Notes

1. The public forum doctrine generally uses the type of property employed in an expressive act to determine how much freedom a citizen enjoys.
2. For example, as early as 1882 the *Los Angeles Times* printed letters to the editor in a section it referred to as the "Public Forum" (*Los Angeles Times*, 1882, p. 3). In 1891, the *Chicago Daily Tribune* proposed that a new "art and library structure" constructed for the Chicago World's Fair be retained as a place for "popular gatherings—a great public forum" (*Chicago Daily Tribune*, 1891, p. 4). In addition, historian David A. Ryfe has suggested that 19th-century newspaper coverage of presidential campaigns reflect a cultural value in the "associational assumptions of public life," a value that is central to the idea of the public forum (2006, p. 67).
3. Several scholars have used the term spatial framework. Timothy Zick has suggested that the Constitution puts forward a spatial framework that "contains troubling extra-territorial and intra-territorial gaps in protection of basic liberties" (2009a, p. 608). Ethan Katsch has argued that one of the advantages of adopting spatial frameworks as an analytical tool is that they do not isolate activities but rather link those activities to other institutional and social changes (1993, p. 412).

4. Freund's ideas differed greatly from those of another pioneer of administrative law, Felix Frankfurter, who saw administrative law as a way to free government from the oversight of courts (see Ernst, 2009).
5. The bad tendency test allowed government to punish or prevent expressive acts that were deemed by authorities to be potentially damaging to the public welfare.
6. The zenith of the Place Framework was the Court's decision in *Schneider v. State* (1939) limiting government's ability to use the police power to control expressive activities in parks and city streets. Justice Owen Roberts wrote, "We are of the opinion that the purpose to keep the streets clean and of good appearance is insufficient to justify an ordinance which prohibits a person rightfully on a public street from handing literature to one willing to receive it.... [T]he streets are natural and proper places for the dissemination of information and opinion; and one is not to have the exercise of his liberty of expression in appropriate places abridged on the plea that it may be exercised in some other place" (*Schneider v. State*, 1939, p. 163).
7. For Arendt, *polis* referred to the public sphere, "the sphere of freedom" (Arendt, 1958, p. 30). As Arendt notes, to live in the *polis* "meant that everything was decided through words and persuasion and not through force and violence" (1958, p. 26).
8. BART did not try to block cell phone signals from private providers in the area and it did not ask private cell phone providers to close down its service (Cabanatuan, 2011).
9. In the public forum legal literature, this idea has been recognized as the "ample alternatives" test, established in 1984 (see *Clark v. Community for Creative Non-violence*, 1984, p. 293).

References

Abbott, A. (1995). Things of boundaries. *Social Research, 62*(4), 857–882.

Alexander, G. (1997). *Commodity & propriety: Competing visions of property in American legal thought, 1776–1970.* Chicago, IL: University of Chicago Press.

Allen, D. S. (2011). Spatial frameworks and the management of dissent: From parks to free speech zones. *Communication Law & Policy,* 383–424.

Allen, D. S. (2014). The ethical roots of the public forum: Pragmatism, expressive freedom, and Grenville Clark. *Journal of Mass Media Ethics, 29,* 138–152.

Arendt, H. (1958). *The human condition.* Chicago, IL: University of Chicago Press.

Blocher, J. (2009). Categoricalism and balancing in first and second amendment analysis. *New York University Law Review, 84,* 375–437.

Cabanatuan, M. (2011. August 12). BART admits halting cell service to stop protests. *San Francisco Chronicle.* Retrieved from http://www.sfgate.com/news/article/BART-admits-halting-cell-service-to-stop-protests-2335114.php

Carp, B. L. (2007). *Rebels rising: Cities and the American revolution.* New York, NY: Oxford University Press.

Charity, A. (1995). *Doing public journalism.* New York, NY: Guilford Press.

Clark v. Community for Creative Non-violence, 468 U.S. 288 (1984).

Cohen, J. R. (1994). Critical viewing and participatory democracy. *Journal of Communication, 44,* 98–113.

Cohen, M. R. (1927). Property and sovereignty. *Cornell Law Quarterly, 13,* 11–30.

Cornelius v. NAACP Legal Defense and Educational Fund, Inc., 473 U.S. 788 (1985).

Davis v. Massachusetts, 167 U.S. 43 (1897).

Dewey, J. (1927). *The public & its problems.* Chicago, IL: Swallow Press.

Ely, J. W., Jr. (1992). *The guardian of every other right.* New York, NY: Oxford University Press.

Ely, R. T. (1914.) *Property and contract in their relations to the distribution of wealth.* New York, NY: Macmillan.

Ernst, D. R. (2009). Ernst Freund, Felix Frankfurter and the American *rechsstaat:* A transatlantic shipwreck, 1894–1932. *Studies in American Political Development* (2), 171–188.

Fisher, P. (1988). Democratic social space: Whitman, Melville, and the promise of American transparency. *Representations, 24,* 60–101.

Fleming, J. G. (2012). The case for a modern public forum: How the Bay Area Rapid Transit System's wireless shutdown strangled free speech rights. *Washburn Law Journal, 51,* 631–661.

Freund, E. (1976/1904). *The police power: Public policy and constitutional rights.* New York, NY: Arno Press.

Galperin, E. (2011, August 18). Digital devices raise new free speech issues. *Talk of the Nation.* National Public Radio. Retrieved from http://ww.npr.org/2011/08/18/139755302/digital-devices-raise-new-free-speech-questions

Giroux, H. A. (1992). Resisting difference: Cultural studies and the discourse of critical pedagogy. In L. Grossberg, C. Nelson, & P. Treichler (Eds.), *Cultural studies* (pp. 199–212). New York, NY: Routledge.

Habermas, J. (1989a/1981). *The theory of communicative action* (Vols. 1–2) (T. McCarthy, Trans.). Boston, MA: Beacon Press. (Original work published in 1981)

Habermas, J. (1989b). *The structural transformation of the public sphere: An inquiry into a category of bourgeois society* (T. Burger, Trans.). Cambridge, MA: MIT Press.

Habermas, J. (1990). Discourse ethics: Notes on a program of philosophical justification. In C. Lenhardt & S. Weber Nicholsen (Eds.), *Moral consciousness and communicative action* (pp. 43–115). Cambridge, MA: MIT Press.

Habermas, J. (1996). *Between facts and norms: Contribution to a discourse theory of law and democracy* (W. Rehg, Trans.). Cambridge, MA: MIT Press.

Hague v. CIO, 307 U.S. 496 (1939).

Hall, P. (2002). *Cities of tomorrow* (3rd ed.). Malden, MA: Blackwell.

Inazu, J. D. (2015). The first amendment's public forum. *William and Mary Law Review, 56,* 1159–1197.

Jenkins, H. (1992). *Textual poachers: Television fans & participatory culture.* New York, NY: Routledge.

Jhally, S. (1987). *The codes of advertising: Fetishism and the political economy of meaning in a consumer society.* New York, NY: St. Martin's Press.

Jones, A. (1967). Thomas M. Cooley and "laissez-faire constitutionalism": A reconsideration. *Journal of American History, 53*, 751–771.

Jones, R. (2009). Categories, borders and boundaries. *Progress in Human Geography, 33*, 174–189.

Jones, R. (2010). The spatiality of boundaries. *Progress in Human Geography, 34*, 263–267.

Kalven, H., Jr., (1965). The concept of the public forum: Cox v. Louisiana. *The Supreme Court Review, 1965*, 1–32.

Katsch, E. (1993). Law in a digital world: Computer networks and cyberspace. *Villanova Law Review, 38*, 403–432.

Kellerman, A. (2014). *The Internet as second action space.* London: Routledge.

Kitchin, R., & Dodge, M. (2011). *Code/space: Software and everyday life.* Cambridge, MA: MIT Press.

Lackert, R. (2012). BART cell phone service shutdown: Time for a virtual forum? *Federal Communication Law Journal, 64*, 577–598.

Lamont, M., & Molnár, V. (2002). The study of boundaries in the social sciences. *Annual Review of Sociology, 28*, 167–195.

Lefebvre, H. (1984). *The production of space* (D. Nicholson-Smith, Trans.). Malden, MA: Blackwell Publishing.

Letters from the people: A loud call for farmers to economize in forage (1882, September 5). *Los Angeles Times*, p. 3.

McCarthy, T. (1988). *The critical theory of Jürgen Habermas.* Cambridge, MA: MIT Press.

McCurdy, C. W. (1975). Justice Field and the jurisprudence of government-business relations: Some parameters of laissez-faire constitutionalism, 1863–1897. *Journal of American History, 61*, 970–1005.

Nebbia v. New York, 291 U.S. 502 (1934).

Nimmer, M. B. (1984). *Nimmer on freedom of speech: A treatise on the theory of the First Amendment.* New York, NY: Matthew Bender.

Perry Educational Association v. Perry Local Educators' Association, 460 U.S. 37 (1983).

Pitzel, E. (2013). Bay Area Rapid Transit actions of August 11, 2011: How emerging digital technologies intersect with First Amendment rights. *Georgia State University Law Review, 29*(3), 783–822.

Police Department of Chicago v. Mosley, 408 U.S. 92 (1972).

Post, R. C. (1987). Between governance and management: The history and theory of the public forum. *UCLA Law Review, 34*, 1713–1835.

Reich, C. A. (1994). The new property. *Yale Law Journal, 73*, 733–787.

Ryfe, D. A. (2006). News, culture and public life: A study of 19th-century American journalism. *Journalism Studies, 7*(1), 60–77.

Scarry, E. (2006). Who defended the country? In D. J. Sherman & T. Nardin (Eds.), *Terror, culture, politics: Rethinking 9/11* (pp. 184–205). Bloomington, IN: Indiana University Press.

Schneider v. State, 308 U.S. 147 (1939).

Schuyler, D. (1986). *The new urban landscape: The redefinition of city form in nineteenth-century America*. Baltimore, MD: Johns Hopkins University Press.

Sullivan, K. M. (1992). Post-liberal judging: The roles of categorization and balancing. *University of Colorado Law Review, 63*, 293–317.

The lake-front forum (1891, January 15). *Chicago Daily Tribune*, p. 4.

U.S. Const. amend. V.

Upton, R. (2002). Planning praxis: Ethics, values and theory. *The Town Planning Review, 73*(2), 253–269.

Volokh, E. (2011, August 13). An unusual (but likely constitutional) speech restriction. *The Volokh Conspiracy*. Retrieved from http://volokh.com/2011/08/13/an-unusual-but-likely-constitutional-speech-restriction

Wallace, A. (2012). *Media capital: Architecture and communications in New York City*. Urbana, IL: University of Illinois Press.

White, J. B. (1990). *Justice as translation: An essay in cultural and legal criticism*. Chicago, IL: University of Chicago Press.

Zick, T. (2009a). Constitutional displacements. *Washington University Law Review, 86*, 515–608.

Zick, T. (2009b). *Speech out of doors: Preserving first amendment liberties in public places*. New York, NY: Cambridge University Press.

Concluding Remarks: Digital Ethics: Where to Go from Here?

BASTIAAN VANACKER

Having been involved for seven years with the Center for Digital Ethics and Policy at Loyola University Chicago, I have seen a gradual shift in the topics that occupy the debate in digital ethics (DE). For example, questions of piracy and copyright infringement seem less prevalent now, perhaps because with the advent of streaming services, instances of infringement have subsided somewhat. Or because the ethical debate on this topic has been exhausted or solved. Ethical issues regarding violent and/or pornographic content, digital manipulation of images and professional uses of social media also seem to have lost some of their urgency. As technologies are being integrated in our personal and professional lives, a set of practices has emerged that dictates the limits of acceptable uses.

For example, those who are pushing content to users that contains graphic or sexually explicit imagery without some kind of warning (such as NSFW) will receive blowback. They might create a hostile work environment if they do this at work, violate acceptable use policies of the platform they are using, or face angry e-mails, tweets, or comments from their peers. Slowly, we are figuring things out. Most parents now know to show some restraint when posting images of someone else's children. News organizations are figuring out how to use Twitter as a source while avoiding some of the pitfalls that relying on social media can bring about. As digital ethicists, we can assist people, groups, and professions to articulate more clearly the moral underpinning of these emerging practices and connect them with generally accepted ethical principles. This is why Don Heider suggests in his foreword that organizations start hiring in-house ethicists who are familiar with the culture and norms of an organization in order to foster a culture of ethical decision making.

But there are also areas where we have not figured or are not figuring it out, where there is no agreement on acceptable practices for a morality to take root. These are the areas where DE has its work cut out and these are the reasons why DE as a stand-alone field has relevance. Take the privacy question, for example, an issue on which we have made little headway over the past years. Not because of a lack of theorizing about the concept, but because in our daily lives we struggle to give privacy its proper place. Polls show people are concerned about their online privacy and government surveillance, but their online behavior does not reflect this concern. Polls also show that Americans support a right to be forgotten, but the strong free speech protections in this country seem to prevent—for the time being—such a law to take effect here. We feel uneasy about how companies use our data for marketing purposes, yet sign up for reward programs through which our personal data are collected. We have not figured out privacy. The debate about privacy too often centers on slippery slope arguments about what could happen in a worst-case scenario. Often lacking from this debate is a conceptual clarification of privacy. Is it a right or a value? Is it an instrumental right or a fundamental right? Is it an individual or a collective right? Until we answer these questions, online privacy issues will not be resolved.

The advent of the digital age has propelled the privacy issue to prominence, but we lack a framework to analyze these issues with. I give privacy as an example, but there are other arenas where we see a similar disconnect between the ethical problems posed by the digital age and our ability to deal with them. The ethical problems posed by the immersive nature of new technologies and the limits of free speech online are but two other examples where I believe our current ethical frameworks will (are) fail(ing) us. The internet challenges the traditional distinctions between speech and conduct and forces us to rethink what constitutes harm and justice. By approaching digital communities as speech-based environments our legal (and ethical) system is ill-equipped to provide relief to victims of hate campaigns, leaving online platforms to become de facto censors of online communities.

When a female player is groped in a multiplayer virtual reality game, are we dealing with speech (because ultimately this interaction stems from an exchange of information between devices) or with conduct? When hundreds of people collectively attempt to destroy a person's life by posting personal information or engage in online harassment because of a minor transgression, are they engaging in conduct or in speech? It is unlikely that we will figure these issues out as we go along, without a reframing of these questions in a way that challenges our traditional notions of key ethical concepts such as virtue, harm, justice, and intent.

Lastly, DE also needs to overcome the innate techno-utopian bias of much of the ethical questions we ask. By this I mean the notion that each problem presented to us by new technologies can be solved by more and newer technologies. Or the assumption that the problem technology purports to solve is really a problem to begin with. Or the belief that a new technology inevitably will increase the quality of human existence. But at what point does a faster processor, better camera, and higher resolution screen on a phone actually becomes a drag on the environment more than it adds to our quality of life?

Too often, ethical inquiries arise after a technology has come into existence (an exception to this might be the ethical debate regarding robots and artificial intelligence, which seems to precede the technological developments in these areas by decades) and fundamental questions about the desirability of this technology are foregone in order to address the question of how a technology could be used ethically. So we are forced to debate the ethical use of predictive analytics, live streaming on social media, drones, self-driving cars, smart fridges, etc., but we seldom ask the more fundamental questions about how these technologies contribute to a better society, their impact on the environment, how they affect inequality, how accessible they are to the poor, and how they contribute to a divide between the haves and have-nots.

Technological advancements and social media are often sold as a way to bring people together, yet this nation seems more divided than ever. The technology sector attracts our brightest minds and is one of the main drivers of our economy. But with great power comes great responsibility. DE needs to hold the tech world accountable by actively challenging its normative assumptions, not by implicitly adopting them.

Contributors

David S. Allen is a professor in the Department of Journalism, Advertising, and Media Studies at the University of Wisconsin–Milwaukee, where he teaches classes on freedom of expression and media ethics. In addition to a wide range of journal articles, he is the author of *Democracy, Inc.: The Press and Law in the Corporate Rationalization of the Public Sphere* and co-editor of *Freeing the First Amendment: Critical Perspectives on Freedom of Expression*. His current research examines legal and ethical structures that legitimize the management of public space as a way to control dissent within democratic societies.

Bénédicte Dambrine is a privacy counsel at OneTrust, one of the leading and fastest-growing privacy management software platforms in the world. Prior to joining OneTrust, Dambrine was at the Future of Privacy Forum, a DC based non-profit organization that serves as a catalyst for privacy leadership and scholarship, advancing principled data practices in support of emerging technologies across industries. She also worked at an international law firm in Paris where she advised on data protection and corporate matters. Dambrine is admitted to the Paris Bar and is a Certified Information Privacy Professional (CIPP/US). She holds her master's in business law from the Université Paris II Panthéon Assas and an LLM in international law from DePaul University.

Kathleen Bartzen Culver is the James E. Burgess Chair in Journalism Ethics, an assistant professor in the University of Wisconsin-Madison School of Journalism and Mass Communication and the director of the Center for Journalism Ethics. Long interested in the implications of digital media on journalism and public interest communication, Culver focuses on the ethical dimensions of social tools, technological advances, and networked information. She combines these interests with a background in law and free expression. She also

serves as visiting faculty for the Poynter Institute for Media Studies and was the founding editor of MediaShift's education section.

Timothy H. Engström is Professor of Philosophy at the Rochester Institute of Technology. He has been a research fellow at the Institute for Advanced Studies in the Humanities, Edinburgh University, Scotland, at the University of Marburg, Germany, and a visiting professor at Malmö University, Sweden. He has published in the areas of philosophy, social and political theory, aesthetics, and philosophy of technology, concentrating especially in comparative 19th- and 20th-century European and Anglo-American philosophy. His most recent book, with Evan Selinger, is *Rethinking Theories and Practices of Imaging*.

Patrick Ferrucci is an assistant professor in the Department of Journalism in the College of Media, Communication and Information at the University of Colorado Boulder. His research examines different aspects of media sociology, primarily economic and technological influences on digital news production.

Jill Geisler is the inaugural Bill Plante Chair in Leadership and Media Integrity, a position designed to connect Loyola's School of Communication with the needs and interests of contemporary and aspiring media professionals worldwide. Geisler is known internationally as a teacher and coach of leaders in media and beyond. She developed and guided key management and leadership programs of the Poynter Institute for 16 years and continues to be the go-to expert when leaders need help managing change, improving their culture and teams, tackling ethical challenges, or building their individual leadership skills.

David J. Gunkel is an award-winning educator and scholar, specializing in the ethics of emerging technology. He is the author of over 70 scholarly articles and has published nine books, including *Thinking Otherwise: Philosophy, Communication, Technology* (Purdue University Press, 2007); *The Machine Question: Critical Perspectives on AI, Robots, and Ethics* (MIT Press, 2012); *Of Remixology: Ethics and Aesthetics After Remix* (MIT Press, 2016); and *Robot Rights* (MIT Press, 2018). He currently holds the position of Distinguished Teaching Professor in the Department of Communication at Northern Illinois University and is the founding co-editor of the *International Journal of Žižek Studies*. For more information, visit http://gunkelweb.com

Don Heider is the founding dean of the School of Communication at Loyola University Chicago. He also helped found the Center for Digital Ethics and Policy. He is the author or editor of six books, as well as a former journalist who has won five Emmy awards for his work.

Joseph W. Jerome is a graduate of the New York University School of Law and works as an information privacy attorney. His article was the product of work undertaken at the Future of Privacy Forum in 2015 to explore information privacy concerns in the sharing economy.

David Kamerer is an associate professor in the School of Communication at Loyola University Chicago, where he teaches courses in digital media, measurement, and public relations. He is the former director of communication at Envision and has consulted for Greteman Group, Via Christi Health, and other small businesses, startups, and not-for-profit organizations in Wichita and Chicago. He earned a Ph.D. in telecommunications from Indiana University and has earned accreditations from the Public Relations Society of America (APR) and Google (Google Analytics Individual Qualification). He blogs at davidkamerer.com.

Mathias Klang is Associate Professor of Emerging Technology at Fordham University. He is fascinated by the ways in which emerging media impacts all aspects of society, in particular how our use of digital technology changes the ways in which our individual and civil rights (mainly speech, privacy, and identity) are both expanded and limited by technology. His current research covers two broad areas: the first area explores acts of digital activism in a wider context of civil disobedience, and the second looks at the ways in which our devices intentionally and unintentionally monitor and control our behavior.

Nora Madison is Assistant Professor of Communication and Coordinator of the Communication Program at Chestnut Hill College in Philadelphia. Her research examines the social and cultural impacts of technology on everyday activism and digital representation, focusing on the importance of digital technologies for bisexual visibility. Nora has presented her findings around the world, including an invited talk at Sweden's International Science Festival (*Vetenskapsfestivalen*). She can be reached her through noramadison.net or @theoryofnora.

Heidi A. McKee is Professor of English and an affiliate faculty member in Interactive Media Studies at Miami University. She has co-authored or co-

edited five books on rhetoric and digital communications, including: *Digital Writing Research: Technologies, Methodologies, and Ethical Issues* (2007); *The Ethics of Internet Research* (2009); *Technological Ecologies and Sustainability* (2009); *Digital Writing Assessment and Evaluation* (2013); and most recently with co-author James E. Porter, *Professional Communication and Network Interaction: A Rhetorical and Ethical Approach* (2017).

Chad Painter is Assistant Professor of Communication at the University of Dayton, where he teaches courses in journalism and mass communication. He studies media ethics with emphases on the depiction of journalists in popular culture, the alternative press, and diversity studies. Currently, he serves as the head of the AEJMC Media Ethics Division and is co-authoring the next edition of *Media Ethics: Issues and Cases*. He has eight years of professional experience as a reporter, an editor, and a public relations practitioner for print and online publications.

James E. Porter is Professor of Rhetoric and Professional Communication at Miami University, with a joint appointment in the Armstrong Institute for Interactive Media Studies and the Department of English. Porter's research focuses on the interconnections between rhetoric, ethics, and professional and digital communications. He has authored or co-authored five scholarly books in rhetoric, including two with Heidi A. McKee: *The Ethics of Internet Research* (Peter Lang, 2009) and *Professional Communication and Network Interaction: A Rhetorical and Ethical Approach* (Routledge, 2017).

Susan Currie Sivek is an associate professor in the Department of Journalism and Media Studies at Linfield College. Her research focuses on the effects of technology on journalism and media production. She teaches courses in multimedia communication, media writing, and media theory.

Bastiaan Vanacker is an associate professor at the School of Communication at Loyola University Chicago, where he also serves as Program Director of the Center for Digital Ethics and Policy. His research focuses on journalism ethics and law. This is the third book he has co-edited or authored. He is the former head of the AEJMC Media Ethics Division.

Stephen J. A. Ward, PhD, is an author, a keynote speaker, and a media ethicist whose research is on the ethics of global and digital media. He is Distinguished Lecturer on Ethics for the University of British Columbia (UBC), Canada. A former war reporter, he is the founding director of the Center for

Journalism Ethics at the University of Wisconsin, a co-founder of the UBC School of Journalism in Vancouver, and the former director of the Turnbull Center at the University of Oregon in Portland. He is the author of six books, including the award-winning *Radical Media Ethics* and *The Invention of Journalism Ethics*.

General Editor: **Steve Jones**

Digital Formations is the best source for critical, well-written books about digital technologies and modern life. Books in the series break new ground by emphasizing multiple methodological and theoretical approaches to deeply probe the formation and reformation of lived experience as it is refracted through digital interaction. Each volume in **Digital Formations** pushes forward our understanding of the intersections, and corresponding implications, between digital technologies and everyday life. The series examines broad issues in realms such as digital culture, electronic commerce, law, politics and governance, gender, the Internet, race, art, health and medicine, and education. The series emphasizes critical studies in the context of emergent and existing digital technologies.

To order other books in this series please contact our Customer Service Department:
 (800) 770-LANG (within the US)
 (212) 647-7706 (outside the US)
 (212) 647-7707 FAX

To find out more about the series or browse a full list of titles, please visit our website:
 WWW.PETERLANG.COM